The SHOCKING STORY *of* HELMUTH SCHMIDT

Michigan's Original Lonely Hearts Killer

TOBIN BUHK

Charleston — London

THE
Hi∫tory
PRESS

Published by The History Press
Charleston, SC 29403
www.historypress.net

First published 2013

Manufactured in the United States

ISBN 978.1.62619.017.7

Library of Congress CIP data applied for.

To Ruth, Erika and Victoria, with love.

CONTENTS

PREFACE

Oakland County prosecuting attorney Glenn C. Gillespie looked out the front window. "April showers bring May flowers," he muttered as he watched strings of light rainfall, causing a flickering effect that reminded him of the moving picture shows at the Oakland Theater. Despite the rain, a group of neighborhood kids had gathered across the street, careful to keep their distance from the "death house."

Undersheriff Harry Cryderman handed Gillespie a gold pocket watch that one of the detectives found in a bedroom dresser drawer. Someone scratched several rows of numbers on the inside lid. The prosecutor ran his finger down the scratches until he came to the last set of numbers, "11-3-17," and immediately thought of the effervescent New Yorker who sought a new life in Royal Oak. After a brief courtship with a Detroiter she met through a matrimonial advertisement, Augusta Steinbach left a cushy job as a lady's maid in Manhattan to marry the man of her dreams. She disappeared on March 11, 1917, last seen entering the bungalow at 9 Oakdale Boulevard in Royal Oak.

Gillespie was running his fingers back up the sequence of numbers when he heard shouting from the backyard. Detective Harry Emerson, a private investigator working for the Ford Motor Company, had found something behind the garage. That rainy morning of April 21, 1918, investigators searched for clues about the fate of Augusta Steinbach. As the morning progressed, however, they realized that they had stumbled onto something much more complex. None of them had witnessed anything like it in their

careers. Over the course of the next week, they would match wits with the "Royal Oak Bluebeard," a criminal the *Detroit Times* called "one of America's master outlaws."

The case was so outrageous, so bizarre, that when the story broke on April 22, 1918, it captivated headlines for a week, pushing news of the Great War to the margins. A *Pontiac Press Gazette* reporter, in a front-page spread on April 22, 1918, called it "one of the most sensational and interesting criminal cases ever developed in this county...No story of fiction ever contained more thrills or romance."[1]

Except this story is not fiction. The following narrative, I think, is a historically accurate depiction of the events as they occurred. The quotes are authentic, not fictionalized, culled from news reports, court documents and the scant documentary evidence still in existence after nearly a century. If a source's reliability is questionable, or if a source is suspected of sensationalizing some aspect of the case, it is documented in the notes. Should the reader desire to attempt a private investigation into this fascinating case, the notes also contain attribution for all sources used and consulted.

Reaching back through history to collar the Royal Oak Bluebeard was no easy task. Over the past few years, I've played a historical detective of sorts, gathering clues in my attempt to unravel the serpentine trail he left behind. There are virtually no secondary sources on this case, so I had to re-create the investigation by traipsing through a thicket of sensationalized and often conflicting press reports.

Since the case never went to trial, where a jury could listen to testimony and give a verdict, the task of final judgment is left to the reader. Pay attention to the evidence, listen to the witnesses and evaluate possible ulterior motives as the various characters discuss their experiences with the Royal Oak Bluebeard.

There are certainly more gruesome crimes, but few are more relevant to our time. Although this story took place almost a century ago, anyone who participates in a chat room or an online dating service will recognize the lesson of this story—a danger inherent in using a third-party service to find mates.

And for the true crime buff, there are fewer places more interesting to visit than Detroit in 1918, where county sheriffs stopped lynch mobs from enacting frontier justice, cops staged lineups in the front yards of victims, suspects sometimes limped away from interrogations with new injuries and reporters sometimes eavesdropped on interrogations and even posed questions to the accused.

It's a real trip. I hope you enjoy it as much as I did.

THE DOMESTIC AND THE SUITOR

LOVE LETTERS

New York City
February 3, 1917

It was a frigid morning in New York when Agnes Domaniecki said goodbye to her best friend Augusta Steinbach. She dreaded the moment when Augusta would leave for Detroit, where she planned to marry a man she had never laid eyes on before. It was the climax of a New World adventure that began three and half years earlier.

In the summer of 1913, about one year before Europe plunged into a conflict that would consume the entire continent, thirty-five-year-old Augusta Steinbach boarded a passenger ship—the *Kronprinz Wilhelm*—en route from Cherbourg, France, to New York. She made the journey across the Atlantic to her new home with a married couple from New York, Charles and Lina Weber. As the ship steamed west, she wondered what her new life in the United States would be like.

In the Old World, she made her living as a lady's maid. She began as a domestic in Berlin around the turn of the century, working among Germany's aristocracy alongside Agnes Domaniecki. Later, the two women drifted to Paris, where they worked as domestics until 1913. With war looming, Paris was no place for German natives, so the two decided to change their milieu. Agnes took a job as a lady's maid in Kingston, Jamaica, while Augusta moved to the Big Apple.

Sketch of Augusta Steinbach made in 1918 by a *Detroit News* artist. *Courtesy of the Detroit News Photo Archives.*

The *Kronprinz Wilhelm* arrived at Ellis Island on June 24, 1913. Shortly after her arrival, Augusta found work among New York's elite, eventually taking a job as a lady's maid for the wife of a wealthy New York banker named Edward Heidelberg, who lived on West Fifty-fourth Street. The Heidelberg family adored the shy but bubbly girl from the German countryside.

Augusta Steinbach enjoyed life among the affluent and liked to spoil herself with expensive clothes and jewelry, but the one thing she yearned for—a house and family of her own—eluded her. It wasn't as if she had gone unnoticed. She had chocolate-brown hair, blue eyes and a full-bodied figure that some men found irresistible.[2]

In April 1914, thirty-year-old Agnes Domaniecki immigrated to the United States and joined Augusta in New York.[3] Even though they didn't work in the same households, they spoke often, usually in German mixed with an occasional English word or two. They giggled about old times, gossiped about New York high society and discussed the war that raged in Europe. Augusta was particularly interested in the news; her four brothers had joined the German military machine, and her sister was a nurse in Constantinople.

Although an ocean away from the trenches, New Yorkers were never very far from the war. America remained officially neutral, but the conflict turned New York City into a place of intrigue. When hostilities began in the summer of 1914, imperial German authorities worried that munitions in the United States would go to their enemies. So they set up networks of saboteurs, which often included immigrants already in the

Department of Justice
Bureau of Investigation

June 26, 1918

Alexander Victor Kircheisen, alias Charles Nelson. Description: 32 years; 5 feet 7 1-2 inches; 155 pounds; dark hair; brown eyes; seaman.

June 1914 to April 1915, Quartermaster on Pacific Mail S. S. China. September 1914, naturalized in California. 1915 to 1917, seaman on ships plying between Atlantic Coast and Dutch ports. June 1917, arrested as German Spy in Copenhagen, Denmark; August 1917, deported to Sweden. Recent movements not reported; may be in the United States.

SUSPECTED GERMAN AGENT. If found, should be arrested, and Chief, Military Intelligence, Washington, D. C., notified by wire.

A. BRUCE BIELASKI, Chief

During World War I, the imperial German government employed German immigrants already in the United States as agents. The U.S. Justice Department used "wanted" leaflets to hunt suspected spies and saboteurs. *Author's collection.*

German American community. Throughout the spring of 1915, their saboteurs went into action, hitting explosives caches along the northern New Jersey coast of New York Harbor.

In July 1916, sabotage on U.S. soil climaxed when German agents blew up a massive cache of ammunition stockpiled on Black Tom Island in New York Harbor. American manufacturers used the pier as a munitions dump for shipments en route to Europe. On July 30, the complex contained over 1 million pounds of ammunition. One barge alone carried 100,000 pounds of TNT.

The initial explosion, which occurred around 2:00 a.m., caused a tremor that rocked nearby Jersey City, New Jersey, and shattered windows in Manhattan. New Yorkers thought that an earthquake shook the city, but it was the "enemy within." This fear of subversives cast suspicion on all things German, but Agnes and Augusta endured these turbulent years together. To strangers, they may have appeared an odd couple; Agnes worried about things, while sanguine Augusta always found a reason to smile.

Sometimes, she and Agnes would deal out the Tarot cards to see if they could find a clue about what fate had in store for them. They mused

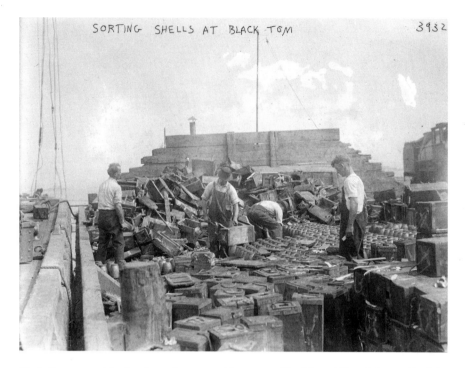

Black Tom was a shipping depot for ammunition sent to English and French forces. On July 30, 1916, saboteurs detonated a large quantity of explosives on the island. *George Grantham Bain Collection, Library of Congress.*

about romance, courtship and marriage, but by the summer of 1916, neither had found a mate. Although she looked much younger than thirty-eight, Augusta was past her dating prime and considered an "old maid." Loneliness mixed with a little desperation caused her to begin sifting through the matrimonial advertisements of the *New York Herald* and the *New York Revue* for possible partners.

In September 1916, she found two advertisements, both in German, posted by gentlemen from Michigan:

> *Good-looking mechanic, 38 years old, five years good job; weekly-wages, $80; seeks to marry suitable person; only well-meaning offers requested. George Roloff, general delivery, Highland Park, Mich.*

> *Gas inspector, 37 years old, without dependents, very respectable and very good-looking appearance; steady monthly income, $180; seeks a suitable lady, may be out of servant class, to marry soon. In explaining, offers*

of well-meaning persons requested. Herman Neugebauer, general delivery, Royal Oak, Mich.[4]

On the surface, both suitors appeared to be a good fit for a middle-aged woman in search of hearth and husband. Each man was about Augusta's age and earned enough money to support a wife. Intoxicated by the possibilities, Augusta responded to both advertisements. Within days, she received responses from both Roloff and Neugebauer. After a brief correspondence, she chose Neugebauer as the best match and began a long-distance courtship.

During the fall of 1916, while soldiers exchanged hot lead from trenches burrowed into the soil around the Somme River in France, the pair exchanged a flurry of letters. Herman Neugebauer described himself as more than six feet tall and having a muscular build. He also said that he attended the University of Heidelberg before coming to the United States. He told Augusta that he worked as a toolmaker for the Ford Motor Company and that he had acquired several properties in the Detroit area, including a bungalow in Royal Oak, where he lived with his two sisters, who took care of his house.

He promised to buy Augusta an electric washing machine—a newfangled extravagance that saved American women countless hours scrubbing clothes on ribbed boards in steel washbasins. He promised to buy her a new wardrobe and, as a wedding present, a car that he would have painted blue. Augusta made promises, too. Although never married, she'd had years of domestic experience. She promised to be a good, faithful wife who would keep an immaculate house and make sure that meals were ready when he came home from work.

There were also other ways she would please him, and Augusta wasn't timid when came to describing her physical attributes. In one letter, she described, in lurid detail, what would make her such a pleasing spouse. But the racy prose landed in the wrong man's mailbox. The postman misread the name on the envelope and delivered it to Adam Nelgebar, a Detroit shoemaker. Unfortunately for Mr. Nelgebar, Mrs. Nelgebar retrieved the mail that day. The woman grew enraged as she read about how Augusta planned to please her husband and accused the confused cobbler of running around on her. She took the letter straight to a local attorney, George Dondero, who was well known among the area's German community, in part because he spoke fluent German. It took some time, but Dondero managed to explain the mix-up.[5]

The correspondence became hot and heavy throughout January 1917, and by the end of the month, Augusta was hooked. She agreed to meet Neugebauer in Detroit. Agnes stood, dumbfounded, as her best friend broke the news that she was about to leave New York to marry a man she didn't know, had never seen

and had never met. Agnes was distraught. "At first when Augusta told me about going so far away to marry a man she didn't know," she later recalled, "I begged her not to. I laid the cards for her—which is a custom we German girls have when we want to know about our future—and I saw black cards there for her."[6]

But the pull toward Herman Neugebauer and the promise of her own family trumped the "black cards" in the deck, and Augusta went forward with her plans. She bought a wedding dress and packed it, along with her other things, in three large steamer trunks. She deposited two of the trunks in Schillinger's Reliance Warehouse on East Sixty-third in New York and told her friends—German domestics throughout the city—that she was going to Detroit to marry a wealthy man.

On February 1, she closed her bank account, withdrawing about $180. She also tried to cash in about $1,000 in German war bonds without success. Since she told Neugebauer that she had about $500 in cash, she borrowed $300 from Agnes. "I told her it was awful risky to go ahead," Agnes later said, but love-struck Augusta didn't heed her warning.[7]

On February 3, 1917, she boarded a westbound train from Hoboken, New Jersey, to Detroit, dressed to the nines. Her ensemble included two diamond rings, a gold chain, a gold watch, a pearl necklace and a red handbag. She wanted to look her best when the train pulled into the station, where she would meet, for the first time, her future husband.

THE MOTOR CITY

Detroit, Michigan
February 6, 1917

In one of his last letters, Herman told Augusta what train to take and how she could recognize him at the station: his car would have an American flag on its fender. Neugebauer even sent a photograph of his automobile with the patriotic symbol over its tire.

Opposite, top: Woodward Avenue in Detroit, circa 1917. At the time, Detroit was the biggest boomtown in America. *Detroit Publishing Company, Library of Congress.*

Opposite, bottom: Henry Ford's offer of five dollars per day in wages drew thousands to Detroit, and the Highland Park plant became one of the nation's largest factories. In order to earn the entire wage, employees had to follow the directives of the Sociological Department. *Library of Congress.*

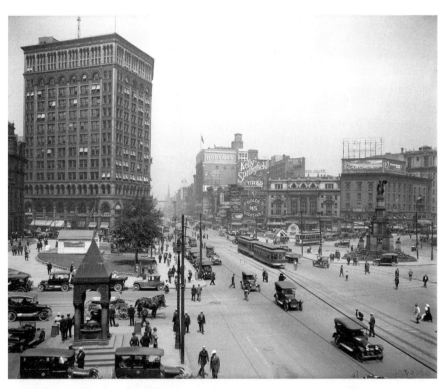

Augusta stared out the window and watched the scenery change from cows milling about in fields to automobiles motoring past rows of houses against a backdrop of tall buildings. The train was headed toward the biggest boomtown in America.

By 1917, the Motor City had shifted into high gear. Almost 500,000 people lived in the Greater Detroit area, with a bulk of the city's laborers employed by the two dozen automotive companies that manufactured car parts. Many of them had moved to Detroit a few years earlier when Henry Ford offered a $5.00 wage for an eight-hour shift—almost twice the going rate. For laborers sweating through ten-hour shifts for a paltry $2.50, Ford's offer seemed like pennies from heaven. People walked away from farms and coal mines all over the Midwest and flooded Ford's Highland Park plant.

The Motor City had a real swinging side in the 1910s. Saloons quenched the thirst of the city's workers, while brothels catered to other needs. The establishments in the lower east side's red-light district kept their doors open all night to service all three shifts of workers.

In February 1917, however, the city's watering holes had just over a year left to live. The previous fall, Michiganders voted for groundbreaking legislation that would dry out the Great Lake State. The new laws came, in part, from concerns about workers' ability to do their jobs in a city with a tavern on every street corner, so Detroit's industrialists took steps to keep their workers from the bottle during their off-duty hours.

Henry Ford played an instrumental role in drying out Detroit. Concerned about the productivity of hung-over employees, Ford took drastic measures to sober up his workforce. Investigators from his "Sociological Department"—a division created to make sure that employees lived a positive lifestyle—made house calls to ensure that his factory workers stayed away from vice. If they didn't, they wouldn't earn the entire five-dollar wage.[8]

Alongside the Michigan Anti-Saloon League and other impresarios who felt that booze affected the bottom line, Ford lobbied the state legislature for a legal measure banning the sale of alcohol. Lawmakers obliged by putting a prohibition amendment on the ballot in the fall of 1916. The law, which passed by a slim margin, prohibited the sale of alcohol in public places. Legislators later passed a measure that also made it illegal to import booze.

On May 1, 1918, saloons, beer halls and taverns would close their doors, and Michigan, in theory at least, would become dry—a year before federal legislation corked the nation's booze bottles. The talk in the city's saloons revolved around "near beer," or low-alcohol substitutes that some of the city's breweries planned to produce in lieu of the real thing.

By March 1917, Congress hadn't yet decided to enter the Great War, but in some ways, the Motor City was already involved. Many of the city's manufacturers had signed contracts with Allies to produce war matériel. Some Detroiters, eager to fight "the Hun," had even crossed the border and enlisted with the Canadian army.

The city's large German American community remained torn about the war. In the years leading up to the conflict, these citizens managed to embrace their ethnic heritage while at the same time blending into the American cultural landscape. Encouraged by the National German American Alliance—a nationwide coalition of German Americans who originally came together to promote German culture in the United States—they formed social clubs and read German-language publications like the *Detroit Abend-Post*. Some Protestant ministers gave sermons in German, and many schools offered German language classes.

When World War I began in 1914, an intense debate about America's involvement erupted. The arguments were never more passionate than inside the taverns and beer halls of the Motor City. Some German American Detroiters, buoyed by an intense pride in their heritage and in the juggernaut of Kaiser Wilhelm's Germany, sympathized with their homeland and favored U.S. neutrality. Some of them even backed Germany's war effort by purchasing imperial German war bonds.

As the war progressed, however, Detroiters of German ethnicity came under fire from those who questioned their loyalty to the United States. Michigan industrialists launched Americanization campaigns. They required their workers to take classes in English and citizenship. The National Americanization Committee—an organization designed to counteract German nationalism and root out disloyalty among citizens—feuded with the National German American Alliance.

Meanwhile, newspapers ran highly biased war coverage. Graphic drawings of alleged atrocities committed by "Hun" soldiers appeared in half-page spreads, and reporters repeated whispers about alleged subversive activity.

The threat of sabotage hit home for the area's residents. Detroit sat at the industrial heartland of North America—a fact recognized by German operatives. During the summer of 1915—at about the same time that agents targeted outgoing ships from New York Harbor—a gang of saboteurs led by Detroit machinist and resident Albert Kaltschmidt used the Motor City as a base in a conspiracy to dynamite Canadian factories involved in producing war matériel. They also plotted, but failed, to destroy the Detroit Screw Works, which manufactured shrapnel.

Kaltschmidt's most ambitious plan involved disrupting traffic between Canada and the United States by imploding the Port Huron tunnel. His scheme involved detonating a "devil car" packed with high explosives at a low point in the tunnel, but the plot never materialized.

A few months later, in December 1915, U.S. authorities discovered records of payment from the German military attaché to Kaltschmidt. The Justice Department didn't arrest Kaltschmidt because it hadn't yet uncovered evidence linking him with the destruction of U.S. property, but it kept a close eye on him.

Augusta was nervous as the train slowed to a stop at the station. She wrung her hands as she looked for a dapper gentleman standing next to a car with a flag draped over its wheel well, but Herman hadn't arrived yet. She sat down on a bench and waited. Someone left a copy of the previous night's *Detroit Times* on the seat. Augusta unfolded the newspaper and scanned the headlines as she waited for Neugebauer to arrive: "FORD OFFERS PLANT TO US; WILL MANUFACTURE MUNITIONS AT COST FOR USE OF THE GOVERNMENT, AUTO MAKER TELLS NAVY SECRETARY; Declares He's Ready to Use His Utmost Efforts in Country's Defense."

The front-page story detailed Henry Ford's offer to commit his factories to America's war effort. "I can without question, and in the event of the declaration of war," Ford told Secretary of the Navy Daniels, "place our factory at the disposal of the United States government and will operate without one cent of profit. I will also contribute my own time and work harder than even before."[9]

Augusta looked up from the newspaper. An hour had passed, and Herman still hadn't made his appearance at the station. Bewildered, she wandered out of the train station and walked a few blocks, eventually finding Woodward Avenue. She stood at the busy thoroughfare and absorbed the sights and sounds of the midwestern metropolis. Despite temperatures in the teens, the main drag buzzed with activity. A woman in a white dress holding hands with a boy in short pants shuffled past, and groups of men in three-piece suits and straw hats walked by in every direction. Streetcars tethered to overhead electric lines whisked down the center of the street, while "horseless carriages" of various types motored past a police officer holding a long pole with a stop sign at the top.

Augusta walked down Woodward Avenue, continuing east for a few blocks until she reached Adelaide Street, where she found the boardinghouse of T.H. Hetherington.

THE GENTLEMAN SUITOR

Detroit, Michigan
February–March 1917

After the failed rendezvous, Augusta checked into the boardinghouse of Thomas H. Hetherington on 45 Adelaide Street in Detroit.[10] A longtime Detroiter, Hetherington sold antique furniture from his storefront and rented a few vacant rooms above the shop.[11] Augusta told Hetherington that she would need accommodations for only a week or two at most, but she wound up staying over a month.

Hetherington and his wife, Louise, immediately took a liking to the New Yorker. She was heavyset but nevertheless quite attractive, with a youthful face and deep auburn hair done up in the fashion of a Gibson Girl. The Hetheringtons enjoyed her girlish giggle, the quaint expressions she imported from the old country and the way she lowered her chin, grinning, slightly embarrassed, when she mispronounced an English word. Louise Hetherington described Augusta as "a big country girl" with a coquettish side. "The first time Neugebauer called she was afraid to go to the door," she later recalled.[12]

Hat in hand, Neugebauer provided an excuse for missing their date at the train station, and the courtship began in earnest. Over the next few weeks,

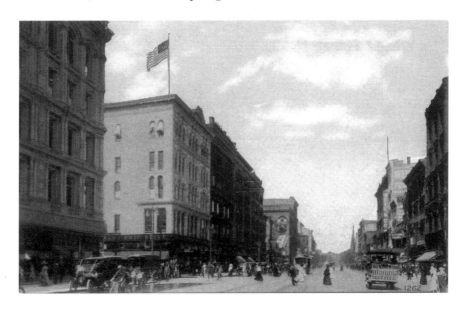

Woodward and State was a busy intersection in 1917. *Author's collection.*

he called on Augusta twice a week. He never stayed for more than a few hours, and he never visited on Sundays, which raised Mrs. Hetherington's suspicion. Typically, a suitor would call on a Sunday, but Augusta explained away this quirk by telling Mrs. Hetherington that Herman had important things to do.

Herman was everything she imagined. He was a real lady-killer: tall with a full head of thick, brown hair and a mustache. Even the three thin scars on his face didn't detract from his rugged handsomeness. They only added to his charm; Herman explained that the scars came from fencing matches—or duels, as he called them—that he fought while he attended the University of Heidelberg.

Herman was a captivating character with a rare blend of Old World charm and New World experience. He told stories about his youth in German high society, punctuated with anecdotes about his time in the United States. A man of culture and refinement, he spoke often of music and the arts. Louise Hetherington later said that Augusta "was very much flattered by the attention of a man whom she believed above her station in life."[13]

Augusta glowingly recounted her visits with Neugebauer. She described her betrothed as a courteous gentleman who was always on time and knew the proper code of conduct when courting a lady. He always insisted that the door remain ajar to avoid the appearance of any improper behavior.

Despite his frequent visits, Herman kept a low profile. During the month-long courtship, Thomas Hetherington met him only once. The smooth courtier apparently wanted to keep his personal affairs private and didn't want Augusta talking about their romance. When Augusta told Louise Hetherington something about Herman, she would always nervously add that Herman would kill her if he knew.

But the "big country girl" just couldn't keep her affairs in the dark. In a volley of letters to New York, Augusta relayed specifics about Neugebauer to Agnes. She described what appeared to be a fairy tale romance. Enraptured, Agnes read the letters and then reread them to a co-worker at the Ritz-Carlton, where both women were employed as domestics. "I liked this chambermaid and she enjoyed hearing what Augusta, my friend, had to say about her courtship and her coming marriage," Agnes later said. The two women delighted as they read Augusta's descriptions of Herman and her new life in the Motor City.[14]

One of the letters contained what Agnes thought was an odd statement. Herman told Augusta to break off all ties with her friends in New York and under no circumstances say anything about how they met through a

matrimonial advertisement. He didn't mind, though, if she kept in touch with Agnes as long as they didn't talk about *how* she and Herman met. Perhaps, Agnes thought, he felt ashamed about ensnaring a bride through the personals.

Just about a month after Augusta arrived in Detroit—on March 4, 1917—Neugebauer broke his pattern and came to call on a Sunday. This time, the couple left the boardinghouse and traveled to Neugebauer's Royal Oak bungalow.

During her visit, Augusta inked a letter describing the bungalow and the two "fine" women who lived with their brother and took care of his home. The older sister, whom Augusta didn't mention by name, was a widow from Chicago who came to Detroit after losing her husband. Augusta didn't like the older sister as much as the teenage sister, Gertrude, whom she called "jolly." The seventeen-year-old walked with a bounce in her step and seemed to find humor in everyday things, whereas the widow rarely smiled. Augusta thought that the older sister might have felt threatened by her presence, since she would soon become the woman of the house.

During her visit, Herman's sisters treated Augusta like royalty and appeared to be quite excited about the impending marriage, although they wanted to fête Herman with a large wedding while Augusta wanted to keep it a small affair.

"Now as I write," Augusta gushed, "his sisters are fixing a fine dinner. His oldest sister is a fine housekeeper. They are planning a big wedding for me and I do not like it because I want a quiet one. They are going to fix the house up before we get married, because they want it all in good order for me. His big sister thinks I look pale and wants me to take a good rest."[15]

Augusta went on to describe the house and its rich furnishings, including sewing machines and piano that Gertrude enjoyed playing. It was an idyllic scene except for one aspect that Augusta didn't like: the master bedroom contained only a double bed, and she much preferred two twins. Neugebauer also showed Augusta a box filled with jewelry that he said he inherited from his mother when she died in Germany. The jewelry, he said, would be Augusta's after the wedding.

When Augusta returned to Detroit later that day, she described the visit to Mrs. Hetherington, who enjoyed listening to her boarder muse about the paradise that she assumed would be her home as "Mrs. Herman Neugebauer." Augusta beamed as she described the property, which sat in a remote part of Royal Oak, not far from a river. A small creek ran through the backyard, and a henhouse stood at the property's edge.

The spacious house, which had a green shingled roof and brown clapboard and stucco exterior, contained six bedrooms, each one decked out with quality furnishings. The formal dining room sported silver service and fine linens.

The Sunday visit went well, and the couple made plans for their future. In a subsequent letter, Augusta asked Agnes to forward her trunks in the New York warehouse to Royal Oak, where Augusta believed the newlyweds would reside after their nuptials.

In a letter to Agnes dated March 10, Augusta announced that the date of the wedding had been set for mid-March, when Neugebauer would take Augusta to his brother-in-law's house. There, a priest whom he knew would preside over a small ceremony instead of the grand soiree that the two sisters envisioned.

Augusta then asked Agnes to not write any letters to her for the next four weeks, since she would be honeymooning with Herman and wouldn't be able to answer them. Augusta's risky romance appeared to be a success, but something didn't seem quite right to Agnes. Augusta's handwriting was typically neat, but Agnes noticed that in this last letter, her penmanship "looked scrawly and funny, not at all like the careful way she used to write. That was the last time I heard from my dear best friend."[16]

The day after this last letter was dated—Sunday, March 11, 1917— Herman Neugebauer came to the Hetheringtons' boardinghouse for the last time. Augusta said that she didn't know exactly where Neugebauer was taking her, but she apparently believed that their nuptials were imminent and that they would spend their honeymoon in the country before settling into Neugebauer's Royal Oak home. She arranged to have the one trunk at the Hetheringtons' and two more from New York forwarded to Royal Oak. She didn't mention a specific address, just "Royal Oak."

It was a bittersweet day for Thomas and Louise Hetherington, who had come to know their guest well over the past five weeks. They would miss her, but they were happy that Augusta's romance by mail had blossomed into a marriage proposal. They watched as Neugebauer's Maxwell car motored down Adelaide, wondering when they would see her again.

A WEDDING PRESENT

Detroit, Michigan
Late March 1917

Augusta was popular, so gossip carried the news of her engagement across New York. Friends and former employers began to purchase wedding gifts for the new bride. But no one, not even Agnes, knew Augusta's new address. They only knew her last known residence: 45 Adelaide Street, Detroit.

So, about two weeks after Augusta left, a gift arrived at the boardinghouse. The package, addressed to "Augusta Steinbach" and dated March 24, contained a wedding present from a Mrs. Strefath of 150 West Twenty-ninth Street in New York City: a glass butter dish and silver plate. When the gift arrived in Detroit, the Hetheringtons didn't know where to deliver it because Augusta hadn't left a forwarding address with them, either. "Naturally," Louise Hetherington recalled, "when the wedding present came, I wanted to get it to her and learn if she were happy."[17]

Thomas Hetherington did have one clue about Augusta's possible address. He had listened carefully to her descriptions of Neugebauer's bungalow, so he and Louise decided to take a drive to Royal Oak in an attempt to find the house and hand-deliver the present.

Hetherington managed to find a house at 9 Oakdale Boulevard that matched Augusta's description: green roof tiles, brown clapboard and stucco siding. Louise clung to her husband's arm as they walked along a paved path and up the steps to the porch. The house was exactly as Augusta described it.

Hetherington rapped on the front door. A few seconds later, a woman answered. Circumspect, she kept herself partially concealed behind the door, but Louise Hetherington noticed that she was attractive, with chocolate-hued, curly locks done up in a rounded pompadour. Mrs. Hetherington, who had a sharp eye, also recognized something familiar just behind the woman: table linens that resembled the fine linen Augusta brought from New York.

The couple stood on the covered porch as Hetherington explained the purpose of their visit. He described Neugebauer and Steinbach, but the woman said nobody by either name lived there. She introduced herself as Helen Schmidt and said that her husband, Helmuth, was away at the moment. Puzzled, the couple hopped into the car and headed back to the city. Hetherington felt a bit foolish. He apparently had misidentified the Oakdale house as Neugebauer's; he was going from his recollection of a conversation that took place a month ago.

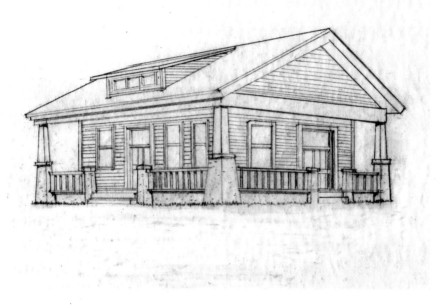

Number 9 Oakdale Boulevard, Royal Oak, as it appeared in 1918. Sheriff O.H.P. Green, unaware of the ghastly secret under his feet, stood on the front porch while he interviewed Helmuth Schmidt about Augusta Steinbach in March 1917. *Sketch by R.P. Buhk.*

Louise Hetherington wasn't so sure that her husband had made a mistake. Not only did the house match Augusta's description, but she was also certain that the linen inside belonged to Augusta. She recognized the pattern from a conversation the two women once had in which Augusta described how she planned to decorate her dining room and showed Mrs. Hetherington the fine linens she packed. Louise Hetherington remembered the conversation well; Augusta had taken an apron from her trunk, put it on and joked that it would soon be a wedding dress.

Something seemed very wrong about the whole affair. There had to be some sort of mistake; perhaps another visit would clear things up. Maybe Mr. Schmidt knew someone who brought Augusta to the bungalow for a visit. Or maybe he had a friend of a friend who knew the couple. Louise Hetherington insisted on going back to 9 Oakdale Boulevard.

The next day, they returned to Royal Oak. Once again, Helen Schmidt told them that she didn't know either an Augusta Steinbach or a Herman Neugebauer, but this time she said that she thought Neugebauer may live a little farther down the street. For the next few minutes, Thomas Hetherington motored up and down Oakdale, slowing as he passed the

occasional pedestrian to see if he might by chance come across Neugebauer or someone who knew him. A few hours passed, but they came no closer to finding either Augusta or her beau.

"We'll find out," Hetherington assured his wife. He knew one way they could locate Augusta: the transit company that shipped her trunk from the boardinghouse to "Royal Oak." He drove to the Adams Express Company, where a deliveryman named Fogarty confirmed that Augusta's things had indeed been sent to 9 Oakdale Boulevard. So, they made a third jaunt to the suburb. And for a third time, Mrs. Schmidt told them that no Augusta Steinbach had ever visited them. Confused, irritated and now worried that something sinister may have happened to their former boarder, the Hetheringtons walked to their vehicle, unsure of what to do.

As they neared their auto, a man approached them. He introduced himself as Mr. Jonathan Welch, the next-door neighbor. He had seen the Hetheringtons come and go the day before and wondered if they needed help; they appeared to be looking for something. Hetherington explained the purpose of their trip to Royal Oak and the odd circumstances that led them to repeat the journey three times.

For the next few minutes, Welch listened, enthralled by their story about the missing New Yorker and her debonair suitor. He was especially curious about Augusta's betrothed; from Hetherington's description, this Neugebauer fellow sounded a lot like his neighbor, Helmuth Schmidt. When he heard Louise Hetherington discuss the table linen, he became suspicious. At one time, he and his wife, Lena, noticed a pile of steamer trunks in the Schmidts' backyard.

That evening, while Jonathan Welch mulled over the possibility of a Royal Oak conspiracy involving his neighbors, the Hetheringtons heard a knock on *their* door. Thomas Hetherington couldn't believe his eyes when he saw Helen Schmidt standing on his doorstep. She had lied, she admitted, about Herman Neugebauer and Augusta Steinbach. Helmuth, her husband, had sent her to "straighten the matter out," she said. He knew the lovebirds, but they had decided not to marry. Neugebauer had lost his job at the Ford plant, and Augusta moved back to New York.

Her explanation was dubious, but then the Hetheringtons observed something even more suspicious. They watched Schmidt's wife walk a few blocks down the street and climb into a car with a man who looked a lot like Augusta's sweetheart, Herman Neugebauer.

A few days later, America was officially at war. On April 6, 1917, the United States declared war on Germany and its allies. True to his word,

During World War I, Ford Motor Company produced war matériel, including the Whippet Tank. *National Archives and Records Administration.*

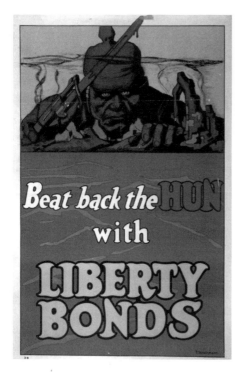

A World War I–era poster encouraging people to purchase Liberty Bonds. Note the depiction of the "Hun" as a demon with glowing eyes and bloodstained hands. *Library of Congress.*

Henry Ford put his factories to work for the federal government. Ford Motor Company employees continued to churn out automobiles for the domestic marketplace, but they also built trucks, airplanes and ships for the military. The Highland Park plant even produced the experimental Whippet Tank—a light armored vehicle that Ford tested on artificial hills constructed on the factory property.

While the doughboys led assaults on the German trenches in Europe using Ford-built equipment, dyed-in-the-blue Americans attacked Germans and German culture in the United States. Some German families had yellow paint thrown on their doors, and a few who were suspected of disloyalty were imprisoned in internment camps. Americanization efforts led to the rechristening of all things German. Sauerkraut became liberty cabbage, and hamburgers became liberty sandwiches. The elders of Berlin, Michigan, threw away their association with the German capital by renaming their town Marne after a major battle.

President Woodrow Wilson labeled all non-naturalized residents who came from one of the nations now at war with America as "enemy aliens." Later, in November, all "enemy aliens" were required to register with the

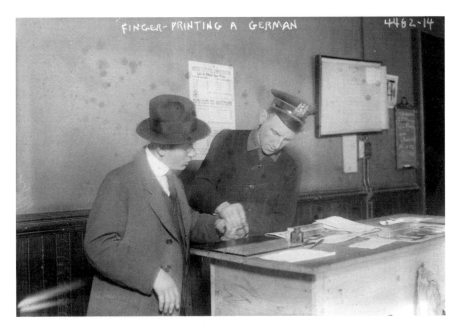

A German resident of New York is fingerprinted by a New York City police officer. In late November 1917, all non-naturalized German residents of the United States were required to register with local authorities as "enemy aliens." *George Grantham Bain Collection, Library of Congress.*

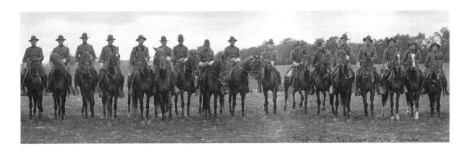

As a wartime measure to protect vital assets, the Michigan legislature created the Michigan State Constabulary in 1917. This forerunner to the state police was organized into two divisions of mounted and motorized units. *Linn Photo Company, Library of Congress.*

government. Germans from all over the United States marched to the office of their local U.S. marshal to fill out "enemy alien affidavits."[18]

Now that the United States and Canada were officially allied, authorities arrested Detroiter Albert Kaltschmidt and charged him for numerous counts under the Neutrality Act. A federal grand jury subsequently indicted the mastermind and a dozen of his cohorts on three counts of conspiracy

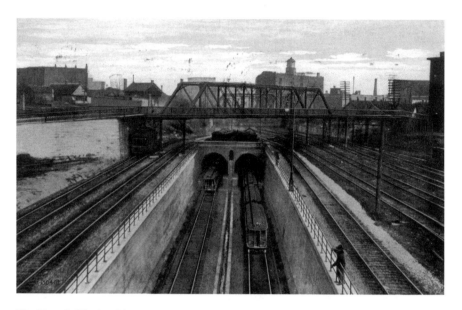

The Detroit-Windsor Tunnel, circa 1915. Convicted German saboteur Albert Kaltschmidt made plans to destroy the Port Huron Tunnel, but the plot never materialized. The need to protect such infrastructure from saboteurs in part led to the formation of the Michigan State Constabulary in 1917. *Author's collection.*

against the United States. In December, Kaltschmidt was convicted and sentenced to four years at Leavenworth.

To protect vital wartime assets from any possible sabotage, the Michigan legislature passed a law creating the Michigan State Constabulary—the forerunner of the state police—as an early form of homeland security.

The war against Germans, both in Europe and at home, was in full swing.

THE SPY NEXT DOOR

Royal Oak, Michigan
April 1917

The Welches had lived next to the Schmidts for the better part of a year. Helmuth Schmidt contracted Jonathan Welch to build his house based on plans he himself drew. Welch completed the project in the fall of 1916, and the Schmidt family moved from Highland Park to Royal Oak. Despite living close by, the two couples remained distant, separated by a language barrier;

the Schmidts spoke little English, and the Welches couldn't speak a word of German. They managed to coexist with the occasional gesture—a wave, a nod of the head—and the occasional platitude.

Only ten feet away, the Welches witnessed bits and pieces of their neighbors' lives; they heard Mr. Schmidt's teenage daughter, Gertrude, play the organ in the living room; they heard the family conversing in German; and they watched Helen go about her daily tasks, such as emptying the fireplace ashes in a heap by a stream that ran through their backyard. Like many Detroiters, the Welches worried about the enemy within and eyed their neighbors with suspicion. The Steinbach woman's disappearance only deepened their concerns.

On March 11, 1917—the last day anyone saw Augusta Steinbach—Lena Welch witnessed some strange scenes at the Schmidt place. She saw a woman (who matched Hetherington's description of Augusta Steinbach) arrive with Schmidt in his sporty Maxwell car. A few minutes later, she heard the sound of a woman groaning or whimpering and then crying. That afternoon, Lena Welch saw someone covering the basement windows with newspaper.

Jonathan Welch began to assemble the pieces. Augusta Steinbach's description of Neugebauer's Royal Oak home fit Schmidt's bungalow to a "T." She addressed her trunks to Royal Oak, and the Adams Express Company delivered them to Schmidt's address, 9 Oakdale Boulevard. His wife saw Augusta Steinbach, or someone with an uncanny resemblance to her, enter the Schmidt home at about the time she apparently disappeared. Welch was certain that Schmidt went by more than one identity.

While Lena Welch believed that Schmidt was a rake and used the "Neugebauer" alias to cheat on his wife, Jonathan's mind turned to a more sinister explanation: Schmidt, as Neugebauer, headed a spy ring, which may have included the Steinbach woman and others hell-bent on wreaking havoc on the United States from within. They burned coded papers in their furnace, which explained the concealed windows and the disposal of the ashes. One way or the other, he believed that the Schmidts knew more than they were saying about Augusta Steinbach's whereabouts. He decided to open his own amateur investigation. Espionage was a serious accusation, and he didn't want to point the finger without proof.

Welch visited the Ford Motor plant where his neighbor worked. Oddly, no one there knew a "Helmuth Schmidt." Even more oddly, they had never heard of a "Herman Neugebauer" either. Schmidt, Welch discovered, worked at the Highland Park plant under the name "Adolph Ullrich." Welch contacted T.H. Hetherington, who went to the Ford plant and tentatively

identified "Adolph Ullrich" as Neugebauer, but he couldn't be certain—he'd only met Augusta's suitor once.

Welch was now convinced that his neighbor was a spy. That would explain the three identities, but how did the "big country girl" fit into the puzzle? Was she part of the ring? The Welches had plenty of suspicions but no proof. The evidence, they believed, lay somewhere locked behind the door of 9 Oakdale Boulevard, and they knew exactly where to find the key.

According to some contemporary news reports, a neighbor overheard Helen Schmidt utter, "I hope Germany wins." The anonymous neighbor reported the remark to agents from the Justice Department, who now suspected Helmuth Schmidt as a possible enemy operative. Whether Helen Schmidt made the remark or not, it gave Oakland County sheriff Oliver H.P. Green all the authority he needed to poke around 9 Oakdale for the missing domestic.[19] Green and two agents from the Justice Department—J. Herbert Cole and S.T. Klawans—visited Royal Oak in mid-April. They informed Schmidt that they were responding to allegations that he was a spy.

Helen Schmidt nearly fainted when she saw the agents walk through the door. Her husband, on the other hand, appeared calm and collected throughout the visit. He answered all of Green's questions in a simple, straightforward way. He didn't stumble with his answers or contradict himself. When Cole told Schmidt that he was suspected of espionage, Schmidt grinned. He knew agents, he said, but he didn't work with them. He even offered to give them a list of names, but Green believed that Schmidt was trying to divert his attention from Augusta Steinbach.

While Cole and Klawans explored the house, Green grilled his suspect. Not one to mince words, Green asked if Schmidt also went by the name of Ullrich. Schmidt admitted to going by that name at work but gave no explanation for it. Green's first question naturally led to the one on Jonathan Welch's mind: did Schmidt also use the name Neugebauer? Schmidt smiled like a man without a concern in the world. No, he said, but he did know Herman.

Then they heard Cole's voice from the cellar: "Down here." Green, with Schmidt trailing behind, made his way down the flight of creaky wooden steps into the basement. During a brief sweep of the room, Cole found Augusta Steinbach's three steamer trunks. A cursory examination of the trunks revealed a wedding dress, clothes and a box of jewelry—items that one might expect in the luggage of a woman expecting to be married.

Green turned to Schmidt, who repeated the story that Helen had told to Hetherington. He knew Herman Neugebauer and had met his friend's betrothed, Augusta Steinbach. Ultimately, Schmidt explained, Augusta had

decided not to marry Herman and returned to New York. Steinbach asked Schmidt to hold her trunks until she found a place to live, when she would send for them.

The explanation satisfied many of the concerns raised by Welch and Hetherington. It explained why the Welches had seen Augusta at the Schmidt residence. It explained why no one had seen Steinbach for a while. It also explained the presence of Steinbach's things at the Royal Oak home. But it did not cast any light on the mysterious Herman Neugebauer, and it didn't explain why Schmidt used a different name at the Highland Park Ford plant.

While a few questions remained, the agents from Justice were satisfied that Schmidt wasn't a spy, and at least for the time, Sheriff Green was satisfied that Helmuth Schmidt was telling the truth about Augusta Steinbach. Perhaps it was all much ado about nothing; Steinbach would surface and send for her things.

A few days later, Thomas Hetherington received a postcard from New York, postmarked April 14, 1917:

> *Dear Mr. Hetherington: I would like to ask you if there is any mail for me to send it to Mr. H.E. Schmidt, 09 Oakdale boulevard, Royal Oak, Mich. Thanking you in advance, respectfully,*
>
> *Augusta Steinbach.*[20]

To Thomas Hetherington, the note suggested that Augusta was alive and well and probably off honeymooning with Neugebauer. He breathed a sigh of relief and smiled as he slowly reread the note. The handwriting was unmistakably feminine. After sharing the good news with Louise, Hetherington placed the letter in one of the hutches in his office bureau and forgot about it.

"YOURS, AUGUSTA STEINBACH"

Royal Oak, Michigan
May 1917

By late May, another month had passed, yet Augusta Steinbach still hadn't surfaced. Neugebauer hadn't made an appearance, either. Green decided to take a closer look at Steinbach's trunks, so he made another trip to Royal Oak.

Green stood on the front porch as Schmidt came to the door. When the sheriff asked to see Augusta's things, Schmidt handed him a letter dated April 25, 1917, and addressed to "Worthy Mr. Schmidt." Green studied the note:

> *Dear Worthy Mr. Schmidt—Sorry I did not write to you, as I was sick. Meanwhile, I am here with old friends where this man has also lost his job on account of the war. Through all this excitement I had not even time to think about myself. I am sending you money and the address. Will you kindly send my trunks to the enclosed address? Thanking you again for your kindness.*
>
> *Yours, Augusta Steinbach*[21]

Green sighed when he read the closing, "Yours, Augusta Steinbach." Here, at last, was proof that the missing domestic was no longer missing. Green examined the sweeping curves in the salutation—the handwriting appeared to be a woman's. A slip of paper enclosed with the letter contained the address of Augusta's "old friends" in New York: 306 East Sixty-fifth Street.

Schmidt added some backstory to the letter. Neugebauer had placed an ad in a matrimonial paper, and Augusta had responded. She came to Michigan with wedding vows in mind but ultimately decided against matrimony. Augusta went back to the Big Apple, Schmidt said, but all of her friends believed that she was already married. So, ashamed of the failure, she stayed away for a while.

This explained the movement of the trunks from New York to Detroit to Royal Oak and back to New York. It explained why no one had heard from her. By all accounts, the letter should have dissolved all doubt about Helmuth Schmidt's role in the disappearance of Augusta Steinbach.

But it didn't. Something kept nagging Sheriff O.H.P. Green about the whole affair. According to T.H. Hetherington, Augusta Steinbach was ecstatic when she left to marry Neugebauer. She had uprooted herself from New York to begin a new life in Royal Oak. Then, all of a sudden, she decided to pull the plug on the romance and abruptly return to New York. What went wrong?

Back in Manhattan, Agnes Domaniecki had become worried. Augusta said to wait for four weeks before sending any more letters. Perhaps, Agnes thought, when the honeymoon ended, Augusta would send her a letter. Surely, she

would have many wonderful things to tell her chum about Michigan's verdant countryside and her new life with Herman.

But six weeks had passed, and Agnes still hadn't heard from Augusta. By early May, she couldn't wait any longer. She inked a note and, since Augusta didn't leave a forwarding address, sent it to her last known whereabouts: 45 Adelaide Street. She waited for a response, but instead, her letter was returned unopened. There must be some mistake, she thought, and sent another. Once again, it was returned. In all, a dozen of her letters bounced back to New York.

Agnes contacted an acquaintance in Detroit who agreed to look up Augusta in Royal Oak. A few weeks later, Agnes heard back: the residence at 9 Oakdale Boulevard was occupied by a man named Schmidt, who was married and had a seventeen-year-old-daughter named Gertrude. This sounded eerily familiar to Agnes. In her letters, Augusta described a visit with Neugebauer's sisters, one of them a teenager, coincidentally named Gertrude.

Her suspicion piqued, Agnes went to Schillinger's Reliance Warehouse on East Sixty-third. The warehouse clerk confirmed that Augusta's trunks made the trip to Royal Oak. Agnes's eyes widened when the clerk read the address: 9 Oakdale Boulevard. Surprise turned to shock when the clerk noted that the trunks had been returned on May 17 and remained in storage, unclaimed.

Agnes wanted to open the suitcases to see if they contained any clue as to Augusta's whereabouts, but she did not have the authority. By this point, Agnes feared the worst. "I couldn't sleep," she later said. "I seemed to hear Augusta calling me to come and help her." Augusta, Agnes feared, had become "the victim of white slavers."[22]

She whipped off a letter to Sheriff O.H.P. Green. A few days later, she received a reply. Green described Schmidt's story about Augusta's return to New York and the note she apparently sent asking him to forward her luggage. The news left Agnes conflicted. Green's letter suggested that Augusta was alive and well, but it didn't sound credible. Agnes had known Augusta for fifteen years. Embarrassed or not, her chum would not return to New York without contacting her. But Green said that he had seen a note in a woman's handwriting verifying it. If Schmidt's story wasn't true, there was only one logical conclusion, Agnes reasoned: the note wasn't in Augusta's handwriting.

She sent another letter to Sheriff Green, but when it arrived, the sheriff was facing the worst crime wave in the county's history.

CRIME WAVE

Pontiac, Michigan
Summer 1917

O.H.P. Green made a name for himself as an undersheriff, earning a reputation that would win him the sheriff's election in January 1916. A lawman with a keen instinct and a bulldog's tenacity, Green had the know-how and experience to work the hardest crimes and crack the toughest criminals.

During his second year in office, Green faced not one but five of the most perplexing criminal cases in Oakland County's history. A little over a month after Green visited Schmidt for a second time, the murder of a child rocked southeast Michigan.

On the afternoon of July 4, thirteen-year-old Hope Alexander and her ten-year-old playmate, Elizabeth Stilber, were attacked at the edge of a wooded area called Sylvan Gardens, where the girls went to collect wildflowers. The perpetrator knocked Elizabeth Stilber to the ground and shoved Hope Alexander on top of her. He then pulled a revolver and fired twice. The first slug struck Alexander in the temple, killing her instantly. The other tore through Stilber's shoulder.

Stilber played dead while the man dragged Hope Alexander's body about thirty yards through a patch of ferns and into a thicket of trees. Five minutes later, he emerged and pulled Stilber into the woods, where he trussed up the hands and feet of both girls with twine he took from a leather satchel before bolting.[23] After lying motionless for a few minutes, Stilber dug her feet into the ground and pushed, worming her way out of the glade. She managed to crawl toward a nearby road, where a passerby spotted her. Within minutes, a police officer had arrived and listened as Stilber, in between shrieks, described her assailant.

Disgusted citizens lined up to form a posse. Led by Oakland prosecutor Glenn C. Gillespie and Sheriff Green, some 150 people combed the dense woods in the vicinity. People began to wonder about those five minutes that the perpetrator spent in the thicket alone with Hope Alexander's still-warm body. Back in William Sullivan's undertaking rooms, Oakland County coroner O.C. Farmer found that the girl had suffered a postmortem "assault," but people didn't need to wait for an official report.[24] When the dragnet caught a suspect, they had already made up their minds to save the county the expense of a trial.

Q. What is his initials?

A. James S. I think.

Q. Now, what was the nature of the wounds you found on the Alexander girl?

A. Why a bullet wound in the left temple.

Q. Do you know what kind of a bullet made the wound?

A. I could'nt tell from examination.

Q. Whether or not it seemed to be a good sized bullet?

A. Yes sir.

Q. What would you say whether or not death would be practically instantaneous?

A. Yes sir.

Q. Was there any other wounds on the girl's body, Doctor?

A. Not from any bullet wound.

Q. Did you make an examination to see whether she had been assaulted or not?

A. Yes sir, I made an examination.

Q. And from that examination what is your judgment whether she had been or not?

A. I think she had been.

Q. Were the hands and feet still tied when you got there?

A. I don't know, when I got to the woods the body was covered up, I would'nt say.

Q. Quantity of blood round there?

A. In the woods?

Q. Yes.

A. I did'nt examine her at all in the woods.

Q. You went to the house?

(No answer)

Q. There was the body at the time you made the examination?

A. In the morgue in Mr. Sullivan's undertaking rooms.

Q. - 15 -

Dr. William S. Gass describes Hope Alexander's wounds to Prosecutor Gillespie during testimony taken on July 31, 1917. *Oakland County Circuit Court, Michigan.*

The enraged posse would have lynched the trembling man, but O.H.P. Green, who stood about a foot taller than most of the posse, quelled the angry mob. "Gentlemen," he bellowed, "we must give this man the benefit of the doubt." He paused to let the grumbles die down before continuing. "This is a terrible crime and we must make no mistake. It would be an awful thing to do violence in our state."[25]

Green's words pacified the crowd. The suspect turned out to be an innocent bystander, and the *Detroit Free Press* lauded Green as a paragon of law enforcement, noting that "officers quite generally over the state and country could learn from his fidelity to law and order."[26]

A few days later, Detroit cop Mathew B. Weldon spotted a man fitting the description of Stilber's assailant emerging from an alley at the intersection between St. Antoine and Hastings Streets. As he arrested the suspect—a Detroiter named Allan Livingston—Weldon noticed some spots of blood on the man's jacket. At first, Livingston said that they were dirt smudges, but he later changed his story—they were blood, he said, from a nosebleed following an argument that turned into a fistfight.[27]

After booking Livingston, Detroit authorities took him to the Stilber residence, where they staged a lineup on the front lawn. Green, afraid that another lynch mob would form, waited outside while Gillespie went inside to talk to the girl. Peering through the window, Elizabeth Stilber pointed at Livingston. They repeated the lineup three times, and each time, the ten-year-old identified Livingston as the man who attacked her and murdered Hope Alexander. During one of the lineups, they told her that the suspect wasn't present. "There he is right out there," she said, pointing at Livingston.[28]

The Stilber girl's positive identification wasn't the only thing tying Allan Livingston to the crime. The twine on his pants matched the type used to bind the two girls, and eyewitnesses placed him in the vicinity of Sylvan Garden when the attack occurred. Despite this damning evidence, the Alexander slaying was not an open-and-shut affair. Livingston insisted that he had an alibi and that his arrest was a case of mistaken identity.

The Hope Alexander murder was still open when one of Green's deputies went down in the line of duty on August 12. Deputy Albert Anderson and his partner Harvey Taylor were on their way home after the late shift when they noticed a man loitering around a building. Since the area had been beset with robberies, the two deputies stopped and questioned the man. During the conversation, the man drew a revolver, shot Anderson in the stomach and then ran away.

After the shooting, police found a cache of coins near the scene, suggesting that the man Anderson and Taylor cornered was indeed the store thief. Anderson died a few days later in a Detroit hospital. The police zeroed in on one suspect—a man who gave the name "Donohue"—but due to a lack of evidence, they released him. The murder remained unsolved, and adding insult to injury, the store robberies continued.

The Alexander and Anderson homicide investigations kept Green from responding to Agnes, so she hounded him with more letters requesting an update. Finally, in late September, Green returned to the Steinbach case and sent Agnes a reply.

"We have learned nothing new in your friend's case," Green said in a letter dated September 27, 1917, "but expect to take up the various clues within a couple of weeks and will then advise you of the developments." The sheriff ended his letter with a request: "I wish you would send me any old letter you may have that was written you by Augusta so we can compare her handwriting with some that we have here. Have you some of her handwriting in English or German? If you have, please send it to me. Again thanking you for your kind assistance."[29]

Green wanted to use a known example of Augusta's handwriting to verify the authenticity of the "Dear Worthy Mr. Schmidt" letter, but before he had the chance, the discovery of two additional homicides again diverted his attention from the missing New Yorker.

On the same day Green stamped and mailed the letter to Agnes, police found the body of a Troy farmer named Theodore Radtke, who had been hacked to death with an axe. Police had yet to identify a suspect in the Radke murder when, a month later, another body was discovered lying in the middle of a backcountry road. The unidentified man had been shot in the back of the head.

Through legwork, Green identified the victim as cab driver William Worsham, who had a late fare from Detroit on the evening of October 28. On the twenty-ninth, investigators found Worsham's cab abandoned, the driver's seat spattered with blood. Worsham's shoes were not dirty, and tire marks at the scene indicated that a car paused and then sped away. Using these clues, Green theorized that Worsham's passenger shot him from the back seat, dumped the body and then drove away in the cab. Despite an exhaustive investigation and search, however, detectives could not find a single suspect.

The five unsolved cases—Steinbach, Alexander, Anderson, Radtke and Worsham—loomed over Sheriff O.H.P. Green. Four of the crimes lacked

viable suspects, and Green apparently didn't feel confident about the prime suspect in the Alexander case. "Tell Livingston I'm sorry for him," he allegedly said to Allan Livingston's attorney. "If they don't get the right man they're going to railroad him."[30]

According to some accounts, Green fell into despair over what he saw as his personal failure to solve the crimes; what was once a razor-sharp criminal mind, Green feared, had become dulled with age. He also struggled with the administrative aspects of the position. As comfortable as the tough lawman was in the field, he was uncomfortable behind the desk. He sometimes misplaced files and mismanaged his budget—both bureaucratic sins that would continue to haunt him for the rest of his life.

"A Real Queer Case"

Paper Trail

New York City
Fall 1917

Agnes Domaniecki grew impatient with Green's lack of progress, so while the Steinbach case file collected dust in Michigan, the diminutive domestic turned detective and began her own line of inquiry in New York. For help, she turned to tough-as-nails New York homicide detective Cornelius Willemse.

Captain Cornelius Willemse spent much of his career walking a beat in the "Wild West" atmosphere of New York's East Side during the turbulent first quarter of the twentieth century. His career spanned several decades, during which he played a key role in bringing down perpetrators ranging from homicidal housewives to gangsters.

Dr. Charles Norris, the chief medical examiner of the city of New York during Willemse's era, described the captain as a "whale of a man in physique" who probed every nook and cranny on his beat. He knew every thief, pimp and barkeep in his jurisdiction, and according to Dr. Norris, he knew all of their habits and tendencies as well. The big man also had a big heart. He "bossed when bossing was required," Norris said, and "struck hard when a blow was needed" but "could and did find time to become the friend, counselor and benefactor" to many.[31] One of the many was thirty-three-year-old Agnes Domaniecki. Willemse, a Dutch native, conversed with Agnes in German, which

Photograph of Agnes Domaniecki from a passport application she submitted in 1924. *National Archives and Records Administration, image by Photo Response.*

he later recalled seemed to put her at ease and immediately created a bond between them.

Much of the credit for finding the truth about Augusta, according to Willemse, was due to the dogged determination of Agnes Domaniecki. The shy housekeeper kept to herself and shunned the spotlight. For this reason, Willemse later said in his autobiography *Behind the Green Lights*, the "true story of her activities never became known to the public." However, Willemse noted, "when Agnes got going, she set the pace for the police departments of two great cities, made prosecutors hop to her bidding and proved that she could cut more red tape than a police commissioner."[32]

Because the case did not take place in New York, Willemse's superiors did not want him to pursue it. But something seemed amiss to the veteran homicide detective, so he decided to look into the matter anyway. After listening to Agnes's story, Willemse let his fingers do the walking and thumbed through back issues of the *New York Herald*. Eventually, he came across Herman Neugebauer's matrimonial advertisement published in the September 16, 1916 edition. This Neugebauer fellow sounded too good to be true, although Willemse knew that the lonely hearts who submitted matrimonial ads often exaggerated their better traits and ignored the rest.

Agnes told Willemse that Augusta corresponded with two Detroiters. Not one to leave any stone unturned, Willemse continued to search through the *Herald*'s personals, eventually finding one in the name of George Roloff. Curiously, the wording and the structure of the Neugebauer and Roloff advertisements were nearly identical. Willemse also noticed that both contained the phrase "general delivery."

The tenacious New York cop continued to dig through the newspaper's back files, eventually uncovering several ads that were eerily similar: one from

a Detroit mechanic, posted in 1915, signed "Carl Ullrich, General Delivery, Detroit"; another, posted in 1914 by "F. Helmuth, General Delivery, Kansas City"; and another, posted in 1913 by C. Hamann, General Delivery, Lakewood, N.J." All ads had the vague address, "General Delivery."

Next, Willemse turned to the boxes of original handwritten letters sent by correspondents requesting placement of their lonely hearts personals. He was hoping to find the originals that Roloff and Neugebauer had mailed to the *Revue* and the *Herald*. After several hours thumbing through dusty stacks of mail, he found the two letters—both postmarked from Detroit:

> *New York Revue. Very honored sir. You place this advertisement this coming Sunday and a Sunday later. Enclosed a check for $3.60. Respectfully yours, George Roloff, care H. Schmidt, Detroit, Mich, 418 Glendale avenue.*

> *New York Herald. Enclosed $2. May I ask you to place the following advertisement the coming Sunday. Respectfully yours, Herman Neugebauer, care of H. Schmidt, general delivery, Royal Oak, Mich.*[33]

The letters, Willemse discovered, contained a strand connecting Roloff and Neugebauer, one invisible to Augusta Steinbach or anyone reading the printed copy of the personals: both handwritten matrimonial ads were tied to an "H. Schmidt." George Roloff listed his address as "care of H. Schmidt, 418 Glendale Ave., Detroit, Mich." The Neugebauer advertisement directed "general delivery" to "Royal Oak, Mich."—the same place where "H. Schmidt" lived at 9 Oakdale Boulevard.

The "H. Schmidt" mentioned in Neugebauer's ad, Willemse reasoned, had to be Helmuth Schmidt. If the two men were friends, it made sense that Neugebauer's correspondence would go to Schmidt's address. Oddly, George Roloff's correspondence also went to an "H. Schmidt," although to a different Detroit-area address. "Schmidt," Willemse knew, was one of the most common German surnames. The size of Detroit's German American enclave made it likely that more than one "H. Schmidt" lived and worked in the midwestern metropolis. It was also possible that this "Schmidt" fellow knew both Neugebauer and Roloff.

Willemse placed the two letters side by side and studied the penmanship. Anyone, even the newsboy hawking papers on the sidewalk outside, would agree that the writing came from the same hand. Either Roloff and Neugebauer knew a common acquaintance who penned the letters for them, or Roloff and Neugebauer were one and the same. "I left the office

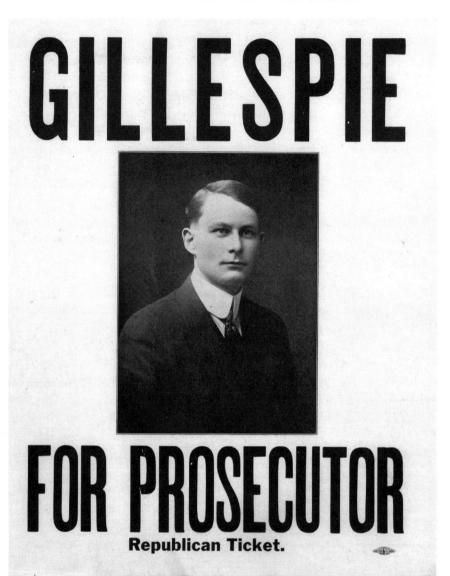

Glenn C. Gillespie's campaign advertisement for the 1916 election. *Glenn C. Gillespie Papers, Bentley Historical Library, University of Michigan.*

of the *Herald*," Willemse later said, "knowing that I was up against a real queer case."[34]

It was time to reconnect with the Detroit authorities. Agnes didn't trust Green, so the captain decided to take a different tact. He sent a telegram to Glenn C. Gillespie, Oakland County's chief prosecutor. Thirty-two-year-old

Glenn C. Gillespie was known as a ruthless prosecutor with a keen legal mind and a no-nonsense approach to law and order.

Born in 1885, Gillespie grew up on a small farm in Addison Township. As a teenager, he took a job as a telegraph operator in order to earn enough money to attend college. He graduated from the University of Michigan's law school in 1910 and opened a private practice in Pontiac before he went to work in the public sector. He spent four years as Oakland County's assistant prosecutor under Frank Doty before winning his first term as chief prosecuting attorney in 1916.[35] Gillespie quickly earned a reputation as a tireless crime fighter in an area where law and order began to deteriorate with Detroit's urban sprawl. By 1917, Prosecutor Gillespie had closed the cell door on perpetrators from all points on the spectrum of crime, becoming Oakland County's authority on criminal law.

When not in court or poring through law books in his Pontiac office, Gillespie loved sports and belonged to several athletic groups despite a childhood accident that left him with a limp and dependent on a cane. He adored baseball and often traveled to Navin Field to watch the Detroit Tigers, perhaps living out a boyhood fantasy vicariously through Cobb, Crawford, Heilmann and the team's other star players.

Whenever possible, Gillespie, along with his wife, Leola, and their daughter, Elenor, retreated to the serenity of the north woods, where he spent his time hunting and fishing. It was a place where the prosecutor with the boyish good looks could escape the ugliness of big-city crime.

The Suicide of Sheriff O.H.P. Green

Pontiac, Michigan
December 10, 1917

Willemse's timing couldn't have been worse. When his telegram reached Oakland County's chief prosecutor, Gillespie had his hands full with unsolved homicides, allegations of corruption within the police department and a despondent top cop.

By early December, O.H.P. Green had slid into a deep depression. All five major cases Green faced in his second year as sheriff—the four murders and the disappearance of Augusta Steinbach—remained open. He had misplaced files in the Alexander, Radtke and Steinbach cases, including the

notes detailing his interviews with Helmuth Schmidt. More than ever, Green feared that he had lost his acumen as a lawman.

He also struggled with the business affairs of his office, particularly the expenses of the jail, which he administered with the help of his wife, Josephine, and daughter, Grace, who kept the books. In October, he submitted a bill of $17,000—the largest in the county's history—and he was worried that the next bill would be even higher. The county board acknowledged the problem and voted a twenty-cent-per-prisoner increase in funding, but the increase would not take effect until the first of the year.

The pressures of this mounting debt, coupled with the five unsolved cases, crushed O.H.P. Green. On December 10, 1917, at about 9:30 a.m., Miss Margaret Christian, a Red Cross Worker, opened the door of the Supervisor's Room at the county courthouse and discovered a grisly sight: Sheriff Green lying facedown on the platform, with a crimson halo around his head. A small rivulet of blood ran down the steps. Miss Christian shrieked and raced down the hall, screaming.

The county clerk immediately ordered the room sealed, and within minutes, Oakland County coroner O.C. Farmer arrived to examine the scene. Green had apparently shot himself in the temple about an inch above his right ear. Farmer found Green's .38 revolver under the body with one chamber empty. The bullet passed through Green's skull and into the wall, where it fell down between the stringers. Investigators stopped short of dismantling the wall to recover the bullet.

The suicide of the county's chief lawman shocked the community. On the morning he ended his life, Green appeared cheerful, according to a deputy who ran into him outside of the courthouse. County Clerk Babcock spoke with Green about twenty minutes before Miss Christian found the body and noticed nothing out of the ordinary. Others said that Green had become sullen and had made a few ominous remarks. When he traveled with his deputies to a home where a woman was found frozen to death, he said, "Well, there is another one found dead, and there will be more before long, I suppose."[36]

He had developed an uncharacteristic paranoia. He believed that his political enemies were out to get him, and during a meeting with Gillespie the night before his suicide, he asked the prosecutor if he planned to investigate him—a question with sinister overtones. Surprised by the question, Gillespie told Green that he never even considered conducting a probe. Green also told Gillespie that he had just returned from a ten-day trip about a certain case and came away with no new clues—a fact that appeared to weigh heavily on his mind.

His troubles had also affected his appetite. The portly sheriff was a big eater and never left without his morning meal, yet on the morning of his death, he skipped breakfast. Alarmed, his wife sent Undersheriff Charles M. Cross to find him, but by the time Cross caught up with Green, it was in the Supervisor's Room.

Green left letters for his wife and his daughter apparently citing two factors that pushed him to turn his gun on himself: finances and his inability to crack the five cases. Green's family refused to release the letters, which fueled speculation that the sheriff was murdered because he had wandered too close to the truth in one of the unsolved cases.

Helmuth Schmidt supposedly met with Green just days before the sheriff shot himself, and people didn't fail to notice that the Schmidt case file vanished with Green's death, leading to a conspiracy theory that placed Schmidt behind the sheriff holding a smoking gun. Most Oakland County residents, however, dismissed this talk as nothing but idle speculation. On Thursday, December 13, 1917, the fifty-one-year-old sheriff was buried without an inquest.

In the wake of Green's suicide, a number of questions came up about the sheriff's handling of county business. One incident that raised a few eyebrows involved a "wild goose chase" that Oakland County financed under the sheriff. Green sent Assistant Prosecutor Floyd Blakeslee to Denver to escort a suspect named "H. Moore" back to Detroit. After stealing a car, Moore supposedly fled to Colorado, where Denver authorities nabbed him and were holding him. But when Blakeslee arrived in the Mile High City, the police there had never heard of an "H. Moore." The junket cost Blakeslee $142 in expenses that he paid out of his own pocket. Green refunded Blakeslee $70 but billed the county for more than $200. Green also billed the county for a trip he took to New York, where he supposedly followed the trail of Augusta Steinbach's trunks. New York police, however, could not verify Green's presence in the city.

Undersheriff Cross took over as acting sheriff. He searched for Green's notes on the Augusta Steinbach investigation but came up empty-handed. According to some reports, Green burned them; according to others, he mislaid them. If the Augusta Steinbach disappearance was to be solved, Cross and Gillespie were going to have to reconstruct Green's investigation.

They did manage to locate one key piece of evidence: the letter from Augusta Steinbach to Helmuth Schmidt asking him to forward her trunks to a New York warehouse. Gillespie obtained it from Agent Cole of the Justice Department.

CLOSURE

Pontiac, Michigan
January 1918

The Steinbach investigation lay dormant for the first two months of 1918 as Glenn Gillespie mopped up one of the cases that troubled O.H.P. Green: in mid-January, Allan Livingston went in front of a jury for murdering thirteen-year-old Hope Alexander.

The trial coincided with one of the coldest periods on record. None of the city's older residents could remember a more frigid time than the week of January 7, 1918. The mercury dropped to below zero, and people quickly exhausted their stores of coal, causing a run on the state's suppliers. Most of the area's coal merchants ran out altogether, creating an acute shortage that threatened to leave many people without heat. The situation became so dire that local authorities required businesses—except for pharmacies, restaurants and hotels—to close their doors. The local coal authority even requested that families move in together to conserve as much fuel as possible.

Oakland County's circuit court, however, remained open for business as usual. The Livingston trial got underway on January 7, 1918, in front of a packed courtroom. The drama began with jury selection as Gillespie questioned each potential juror. In addition to the usual questions, Gillespie asked each juror if he had read any news items about Green's suicide that mentioned the Livingston case—a reference to the mysterious missing files and the conspiracy theories circulating about a possible murder of Green.

It took little time to empanel a jury, many of them farmers and almost all of them fathers. As Livingston listened to the testimony, he appeared to be a man without a worry in the world. He chewed on a plug of tobacco, every few minutes spitting into a cuspidor by his feet. The jury members shivered as they looked at crime scene photographs of Alexander's body while Undersheriff William Sullivan identified the torn, blood-spattered clothes worn by the victim. Sullivan also testified that it appeared evident that a postmortem assault had been committed.[37]

The prosecutor's case was fortified with damning statements that the defendant allegedly made while in jail. Gillespie called several fellow prisoners who testified that Livingston, troubled by a heavy heart, confessed that he went to Sylvan Gardens with the intent of assaulting a young girl if he could find one.

On the second day of testimony, the prosecutor called his star witness, ten-year-old Elizabeth Stilber, who testified in front of a standing room–only crowd. The girl trembled when she pointed at the defendant as the man who murdered Hope Alexander.

Livingston's defense attorney, Charles S. Matthews, attempted to get his client off the hook by poking holes in the prosecution's evidence. Through a chain of defense witnesses, he tried to cast doubt over whether Livingston wore a twine or a leather belt—one of the key pieces of evidence tying the defendant to the crime. He also tried to admit the statement that Sheriff Green allegedly made about framing his client, but Judge Rockwell ruled it inadmissible. "A person who commits self-destruction," he said, "is not accountable for what he says."[38]

Rockwell did instruct the jury to ignore statements made by Livingston's fellow inmates, but nothing could overshadow the testimony of Elizabeth Stilber. After less than an hour of deliberation, the jury found Livingston guilty. On Saturday morning, as a blizzard buried Pontiac and the mercury dipped to twenty degrees below zero, Livingston went in front of Judge Rockwell for sentencing.

"It is not my purpose to lecture you," Rockwell admonished the prisoner. "You stand convicted of one of the most atrocious crimes known to the curriculum of criminology. At least in the future you will have time to reflect on the crime."[39] Rockwell sentenced Livingston to life in Marquette State Penitentiary, his time to be split between solitary confinement and hard labor.[40]

While Cross escorted Livingston north, Agnes Domaniecki continued her private investigation in Manhattan. She followed the personals in the New York papers to see if another note advertising a "respectable" and "very good looking" paramour emanated from the Motor City.[41]

She spotted an advertisement with the return address "General Delivery, Detroit" and decided to set a trap. In the guise of a forlorn lonely heart, she began a correspondence relationship with the Detroiter. The two conversed about the old country, about the New World and about their likes and dislikes. Agnes embellished, writing lengthy and florid descriptions of her life among New York's aristocracy. She described her love of fine things: linens, silverware and, above all, jewelry. None of it was true, but Agnes believed that it would draw her correspondent into making an incriminating error.

In one letter, the mysterious man from Detroit enclosed an enameled pocket watch as a token of his affection. Agnes's stomach turned when she held the watch in her palm and studied it. It belonged to Augusta Steinbach.

THE MANHATTAN CONNECTION

New York City
March 1918

With Allan Livingston behind bars in Marquette State Penitentiary, Gillespie turned his attention to the disappearance of Augusta Steinbach. On March 3, 1918, he and Undersheriff Harry Cryderman hopped a train bound for New York City.

Captain Willemse led a party including the two Michigan investigators, Agnes Domaniecki and a locksmith to Schillinger's Reliance Warehouse, where they pried open the trunks that had been returned on May 17, ostensibly at the request of Augusta Steinbach.[42]

Agnes sifted through the clothes and discovered that several expensive items were missing, including a box of jewelry and Augusta's fur boas. Willemse also found a pump with a black stain that looked like dried blood. (According to Willemse, a "chemical test" later proved that the stain was blood.)

In Willemse's office, Agnes recounted the tragic tale of her friend's love affair, gleaned from the sequence of letters Augusta sent during her courtship with Neugebauer. Unfortunately, Agnes no longer had the letters. When she changed employers, she discarded them. But she remembered them in vivid detail, in part because she read them to a co-worker who had taken an interest in Augusta's romance.

Gillespie and Cryderman were especially interested in Agnes's description of Neugebauer's Royal Oak home and the two sisters who lived there. The house sounded just like 9 Oakdale Boulevard, where Helmuth Schmidt lived with his wife, Helen, and teenage daughter, Gertrude. And almost a year earlier, Sheriff O.H.P. Green had examined Augusta's trunks in the basement. If Neugebauer knew Schmidt well, the newlyweds might have left some things there while they were off honeymooning. Neugebauer may also have referred to Schmidt's wife and daughter as sisters. In any event, Augusta Steinbach's trail appeared to end in Royal Oak.

Gillespie and Cryderman left New York abruptly when they received word that one of Cross's boys had made an arrest in the Radtke hatchet murder. In the meantime, Gillespie promised to keep an eye on Schmidt.[43]

One of the nails in O.H.P. Green's coffin turned out to be an open-and-shut case. Following a hot tip, Deputy William Wheeler had collared an acquaintance of Radtke's named Frank Paroski. At first, Paroski denied

knowing Radtke, but after a thorough grilling, he made a full confession to Cross and four reporters who sat in on the interrogation.

On the night of the murder, Paroski said, he passed by the Radtke place when the old man spotted him and asked if he wanted some work. They agreed to discuss it inside, where Radtke served him a drink. Their conversation quickly turned to the war. "He said the Germans are going to lick everybody in the United States before they get through," Paroski recalled. "I told him he was crazy. At this time he grabbed his axe and started to chase me. On the second time around I grabbed a hand axe which was laying on the floor and threw it at him, hitting him in the back of the head, knocking him down. After this, I hit him three or four more times—I don't know how many."[44]

The jury rejected Paroski's self-defense scenario and found him guilty of first-degree murder. While Frank Paroski traveled to Marquette to begin his life sentence, Gillespie took a closer look at the mysterious resident of 9 Oakdale Boulevard.

The Case Against Helmuth Schmidt

Pontiac, Michigan
April 1918

The legal grasp around Helmuth Schmidt's neck tightened in mid-April when Gillespie consulted a handwriting analyst and interviewed several key players in the drama. Jonathan Welch recalled how he grew suspicious of Schmidt and how he discovered that Schmidt worked at the Ford Highland Park factory under the name "Ullrich."

Lena Welch told the prosecutor about the suspicious events she saw and heard through her kitchen window. On the day Augusta Steinbach vanished, she heard what sounded like moaning or weeping coming from the house. Later that afternoon, she saw someone papering over the basement windows. A few months later, she noticed a thick black smoke pouring from the chimney and a putrid stench of something burning. She couldn't quite place the odor. At about the same time, she noticed Helen Schmidt scurrying to the back of the property with a box of ashes from their furnace, but instead of dumping them on the ash pile as usual, she dug a hole, buried them and then scrubbed the pan in the river.

According to Mrs. Welch, Augusta Steinbach visited Schmidt's house at least once before March 11. Welch said that she watched Schmidt escort a woman matching Steinbach's description into the bungalow. A few minutes later, she heard several women conversing in German. Without corroboration, however, the statement amounted to little more than an unverified memory.

After leaving the Welch residence, Gillespie and Cryderman drove into Detroit to interview Thomas Hetherington. Hetherington said that Augusta stayed at his boardinghouse for five weeks, leaving just once, on March 11, 1917—the day she disappeared with Neugebauer.[45] Hetherington recounted his attempts to deliver the belated wedding present, including the strange visit from Helen Schmidt. He described how he watched Helen walk down the street and climb into a car with a man who matched Neugebauer's description.

Hetherington also told Gillespie about the note he received from Augusta the previous April requesting that her mail be forwarded to H.E. Schmidt, but the elderly man forgot where he put it. So instead, he described its contents and promised to scour the house for the original. The note, Gillespie reasoned, was Schmidt's attempt to throw off the bloodhounds closing in on his trail. If a woman penned the letter, as Hetherington believed, Schmidt could have had a female acquaintance write and sign it in Steinbach's name.

Gillespie cursed the old man's failing memory as he knocked on the door of Francis J. Courtney, an expert in chirography, or handwriting analysis. The missing note would have been a valuable addition to a collection of handwriting samples he had gathered for Courtney's examination.

In addition to the "Dear Worthy Mr. Schmidt" letter, Gillespie managed to locate a few samples of Augusta's handwriting in New York. To the prosecutor, the handwriting on the letter did not match the known samples of Steinbach's writing, although they both appeared to come from a woman. But then again, Gillespie knew that he lacked expertise in these matters, so he called on Mr. Courtney to give him a definitive answer.

Courtney fumbled in his desk for a jeweler's loupe and popped the monocle in his eye with his right hand while he placed one of Steinbach's writing samples next to the letter. Gillespie smiled as he watched the old man's head bob up and down and side to side as he examined the papers. After a few minutes, the chirographer had come to a conclusion: both samples appeared to have been penned by a woman, just not the *same* woman. Courtney's analysis left little doubt: Schmidt used a female accomplice.

Next, Gillespie handed Courtney the handwritten notes from George Roloff and Hermann Neugebauer requesting that the New York newspapers run their matrimonial advertisements. Gillespie had acquired them from Captain Willemse during his visit to New York City in March. Courtney confirmed that both notes came from the same hand: the first, concrete evidence indicating that Neugebauer and Roloff were one and the same. Willemse's excavations of the newspaper's back files suggested that this Neugebauer/Roloff fellow used other names as well, such as Helmuth Schmidt. Gillespie was absolutely convinced that Helmuth Schmidt had used the matrimonial advertisements to lure Augusta Steinbach to Detroit, rob her of her valuables and then murder her.

After Courtney left, Gillespie and Cryderman reviewed the evidence: at least four sources placed the missing woman inside Schmidt's Royal Oak home on or around the time she disappeared; the missing items from Steinbach's trunks hinted at robbery, and the bloodstained pump suggested a possible violent confrontation; and Helmuth Schmidt worked at the Highland Park Ford plant under the name of "Ullrich"—a fact confirmed by Schmidt himself when questioned by Green the previous April. Schmidt offered no explanation for his two identities, but all of the evidence indicated that Schmidt also masqueraded as Herman Neugebauer and possibly others.

Gillespie had had a disturbing conversation with a bartender at a tavern in downtown Detroit. The barkeep tentatively identified Schmidt as a man who frequented the watering hole. This man, who called himself Braun, spoke of a wife named Mae. After a little digging, Gillespie also discovered that Helmuth Schmidt owned another house on Glendale Avenue. Neighbors confirmed that Schmidt had a housemaid who disappeared there under mysterious circumstances.

The "Dear Worthy Mr. Schmidt" letter indicated that Schmidt ran his scam with female accomplices, one of whom penned the letter and probably played the role of Neugebauer's older sister. The chief suspects were Schmidt's wife, Helen, and his eighteen-year-old daughter, Gertrude.[46]

By mid-April, Gillespie had all the evidence he needed to bring in the Schmidt family for questioning. He hatched a plan to divide and conquer the three suspects. Schmidt and the two women would be held in separate locations and questioned individually.

The Roundup

Detroit, Michigan
Monday morning, April 22, 1918

By mid-morning of Monday, April 22, 1918, the temperature jumped to a balmy fifty degrees. Humidity hung in the air and foreshadowed the rainstorm that forecasters had predicted for the next day or two. Newspapers left lying around over the weekend turned damp, and the city's older residents carped about their aching joints.

At about the time the morning edition of the *Detroit Times* hit the streets, two Model Ts screeched to a halt in front of 9 Oakdale Boulevard. A squad of investigators, led by Prosecutor Gillespie and Deputy William Wheeler, climbed out and headed up the steps to the front door.

Helen, an experienced dressmaker and seamstress who did tailoring for Royal Oak residents, was sitting at the table going over a dress alteration with a client as detectives entered the room. Her mouth dropped open when she saw Prosecutor Gillespie.

"I guess you had better put on your coat and come with us," Gillespie said. "It is about that matter we were here on a year ago—about the disappearance of that Steinbach woman."

Helen gulped. "Why that matter was all cleared up. What became of her?"

Gillespie smirked. "You'll find out soon enough."[47]

Helen apologized to her shocked customer and then slipped on a coat and pair of shoes. She began to cry as the officers led her from her front door to the car that would transport her to the county jail. At the same time detectives took Helen to the county lockup, Sheriff Cross and Deputy Sheriff Cryderman, along with a reporter from the *Pontiac Press Gazette*, raced to the Ford plant in Highland Park to collar "Ullrich." They phoned ahead and requested that Detective Gillis—a private eye employed by Ford—watch their suspect until they arrived. For the next half hour, Gillis didn't take his eyes off "Ullrich." As the two detectives motored into the parking lot, Gillis escorted him to the front office.

In the manager's office, Cryderman handed Schmidt an arrest warrant. "I no do it," he said as he slowly read the document. When detectives clamped Schmidt's hands in the "bracelets," he mumbled something about his innocence in a jumbled mix of German and English. The two detectives loaded their prime suspect into their Model T for a short drive to the Highland Park Police Station.

The *Gazette* writer scribbled notes on a tablet while Captain Warden booked the suspect. "Can you read or write English?" Captain Warden asked as two officers frisked Schmidt.

Schmidt hesitated. "Read or write? No."[48] The officers then began measuring the suspect. At the time, Detroit police officers, like their New York counterparts, still followed the Bertillon system, which called for taking various measurements such as height and arm span. In the early days of fingerprint identification, these measurements helped police identify suspects, even those in disguise. As one officer read the tape, the other jotted a brief description: five-foot-seven, 148 pounds, dark brown hair and brown eyes.

"Where do I go from here?" Schmidt asked. Captain Warden escorted him to a solitary cell, isolated from other prisoners and kept from communicating with friends and acquaintances.

From the station, Cross and Cryderman headed to Detroit to apprehend Gertrude Schmidt. En route, they stopped at the Highland Park Post Office. The postal clerk identified a photograph of Schmidt as the man who, on September 1, 1917, came to the office and requested all mail addressed to "George Roloff" be rerouted from the general delivery window to 418 Glendale Avenue. "Roloff," they now realized, was one of Schmidt's many noms de plume.

From the post office, Cross and Cryderman made a beeline to downtown Detroit, where they arrested Gertrude Schmidt at Newcomb-Endicott & Company, a department store on Woodward Avenue where she clerked. When Cross told Gertrude that he had arrested her father for murder, the stupefied teenager's eyes widened. "That's strange. I don't understand what it all means. I don't know why you want me."

On the drive back to Pontiac, the detectives quizzed Gertrude. Did she know Augusta Steinbach? Did she know Neugebauer or Roloff? Gertrude shook her head. Did she know Ullrich? She hesitated. "Why, yes—but my father can tell you more about that,"[49] she said. Gertrude nonchalantly chatted with the two officers for the rest of the trip. She said she was born in Berlin but spent much of her early childhood in Hamburg. She described the beautiful landscapes and picturesque villages but, keenly aware of the anti-German sentiment sweeping the nation, made it a point to tell them that she didn't have a very favorable opinion about the *Vaterland*. She said that her father, disenchanted with the Old World, left Germany to make a new life in America.

A cool operator, Gillespie kept the three suspects on ice while his men searched the Royal Oak bungalow for clues that he hoped to use as leverage

in prying the truth from the Schmidts. Newspapermen joined assistant prosecutors and sheriff's deputies in combing the house. Even a few of Henry Ford's private investigators joined the hunt.

Ford's men had a vested interest in "Ullrich." While Schmidt admitted to going by the alias "Ullrich" at the Highland Park plant, he never really explained why. Since the plant had begun manufacturing tanks, Jonathan Welch's suggestion that the next-door neighbor was an imperial German spy had gained new momentum.

At first, Gillespie didn't believe that Schmidt was an enemy agent, but a sweep of the house uncovered a few pairs of binoculars in a hutch, along with some sketches under a pane of glass in Helen's sewing room. Gillespie, an aviation enthusiast, immediately recognized the drawings as airplane parts. Several Detroit-area companies, such as Packard, experimented with new aviation technologies. All of a sudden, the spy story didn't seem so far-fetched.

The bungalow yielded bits and pieces of Schmidt's multiple identities. Detectives found a sheaf of papers containing a marriage license uniting "Helmuth Schmidt" with Helen Anna Tietz. The same bundle also contained a land contract signed by "George Roloff," with the name crossed out in red pen and the name "Helmuth Schmidt" written above it. The document, along with the discovery made by Cross and Cryderman at the Highland Park Post Office, left little doubt: Schmidt, who was

The quantity of jewelry found at Schmidt's Royal Oak address is documented in this Oakland County Probate Court inventory. The rings became a bone of contention as the women in Schmidt's life squabbled over his estate. *Oakland County Probate Court, Michigan.*

"Ullrich" at work, also prowled German-language newspaper matrimonial advertisements as "George Roloff."

The small abode also contained a suspiciously large amount of jewelry. One officer discovered a cache concealed in the player piano at the center of the living room. From the detailed descriptions that Agnes Domaniecki provided, it appeared that several of the pieces belonged to Augusta Steinbach.

They uncovered several other troves of jewelry throughout the first-floor rooms. One detective handed the prosecutor a gold pocket watch. Gillespie turned the watch over in his hand and marveled at the ornate design. Opening the watch, he discovered an odd pattern of scratches—what appeared to be a sequence of names, initials and dates. The last date in the list, "11-3-17," was the date Augusta dropped out of sight.[50] Gillespie wondered, as he studied the watch, if the eleven minute etchings presented a coded biography of the mysterious Helmuth Schmidt and his alleged crimes.

The stash of jewelry included seven golden lockets. *Oakland County Probate Court, Michigan.*

The cache of jewelry contained seven gold lockets, two with photographs of Helmuth Schmidt on the inside. One of the officers, a fisherman when off duty, made an offhand comment about the lockets as lures for lonely women—a remark not lost on Gillespie, an expert angler.

The closets were crammed with women's clothing, including four furs and two sealskin muffs. This was a decadent amount of clothing for two women, especially the wife and daughter of a machinist earning five dollars per day. More than likely, Agnes could identify some of the dresses as Augusta's. Gillespie wondered how many other women had lost dresses in the house.

The searchers next turned to the basement. They discovered that Schmidt had carefully boarded up a window toward the front of the house. As Wheeler pried the boards loose, Gillespie scanned the room. All of the windows along the side of the house facing the Welches had been covered by newspapers, just as Lena Welch described.

Within a few minutes, Wheeler managed to pull off the last plank to reveal a recess under the front porch. Standing on a stepladder, he slipped headfirst into the hole, his torso disappearing into the darkness. Once inside, he lit a match and began feeling through the dirt for clues.

Gillespie watched the flickering light as Wheeler probed the space. A muffled voice came from the darkness: "Found something." At the back of the hole, Wheeler spotted some fragments of a woman's dress and a small shovel with a broken handle. He also found a pile of rags smothered with what appeared to be coagulated blood. He handed each item to the prosecutor, who examined the rags. The black blotches looked like blood, but he would need to send them to a doctor for confirmation.

The searchers made another grisly discovery in the backyard. In a cavity under the garage, they found a charred piece of what looked like a human hip bone, along with a bloodstained cleaver and hanks of auburn-tinted hair. Augusta Steinbach had chocolate-brown hair with an auburn hue. This, the investigators now realized, was all that was left of the gullible domestic.

Gillespie returned to the cellar and examined the small furnace. The front was covered with dark brown stains. It was too small for a human body, so Schmidt must have hacked the corpse into pieces using the cleaver and incinerated it one piece at a time. The furnace would not have generated enough heat to consume the bones, which explained why Schmidt had secreted the chunk of bone under his garage. He probably deposited other bones in other locations. This scenario explained the strange goings-on witnessed by the nosy Mrs. Welch; Schmidt covered the basement windows with newspapers to keep his macabre secret from prying eyes and later enlisted the help of Helen in scattering the ashes in the back of the property.

Gillespie decided to let Schmidt sweat out twenty-four hours in jail before he and Highland Park chief of police Charles Seymour confronted him with the cleaver and the bloodstained rags. While the suspect lay on an iron bed hinged to the wall of his Highland Park jail cell, Gillespie and Sheriff Cross briefly questioned Helen and Gertrude Schmidt in Pontiac. Both women denied any and all knowledge of Augusta Steinbach. Both appeared nervous, but the ordeal had clearly unhinged Helen, who shook like someone suffering from malaria tremens.

After Gillespie and Cross left, a *Pontiac Press Gazette* reporter tried to interview the Bluebeard's wife at the Oakland County Jail, but Helen's nerves had frayed too much to give a full statement. From beyond the bars of her cell came a jumbled mix of German and English in between moans and gasps. The correspondent quickly inked each word into his journal. "There is only one who knows that I am innocent," Helen wailed, "and he cannot say. It is the good God."

She stood by her man, despite the mounting evidence that he knew and probably murdered Augusta Steinbach. "It is impossible he had anything to do with it. He could not. He was too good a man. He was always good to me. He was never away nights and I was never away from him but once in my life that being on a Sunday afternoon when his daughter and I went to a picture show in Detroit." That Sunday afternoon was March 11, 1917, when a naïve Augusta Steinbach followed Neugebauer to Royal Oak.

"And what is to become of me?" she continued. "What have I done? I am but his wife. I cannot go out into the world again and look anyone in the face. I am getting old. I am 37 now and for years I had nothing to do with any man. In fact he is the first man that I ever paid attention to and we were married but two years."

Helen stood up from the cot and began pacing back and forth. "I have worked hard all my life. I have slaved from 5 o'clock in the morning until 12 o'clock at night. I have saved and scrimped and had more than $3,000 when we were married. This has since been invested in Royal Oak real estate, every penny of it."[51] Schmidt apparently used Helen's bankroll to fund the construction of their house.

"We were getting along so nicely it doesn't seem possible that we should be visited with this curse. It can be nothing else. Why I had started to do sewing in order that there might be more money coming into the house and to help out during these times. My husband was getting a good salary. He always got $30 a week and sometimes his check would go as high as $34. With what I could make sewing we would have got along very well."[52] Exhausted, Helen Schmidt slumped back on the cot in her cell. She buried her face in her hands and sobbed.

The jailing of the Schmidt family made front-page news in all the area's papers. The *Pontiac Press Gazette*'s coverage of the arrests occupied most of the April 22 edition's front page. The *Detroit Free Press* also ran a half-page item about the case under the headline "Three Held in Girl Murder Probe." The Schmidt story had pushed the news of the war to the margins.

BREAKTHROUGH

Highland Park, Michigan
Tuesday morning, April 23, 1918

The prosecutor's ploy worked perfectly. By Tuesday morning, April 23, 1918, Helmuth Schmidt's stoic façade had begun to crack. The grilling began in the late morning. A group of fascinated cops watched as Gillespie and Seymour confronted Schmidt in his cell.[53]

They began with questions about the mysterious housekeeper who dropped out of sight while living with Schmidt in Detroit. Schmidt admitted knowing the woman, whom he identified as Irma Pallatinus, although he insisted that she left his employ of her own free will in December 1915.

Schmidt stuck to his story that he didn't know Augusta Steinbach, so Gillespie tried a different tack. He noted that Helen and Gertrude faced charges as accomplices to murder—unless, of course, Schmidt could set the record straight. The terrified suspect insisted that his wife and daughter knew nothing of Steinbach's disappearance, and he continued to deny any involvement in the woman's disappearance.

Then Gillespie held up the bloody meat cleaver in one hand and the lock of auburn hair in the other. The color drained from the suspect's face. "You Americans so nice. I no can lie to you. You look in my face and see everything. It is no use to try and hide anything. I have something in my mind but I not know how to tell it."[54] Schmidt took a deep breath and thought about what he wanted to say. Gillespie waved the cleaver in front of him, a morbid prompt that started the suspect mumbling in German.

"Yes, yes, I cut up her body and burned it. But I didn't kill her," Schmidt admitted. Gillespie listened intently as Schmidt described the circumstances that climaxed in his dismemberment of Augusta Steinbach. Just after his housekeeper Irma Pallatinus had left, Schmidt explained, he decided to put his Glendale Avenue home on the market. A German immigrant named Hermann Neugebauer said that he would be willing to buy the property if Schmidt agreed to help him find a wife.

So, at Neugebauer's direction, he authored a matrimonial advertisement and mailed it to the *New York Revue*. Augusta Steinbach answered the advertisement and, after a lengthy courtship through the mail, came to Detroit to tie the knot, with Schmidt acting as a go-between. But Neugebauer changed his mind and left for Mexico, leaving Schmidt to deal with his bride-to-be.

The suspect had invented a convenient cover, Gillespie thought. The fable fit all of the facts in the case: how the matrimonial advertisements came to be in Schmidt's handwriting, how and why Steinbach visited Schmidt's Royal Oak home and how her trunks wound up in his cellar. There was just one loose end: Captain Willemse had also traced an ad in the name of George Roloff that was also written in Schmidt's handwriting. The Highland Park postal clerk identified Roloff as Schmidt, and documents found in Schmidt's house verified this fact.

Gillespie smirked and furrowed his brows—an expression that his suspect immediately recognized to say, "I don't believe it." An experienced interrogator, the chief prosecutor knew how to force Schmidt's hand. He asked Schmidt to account for the masses of jewelry found concealed in the organ, some of which belonged to Augusta Steinbach.

Schmidt realized that the hounds had made it past the red herrings he had dragged across his trail. He sighed deeply and began again, this time with the monotonous tone of a man resigned to his fate. They had caught him. There was no escape now. He admitted to placing matrimonial ads in the names of Neugebauer and Roloff. After he lured Steinbach from New York, he began a courtship that was a complete sham. For weeks, he had lived a double life: dashing poseur Herman Neugebauer in Detroit and loyal father and husband Helmuth Schmidt in Royal Oak.

This was the revelation Gillespie and the other investigators had been anticipating. Schmidt was Neugebauer. And Roloff. And Braun. And at the Highland Park Ford plant, he went by the name Ullrich. It was a dizzying array of characters played by a gifted con man who had confounded authorities for months with his cast of alter egos.

Schmidt resumed his lurid tale. On the Sunday Steinbach disappeared, she visited Schmidt at his home while Gertrude and Helen were at church. The two had sex, and Augusta demanded that Schmidt leave his wife and daughter. When he refused, she raced to the bathroom with Schmidt on her heels. Just as he stepped into the room, the distraught woman downed some white powder and collapsed to the floor, dead.

"She killed herself," Schmidt explained. "She took poison when she found out I was already married. She wanted me to leave my wife and daughter and go away with her. I said I wouldn't. Then she swallowed a tablet and fell over dead."

Seymour and Gillespie exchanged a glance. Once again, the suspect had fallen back into fiction. Schmidt's story suggested that Augusta Steinbach knew that her lover had a wife and was unwilling to be his "other woman."

But statements from the Hetheringtons and Agnes Domaniecki indicated that the love-struck woman followed Schmidt to Royal Oak under the guise that he was Neugebauer leading her off to her matrimonial paradise in the suburbs.

If Augusta Steinbach poisoned herself, she used some fast-acting agent that took effect within seconds, which meant that she either carried it with her or found it in Schmidt's medicine cabinet—both unlikely scenarios. Besides, the exuberant, always cheerful Steinbach didn't seem the type to commit suicide.

"My wife and daughter were away from home that day," Schmidt continued his narration. "I picked up the body and carried into the basement. I sawed a hole through the wooden wall between the basement and the space under the front porch. Then I dug a hole under the porch, buried the body and boarded up the opening. The body stayed in the ground under the porch. Then I got scared. I waited till one day when my wife and daughter were away again, dug up the body, cut it into pieces and burned all but a few of the bones that would not burn in the furnace in the basement."[55]

Gillespie remembered Lena Welch's statement, in which she described a foul stench emanating from the chimney next door a few months after the Steinbach woman dropped out of sight. The catalyst moving Schmidt to unearth the remains and incinerate them had to be the visit from O.H.P. Green and the federal officers after a neighbor—probably Mrs. Welch herself—alleged that she overheard Mrs. Schmidt say, "I hope Germany wins." The bitter irony of it all didn't escape the prosecutor: as Green stood on Schmidt's front porch, the remains of Augusta Steinbach, cocooned in a crawl space, were right under his feet. Sometimes the key piece of evidence, as Gillespie recalled in a police adage, is just under your nose.

The wily prosecutor knew that Schmidt was lying about Steinbach's suicide but decided to let it pass for the time. Schmidt was on a roll; his speech became more fluid, his tone elevated. Bravado had replaced abject fear as he began to discuss the success of his advertisements. He admitted that he met his housemaid Irma Pallatinus through the newspapers, although he didn't specify if their relationship was anything other than platonic. "Could this be the 'Mae' that Schmidt bragged about at a Detroit tavern?" Gillespie wondered as he listened to the suspect. A few months later, Schmidt said, Pallatinus left him and was followed by another housemaid he met through the personals. Her name was Emma, but he couldn't remember her last name.[56]

The interrogation had stretched into the early afternoon, and Gillespie still lacked the satisfaction of a full confession. The "love ad" lothario had

admitted to baiting Augusta Steinbach through the advertisements, but despite hours of intensive questioning, he had only admitted to incinerating her corpse after concealing, unearthing and dismembering it. But these admissions amounted to only a partial confession. Again and again, Schmidt had insisted that he did not murder Augusta Steinbach.

Finally, at about 1:30 p.m., Schmidt agreed to make a full, formal statement including the truth about the Steinbach murder, the missing housekeeper and other matters if they gave him a brief lunch break. Gillespie was one to do things by the book, so he sent for an official court stenographer and acquiesced to Schmidt's request for a thirty-minute lunch reprieve.

Despite the exhilaration of finally solving the Steinbach case, Gillespie was exhausted. Following Schmidt's serpentine trail from Royal Oak to New York and back to Royal Oak had taken its toll on the prosecutor. And just as he was about to close the book on the Steinbach file, he would have to open another on Irma Pallatinus and possibly others.

More than ever, Gillespie believed that Schmidt was Michigan's Belle Guinness. Steinbach was merely the last in a long line of gullible old maids waiting for Mr. Right and then finding him, tragically, in the person of Schmidt or Braun, or whoever he was in reality. Only Schmidt knew how many others had taken this twisted trip down the aisle to the basement of his Royal Oak address.

Gillespie would try to pry that information from his suspect during the next interrogation. Schmidt had been a tough nut to crack, but now that he had opened up to the Steinbach murder, perhaps he would spill the rest, although the prosecutor doubted that it would be that easy. Nothing else in the investigation had been.

Chief Seymour locked the door to Schmidt's cell. As he walked away from the cellblock, he called out to the prisoner, "You know you haven't told all the truth, Schmidt. You know you killed the girl."

Schmidt reiterated his promise: "After I have dinner, I'll—I'll tell you the truth."[57] Ten minutes later, Captain Warden heard a *thud* and darted back to the cell, where he found a macabre scene: Schmidt lying facedown, his head enveloped in a growing pool of blood.

Gillespie had taken a few steps to the Model T parked outside when one of the deputies waved him back inside. His heart sank when he realized what happened. In Schmidt's cell at the Highland Park jail, the steel bed frame was hinged to the wall so it could be raised when not in use. Kneeling under the bed frame, Schmidt pressed it to arm's length and then slammed it back down on his head. The crushing blow caused multiple skull fractures, killing him instantly.

A Wayne County jail cell, circa 1920. Jail cells of the era typically contained iron cots hinged to the wall. When not in use, the bed frame could be moved out of the way to allow for more room. *Walter P. Reuther Library, Wayne State University.*

"He must have knelt there like a man saying a prayer," Gillespie thought as he surveyed the scene and watched the ring of blood around Schmidt's head grow larger. The prosecutor stood transfixed for a moment when Seymour nudged him. Scrawled on the back wall of his cell, Schmidt left one final statement to the authorities: "Wife and child innocent."

The Highland Park cops barely had time to clean up the blood spatter when the news hit the streets of Detroit. Schmidt's jailhouse suicide

captivated the area's front pages in stories with headlines that stretched from margin to margin. The *Pontiac Press Gazette* spared none of the gory details in its page-one story on Tuesday, April 23, 1918: "Murder Suspect Suicides Today. Bashes Head with Bed Suspended in Cell; Confesses He Buried, Later Burned Woman." "Steinbach Slaying Suspect Kills Self in Jail After Partial Confession," noted the *Detroit Times'* April 23, 1918 headline. The *Royal Oak Tribune*'s story enticed readers with the enigmatic tag line, "Courtship, Murder, and Mystery." The reporter speculated about Schmidt's motives: "Psychologists would probably class him a sex pervert."

While the presses rolled in Detroit, details of the Schmidt case went over the wire to reporters from New York to Los Angeles. Within twenty-four hours, New Yorkers would read all about Augusta Steinbach's dead end in Royal Oak, Michigan.

Helmuth Schmidt had been quite a ladies' man. Thus far, investigators had uncovered a growing list of women associated with the man the press had dubbed Detroit's "Bluebeard." The shortlist included former housemaids Irma Pallatinus and "Emma" (whom investigators managed to identify as Emma Berchoffsky); Augusta Steinbach, whom he courted and bedded while married to Helen Schmidt; and his daughter, Gertrude. But what role, if any, did these last two play in Schmidt's marriage-for-profit swindle? Gillespie suspected that Schmidt lured Helen in the same manner and for the same reasons as the others, but how much did she know about his affair with Augusta Steinbach?

And what about Gertrude, the teenage vixen whose beauty could turn just about any boy's head? She certainly knew something about her father's marital history, but did she have more than guilty knowledge? Did she abet him in his crimes?

Suicide, it appeared, was Schmidt's final attempt to cover his tracks, and with his dying declaration etched in the jailhouse wall, he indemnified Gertrude and Helen. But Schmidt's suicide complicated things for the authorities, who confirmed that Schmidt did at one time own a home on Glenwood Avenue in Detroit and employed a housekeeper named Irma Pallatinus, who had dropped out of sight in the winter of 1915. This was the woman Schmidt alluded to in the off-the-cuff confession he gave before braining himself with the bed frame.

With the key actor out of the picture, investigators had to focus their attention on Schmidt's supporting cast. Helen and Gertrude had followed a hard line with their interrogators, denying everything. Nevertheless, Sheriff

Cross believed that they would crack under pressure. "Both women are extremely nervous, however," Cross told the press. "I am confident they will divulge some information of value within the next 24 hours."[58] As a veteran cop, Cross knew his business.

From the Highland Park jail, Gillespie traveled to a juvenile detention facility where Gertrude was being held. As he walked up the steps, he thought about his three-year-old daughter. Elenor's birth had given him an entirely different perspective on underage suspects.

Gillespie broke the news of the suicide to an incredulous Gertrude. Her eyes widened, she gasped and then she threw herself on the couch and wailed. Gillespie listened as her heaving sobs became whimpers. After a few minutes, her breathing slowed. She sat up on the couch, crossed her legs and stared at Gillespie. She was ready to answer questions.

That evening, Royal Oak residents lined up outside the local cinema to see silent screen siren Mary Pickford in the premiere of the film *Stella Maris*. While they watched the tear-jerker at the "flickers," a real-life drama was taking place a few blocks away in Sheriff Cross's living room as Gertrude Schmidt told her story, a tale with a fresh plot twist that no one expected.

GERTRUDE AND HELEN

Royal Oak, Michigan
Tuesday evening, April 23, 1918

Cross and Gillespie wanted to compare their suspects' stories, so they kept the Schmidt women from seeing each other and interviewed each one separately. Gertrude went on the hot seat first. Gillespie questioned her in the living room of Sheriff Cross, who lived in a house adjacent to the Royal Oak jail. The prosecutor was hoping that the teenager would fill in the gaps left in Schmidt's partial confession.

Gillespie and Cross listened intently. Cross sat up in his chair as Gertrude said that her mother—Schmidt's first wife, Anita—had dropped out of sight before they left Germany. Gertrude originally told officers that her mother died of disease in Germany, although she couldn't pinpoint the nature of Anita Schmidt's illness. Now, it appeared, her story had evolved a bit.

"I came home from school at the usual time in the afternoon," Gertrude explained. "My mother was not there, and when she didn't return at night,

I asked my father where she was. He told me she had run away and would not be back any more. That was all the explanation he would ever give me, and I never saw her again."[59]

Gertrude went on to describe how she and her father left Germany on the eve of war. "My father came from an influential family in Germany," she explained, "and he told me that he had learned through his army connections that war was soon to take place and he wanted to leave the country to escape military service."[60]

They lived first in New York City and then Philadelphia before Schmidt purchased a chicken farm in Lakewood, New Jersey. According to Gertrude, Schmidt then hired a housemaid named Adele Ullrich, but one day, Adele disappeared as well. "I asked my father what had become of her," Gertrude explained, "and he told me he did not know. I never saw or heard of her again."[61]

By this time, her father had hired a new maid named Irma Pallatinus, and in the spring of 1915, the three moved to Highland Park. In December 1915, Irma left her father, absconding with some of his cash. Just after the housekeeper vanished, Helen Tietz came from New York and married Schmidt. Gertrude remembered the small ceremony well. The couple wed in front of a justice of the peace with just two witnesses.

Gertrude concluded the interview by describing the bond that had formed between her and Helen. "My stepmother and I were good friends," she said. "You know, no one can be the same to you as your mother. My step-mother was more like an aunt to me." Gertrude slid her index finger between her lips and began to nibble on her fingernail. "Is she well? I am afraid she will be taken sick because she has heart trouble. This thing will kill her I am afraid."[62]

Gertrude convinced the chief prosecutor that she didn't knowingly abet her father in the murder of Augusta Steinbach, so Gillespie decided to release her from custody.

Gertrude had added two more names to the growing list of women ensnared in Schmidt's scheming: Anita Schmidt and Adele Ullrich. This new information suggested that Schmidt's trail ran all the way across the ocean to Berlin. It also hinted at a horrific possibility: the Royal Oak Bluebeard had operated "murder plants" in both Detroit and Royal Oak.

While Gertrude was calm, cool and collected, her stepmother was none of these things. The arrest had unnerved her, and the news of her husband's suicide left her on the verge of a nervous breakdown. To keep the frantic woman calm, Dr. J.D. Fox visited her cell at the county lockup and dosed her with sedatives.

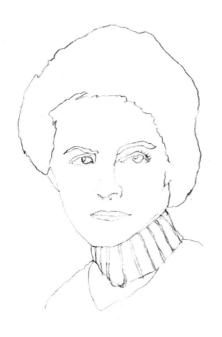

Helen Schmidt in 1918. *Sketch by R.P. Buhk.*

By the early evening of April 23, Helen Schmidt was finally ready to talk. Gillespie, Royal Oak attorney George A. Dondero, Cryderman, Cross and several newspaper reporters gathered in Sheriff Cross's residence adjacent to the Oakland County jail to hear Helen's side of the story.

The suspect, dressed in a blue serge, black shoes and tights to match, sat with her legs crossed and her hands folded in her lap. She left a strong impression on a *Detroit News* correspondent, who described her as "a slight woman, of good figure," with "deep brown" eyes. "Well dressed, her hair done in charming mode, under happier circumstances she would have been a pretty woman."[63]

Assistant Prosecuting Attorney George A. Dondero, who spoke fluent German, handled the questioning. Helen felt comfortable talking to Dondero. There was a certain sense of familiarity that put her at ease. The two had first met a few years earlier, when the Schmidts moved from the Glendale Avenue address to Royal Oak. As village attorney, Dondero helped Schmidt prepare the paperwork when he contracted Jonathan Welch to build his Royal Oak home.

Although slightly older than Glenn Gillespie, George Dondero came from a remarkably similar background. Like the prosecutor, Dondero grew up on a Michigan farm. In 1910, the same year Gillespie graduated from Michigan's law school, Dondero earned his law degree from the Detroit College of Law. He hung his shingle in Royal Oak, eventually becoming the village attorney. At about the time of the Schmidt case, he began a short stint as assistant prosecutor for Oakland County.

Dondero questioned Helen in German and relayed her responses in English to Cross, Cryderman and Gillespie. Helen Schmidt began by once again denying any knowledge of Augusta Steinbach. She insisted that she had

never met her; she could not have been one of the sisters Augusta Steinbach mentioned in her letters to Agnes. Like the slain woman, Helen believed the Neugebauer fiction that her husband spun to explain the evenings he spent in Detroit courting the next "Mrs. Schmidt." He told Helen that he was the middleman in a pending engagement between Neugebauer and a mail-order bride from New York.

The night Neugebauer and his bride-to-be visited their home in Royal Oak—the night Augusta Steinbach vanished—Helen said that she and Gertrude had gone to a movie. They returned later that evening—she didn't know the exact time. One of the reporters asked Helen what her husband was doing when they got home. At first, she said that they found Schmidt eating at the dinner table, but then she said he might have been in the basement. She didn't remember for sure.

Helen's memory about details seemed suspiciously flawed, but she was lucid on one point: Schmidt asked her to hide the blood-streaked meat cleaver. The knife had disappeared from the kitchen, but Helen didn't suspect anything when her husband handed her the bloody blade; she thought he had used it to butcher chickens. Without question, she did as she was told and buried the cleaver under some rocks in the backyard, where detectives recovered it during their sweep the day before. She also said that Schmidt had put a new handle on the axe in late March.

"About two months later, when you came home from Detroit," Gillespie asked, "how did Schmidt explain a fire in the furnace during summertime?"

"He said he built the fire to clean out the chimney," Helen responded. She believed his explanation, but her suspicions peaked when she walked in on him taking clothes out of Augusta Steinbach's trunks. Unruffled by the intrusion, Schmidt said that the Steinbach woman wanted Gertrude to have some of her dresses. Later, he told her that the wedding was off—Neugebauer had left for Mexico, and Steinbach had returned to New York. He even showed her a letter from Augusta requesting her trunks be sent to Schillinger's warehouse.

When Gillespie brought up Lena Welch's account in which she said that she watched Helen dump ashes and wash out the basin in the creek, Helen explained that she often cleaned out the chimney. But she didn't remember scrubbing the basin in the river.

Gillespie then asked Helen how she first became involved with Helmuth Schmidt. She explained that she met Schmidt in Berlin, Germany, before the war. Schmidt had several brothers in the army who warned him about a likely conscription. To avoid service, Schmidt took a fast ship to America to

begin a new life. The two kept tabs on each other through the mail, and in December 1915, Helen came to America, joining Schmidt in Detroit. The pair made it official, marrying in January 1916.

Most of Helen's statement matched Gertrude's, but when pressed on the details, she admitted that she had fibbed about one aspect. She didn't know Schmidt from the old country. Like Augusta Steinbach, she had met him through a matrimonial advertisement. She created the fiction to avoid embarrassment about meeting her husband through the classifieds.

Helen explained that she first came to America in 1907 at the age of twenty-four. Her older sister, Minna, immigrated a few years earlier, and after earning enough money as a seamstress, she returned to Germany to accompany Helen to the New World.[64] Within a few years, the two seamstresses had established themselves in New York City.

In the fall of 1915, Helen and Minna Tietz were running a successful dressmaking business in New York when Helen came across an alluring personal advertisement in a German-language newspaper. She answered the ad and before long had fallen head over heels for her correspondent, Adolph Ullrich of Detroit. She traveled to Detroit, and on December 22, she became his wife.[65] The newlyweds lived on the Glendale Avenue until Schmidt built the place in Royal Oak.

But, Gillespie pointed out, the state's marriage records indicate that Helen Tietz married "Hellmuth Schmidt" and subsequently became Mrs. Schmidt, not Mrs. Ullrich. Helen offered an explanation for Schmidt's alias "Ullrich." Schmidt told her that when he had initially arrived in Detroit, he learned through the German community's grapevine that the imperial German government was going to require all Germans in the United States to register with their embassies, and Schmidt feared that they would track him down and press him into service, so he assumed the name of Ullrich when he went to work for the Ford Motor Company.

She also explained that she entered the marriage with a tidy sum of money. Before she met Schmidt, she had squirreled away $6,250—$3,250 in cash and $3,000 in German war bonds. It took almost two years, but her husband eventually talked her into giving him the cash, which he then used to purchase a house in Royal Oak. Still, Helen believed that Schmidt never found out about the $3,000 she had invested in bonds.

Gillespie nodded. The fact that Schmidt hadn't obtained all of Helen's assets led the prosecutor to theorize that the "Bluebeard" eventually planned to murder Helen once he managed to seize all of her property. With Helen out of the way, Schmidt would go on the prowl for the next "Mrs." Helen

gasped as she realized for the first time that her husband's arrest just may have saved her life.

"I can see it all now," the stunned woman uttered. "I was to be the next." Helen buried her face in her arms and sobbed. Gillespie handed her his handkerchief. After a few minutes, Helen regained her composure. Her tone of despair was replaced by indignation. "I never loved him," she muttered. "I was suspicious of many things he did, but I was afraid of him and never told anyone."[66]

The woman sitting before him—a shattered glass glued together with sedatives—appeared to be just another old maid duped by Schmidt's expertly worded love letters and considerable charms. But if the Schmidt case—this morass of deception—had taught Gillespie anything, it was that appearances could be deceiving. He wondered if Helen's near nervous breakdown came from a guilty conscience. Time and more investigation would dictate whether the Schmidt widow would see the inside of a courtroom or not. For now, she wouldn't go far.

After Gillespie released Helen on her own recognizance, she joined her stepdaughter at the Birmingham residence of a friend, Amelia Kurth, a widow who lived with her teenage son, Erich. For the two besieged women, the small village atmosphere of Birmingham had a calming effect. The comfortable home and pleasant company of the lonely widow and her handsome son made them feel a sense of belonging. For eighteen-year-old Gertrude, it would have a life-altering impact; she immediately fell head over heels for the dashing Erich Kurth.

Despite lingering doubts, Gillespie issued a statement exonerating Helen. "I am convinced," he said, "she had no guilty knowledge either of her husband's luring Augusta Steinbach from New York or of his burning her body after she met death in his bungalow, or of his later digging up the remains, dissecting them and cremating them in the furnace."

"[Schmidt's] conduct toward his wife, in gradually getting all her money, tallies with his actions toward the other women Schmidt had in his power," Gillespie added. "I believe he intended to do away with her as he did with Augusta Steinbach and as we have every reason to believe he did with Irma Pallatinus, who kept house for him at 418 Glendale avenue, Detroit, and suspicion indicates that he did with his first wife in Germany."[67]

It was nearly ten o'clock when Gillespie got home. Leola had put Elenor to bed and waited up for him so they could catch up on the day's doings. Exhausted, the prosecutor slumped into his chair. Leola handed him the newspaper and placed a cup of tea on the coffee table.

Gillespie unfurled Tuesday's edition of the *Pontiac Press Gazette* and scanned the headlines. "MURDER SUSPECT SUICIDES TODAY. Bashes Head with Bed Suspended in Cell; Confesses He Buried, Later Burned Woman. CONCEALED REMAINS UNDER PORCH."[68] He read the front-page item and quickly flipped to page eleven—almost an entire page devoted to the arrest of the Schmidt family and the search of 9 Oakdale.

He nodded as he read the report. The correspondents had done a good job getting the facts straight. After the end of the article, he spied a short item from the Associated Press entitled "Cabarets Dying." Prohibition fever, it appeared, had spread to the Windy City. An "anti-cabaret ordinance" was to take effect next week. The new law banned alcohol from establishments providing any form of entertainment other than instrumental music. The ordinance would kill Chicago's cabarets; theatergoers would abandon them to attend places where they could order a beer. It was a harbinger of things to come in Michigan; in just a week, Michigan's saloons would close in accordance with the new dry laws.

Gillespie folded up the paper, set it on the coffee table and pondered the day's events. Schmidt's trail had contained many sharp, unexpected turns. What surprises, he wondered, would tomorrow bring?

THE HUNT FOR IRMA PALLATINUS

Detroit, Michigan
Tuesday night, April 23, 1918

While the "Bluebeard's" wife and daughter described life with Schmidt, Deputy Mack Hunt went searching for clues as to the whereabouts of Irma Pallatinus. He didn't find the missing maid, but he did find "Emil Braun."

Following his nose around Detroit Tuesday evening, Hunt unearthed information about the twenty-eight-year-old former housemaid whom Schmidt had mentioned during his confession—a woman Schmidt lived with in Detroit under the alias "Emil Braun." Interviews with friends and relatives indicated that Pallatinus may have been more than a just a hired hand.

Hunt tracked down one of Pallatinus's sisters, Mrs. Minna Rederer, who explained that it all began as a whim after reading a matrimonial advertisement inserted in a New York German-language newspaper by a New Jersey chicken farmer named Emil Braun.

"Early in 1915 a friend of my sister Irma, living on One Hundred and Twenty-fifth street, New York city, picked up a matrimonial paper. Reading over the advertisements she laughingly said 'Here is a poultryman down at Lakewood, New Jersey, that wants a wife. I like poultry and am going to write him.' My sister joined with her in answering the advertisement, thinking it a good joke," Mrs. Rederer said.

What began as a joke quickly turned into a love affair. "At that time Schmidt was known as Emil Brown, and it was under that name my sister later married him. When he received the answer to his advertisement he came on and called on my sister's friend. My sister was there at the time and he became smitten with her. She was 28 years old and pretty, but had no money." Minna paused and shook her head. "In his advertisements for a wife he indicated he wished someone with money, but my sister had none. She was pretty and the man seemed infatuated with her."

Minna, suspicious of "Braun," sent her husband, Edward, to Lakewood to get a feel for her baby sister's beau. Edward sent a note to tell Braun that he was coming to meet him. In early April, he made the jaunt from Philadelphia, where the Rederers lived. As detectives would later learn, Schmidt was at the time of Edward Rederer's visit already married and living with his wife. Rederer's letter gave "Braun" enough notice to send his wife away for the day so he could appear to be a bachelor. He wined and dined Edward, giving him the grand tour of his chicken farm.

Everything seemed aboveboard to Edward, but Minna's sixth sense told her that something wasn't quite right about "Mr. Right." Irma ignored her sister's objections, and while the Rederers moved to the nation's new boomtown—Detroit—her relationship with Braun heated up, peaking in an alleged marriage. In mid-April, the newlyweds followed the Rederers to Detroit.

"We then lived at 418 Glendale Avenue," Minna explained, "and on Easter Sunday, 1915, Brown and my sister announced they had been married and came to live with us. I never saw their marriage license or his divorce papers from a previous wife."

The couple appeared happy, but then the honeymoon phase ended, and Minna noticed a change. "Shortly after their marriage his love seemed to wane somewhat," she said. "He allowed her but $6 a week on which to keep the house. Later he increased the amount to $7 and told her he expected her to save some of it."

Minna paused, took a deep breath and resumed her narrative. "We continued to live at the Glendale address until August 16 of that year, when we moved to Crave Avenue near Mack. Later we moved to this house.

Shortly after we came here Brown called and told us my sister did not wish to have anything more to do with her relatives, and taking his word for it, we never called on her or asked about her."

Braun, it appeared, wanted to distance Irma from her sisters so when she disappeared, they wouldn't ask too many questions. By the fall of 1915, he had already met the next "Mrs."—New York dressmaker Helen Tietz—from the classified ads. He had also, for some unexplained reason, changed his name. "Shortly before Christmas of 1915, Brown came to our house and told us Irma had gone to South America and had taken $700 of his money. He said he had detectives looking for her, but they could not locate her. He also told us he had changed his name to Ullrich."[69]

Ullrich, Minna explained, stayed away until, mysteriously, he reappeared on their doorstep in March—at about the same time Gillespie began to retrace Green's footsteps in the Steinbach investigation. "We did not see any more of Ullrich, as we now called him, until a few months ago, when he came and told us that if the foreman of the Ford plant where he worked called and asked about my sister we should say we did not know anything about her. He also notified us he had again changed his name, this time to Schmidt."[70]

Minna handed Hunt a photograph of Irma. The woman in the picture was a mirror image of Augusta Steinbach. Both wore their thick, brunette hair in a bun. Both had strikingly similar facial features: oval face, thin lips, thick necks and double chins. Both had voluptuous, full figures.

Mrs. Rederer's story, coupled with Gertrude's account, indicated that if Schmidt murdered Irma Pallatinus, he did it sometime in late December. This timeline was solidified by Mrs. Grace De Planta, a friend of the "Ullrichs," who gave a brief statement to investigators working the Pallatinus case. Schmidt had met the De Plantas shortly after he moved from Lakewood, New Jersey, and had introduced Irma as his wife.[71]

Just before Christmas, the De Plantas headed downtown to do some shopping for the holidays. They passed the Ullrich place on their way to the streetcar, so they decided to stop in to say hello. Seeing the back of a woman in a room off the foyer, Grace De Planta said, "Hello, Mrs. Ullrich." Mrs. De Planta was astonished when the woman turned. It wasn't Irma—the "Mrs. Ullrich" she knew. It was an awkward moment for everyone present. The woman of the house didn't like being mistaken for someone else; Grace De Planta blushed when she realized she had made the ultimate social gaffe.

Schmidt, caught off guard by the unannounced visit, needed to think fast. He quickly concocted a cover story. After a pregnant pause during which the two women eyed each other suspiciously, Schmidt stammered through an

explanation. Mrs. De Planta, he said, had misunderstood the situation when he had introduced Irma as his wife; she was his housekeeper and nothing more. Irma, Schmidt said, had returned to Philadelphia. After offering this clarification, Schmidt introduced the woman as his wife, Helen, with whom he had exchanged vows just a few days earlier.[72] Then, Grace De Planta recalled, Mr. Schmidt asked her husband to follow him to the cellar to ask him about a renovation project.

A few minutes later, Schmidt and Frederick De Planta emerged from the basement, and the couple left in time to make the streetcar. While they walked to the streetcar stop, Mr. De Planta said that Schmidt wanted his advice about repairing his furnace. De Planta said that he spied something strange by the basement staircase: a wheelbarrow full of sandy soil. Schmidt noticed him staring at the barrow and said he had brought in the sand from outside, but De Planta knew that it was a lie because a recent snowstorm had left the ground outside covered with a blanket of snow.[73]

Hunt also interviewed Mrs. William Taylor, another neighbor of the "Ullrichs." According to Taylor, Schmidt led neighbors to believe that Irma was his wife. She even recalled an instance when Gertrude helped to create this impression. Gertrude once introduced Irma's younger sister, Irene, as her cousin and Mrs. Rederer as her aunt, which according to Taylor lent credibility to the idea that Irma was Gertrude's stepmother.

Taylor also noted that Pallatinus dropped out of sight around Christmas 1915. Not long after, another woman appeared with Schmidt, and he introduced her as his wife. "One of the neighbors expressed surprise at this," Taylor explained, and asked Schmidt, "I thought that other lady was your wife?"

"Oh, no, that was only my housekeeper," Schmidt replied, repeating the story that he fabricated to cover Grace De Planta's embarrassing mistake.[74]

After talking with neighbors, Hunt interviewed Frank Rhode, a bartender who knew Schmidt as a regular at his Woodward Avenue tavern in the summer of 1915. According to Rhode, Schmidt went by the name of "Captain" Ullrich and attended meetings of the German American society that met once a month above a saloon on Gratiot. He bragged about his status as an officer in the imperial German army and often showed up with a woman he presented as his wife, "Mae Murray." His "wife" matched the description of Irma Pallatinus.

Minna Rederer's story, in part corroborated by Gertrude's statements to Gillespie, helped investigators piece together Schmidt's trail back to April 1915, when he first came to Detroit with Irma Pallatinus. As Emil Braun, he cohabitated with her while corresponding with Helen Tietz. At about

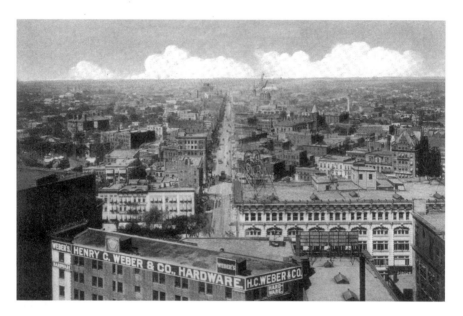

The east side of Detroit along Gratiot Avenue. According to bartender Frank Rhode, Schmidt frequented taverns in his area as "Captain Ullrich" and attended meetings of a German American society that met above a saloon on Gratiot. Rhode said that "Ullrich" bragged about his status as an officer in the German army. *Author's collection.*

the same time Irma dropped out of sight, Schmidt—this time really as Schmidt—married Helen and moved to Royal Oak.

Detectives recognized the possibility that Schmidt disposed of Irma Pallatinus to make way for his next "Mrs." If true, the "housekeeper" may have never left 418 Glendale Avenue. Schmidt admitted to initially burying Augusta Steinbach's body. Perhaps he did the same to the remains of Irma Pallatinus, which would explain the sand that Frederick De Planta spotted in the cellar. Schmidt, investigators learned, had recently evicted the residents, which now seemed to suggest the sinister possibility that, to avoid detection, he had planned to unearth the body, dismember it and then cremate it, just as he had done to the body of Augusta Steinbach.

The cellar seemed the most likely spot for a clandestine grave, but the cement floor didn't appear patched. Gertrude said that her father had removed a root cellar in the basement and patched the wall, so investigators followed a line of thought that Schmidt had buried Pallatinus in a cavity behind the wall.

Interviews with neighbors revealed other promising spots. Just before Schmidt moved to Royal Oak, he had fenced in the area along the east

side, perhaps as an effort to conceal something buried there. And a newly planted garden led to speculation that the Pallatinus woman was pushing up daisies in the backyard. Detective Frederick B. (Fred) Dibble, from Detroit's formidable three-man Homicide Bureau, would lead the excavations. It was too late to begin digging that night, so they planned to break ground the next day.

Front-Page News

Pontiac, Michigan
Wednesday morning, April 24, 1918

By Wednesday morning, April 24, news of the Schmidt case appeared in every major newspaper in America. Front-page items carried headlines stretching from margin to margin.

In the Motor City, area reporters filed stories about the Schmidt case for both the morning and evening editions of Detroit's major news rags, the *Free Press* and the *News*. They glorified Glenn Gillespie as the heroic protagonist who, through sheer intellect and elbow grease, had brought the "Michigan Bluebeard" to justice before the fiend could strike again.

"When confronted with positive evidence of his guilt, in connection with Miss Steinbach's disappearance," a *Pontiac Press Gazette* reporter gloated, "Schmidt lost his former air of stolid indifference and assumed one which could only be illustrated by the prosecutor as reminding him of the way the Germans shout 'kamerad' when they are captured on the western front and beg for their lives."[75]

Gillespie told reporters that he didn't buy Schmidt's partial confession. He characterized Schmidt's story about Augusta Steinbach's suicide as utter folly. He believed that when Schmidt pilfered all of the New Yorker's things, he lured her to his basement and then brained her with a blunt object.

The crime shocked the area's residents, and newspaper correspondents capitalized on the anti-German sentiment of the time. "The German mind probably never conceived and carried into execution a more fiendish plot against human life than that which is laid at the door of Schmidt," exclaimed the *Pontiac Press Gazette*.[76]

In New York City, newsboys hawking papers on streets of Manhattan carried copies of the *New York Times* featuring a story headlined "Admits

KILLING GIRL THEN ENDS HIS LIFE; Helmuth Schmitt [*sic*] Lets Iron Bed Crush His Skull in Cell of Michigan Jail." The *New York Tribune* ran a parallel story titled "MAN WHO LED GIRL TO DEATH ENDS LIFE IN MICHIGAN PRISON."[77] The stories detailed Schmidt's partial confession but left little doubt that investigators believed Schmidt murdered Augusta Steinbach. "His story that the woman took poison," wrote the *New York Times* reporter, "was shattered by the officers, who succeeding in bringing out many conflicting points which made them confident Schmidt had killed the girl."[78]

Agnes Domaniecki read the story with tears in her eyes. Another New Yorker, "Mrs. Braun," read the news with her mouth agape. She dropped the paper and raced to the nearest telegraph operator. She needed to send an urgent message to Prosecutor Gillespie.

THE MYSTERIOUS MRS. EMIL BRAUN

Pontiac, Michigan
Wednesday afternoon, April 24, 1918

Dibble and his crew had just arrived at 418 Glendale Avenue when they received word from Glenn Gillespie to stop their spade work. The prosecutor had received a telegraph suggesting that Schmidt may not have planted the body of Irma Pallatinus six feet under his Highland Park home. The short, mysterious note came from "Mrs. Emil Braun":

> *Wife of Helmuth Schmidt leaving for Pontiac. Hold body until arrival.*
> *Mrs. Emil Braun*[79]

If, as her sister indicated, Irma Pallatinus married Schmidt as Emil Braun, then she and the mysterious "Mrs. Emil Braun" apparently en route to the Motor City could be one and the same. The digging would have to wait until this new character made her appearance in Detroit.

Schmidt's trail now led directly to Lakewood, New Jersey. The night before, Gertrude told about Adele Ullrich, who mysteriously disappeared from Schmidt's Lakewood-area chicken farm. Irma Pallatinus also allegedly married Emil Braun from New Jersey. Perhaps authorities there would know the whereabouts of these women and, most importantly, the identity of the "Mrs. Emil Braun" who asked Detroit police to hold her husband's body.

Gillespie sent a wire to Ocean County prosecutor Richard C. Plummer to see if he could shed any light on this "Mrs. Emil Braun." Plummer immediately sent a response: "Emil Braun, answering description of Helmuth Schmidt, married Adele Ullrich Braun here about Thanksgiving, 1914, and disappeared in April, 1915, with all her money. Police never located him. Mrs. Adele B. Braun, 764 Dawson street, Bronx, N.Y., is wife's present address."[80]

The telegraph cleared up the mystery about the fate of Adele Ullrich, who was alive and well in New York City. But Plummer's telegraph indicted that Schmidt married Ullrich, when Gertrude described her as just a housekeeper. Schmidt allegedly wed Irma Pallatinus as "Emil Braun," so if Schmidt also married Ullrich as Braun, then he married two women using the same alias. This possibility raised another question: was Adele Ullrich Braun the same "Mrs. Emil Braun" who wired Detroit Chief of Police Remember Kent? Or was "Mrs. Emil Braun" Irma Pallatinus?

"Mrs. Braun" watched the blur of green as the westbound train steamed toward the Motor City and wondered if she would, once and for all, resolve the mystery of Emil Braun in the midwestern boomtown. With his square jaw and swarthy complexion, Emil was a handsome man. Adele looked at the wanted poster she held in her lap. For the past three years, she had conducted her own investigation into the disappearance of her husband, who abandoned her in April 1915.

Born in Germany in 1873, nine-year-old Adele Ullrich immigrated with her parents in the fall of 1882. The Ullrich family settled in New York, where Adele became a naturalized citizen and later clerked for several businesses, managing to accumulate a sizable nest egg. She was forty-one, single and working as a bookkeeper for a brewery when she first met Braun in 1914 through a matrimonial advertisement. Following a brief courtship, she became Mrs. Adele Ullrich Braun on December 30, 1914.

The marriage, however, never made it past the honeymoon phase. After Braun managed to sweet-talk Adele out of her life savings, he made her life miserable before disappearing with his fourteen-year-old daughter "Gertie Trudchen" in April 1915. Braun took just about every penny she had, forcing her to fall back on friends and family just to make ends meet, and she had been searching for him ever since.

Braun kept his skeletons in the closet closely guarded, but when he ran away, Adele was free to look around for clues about her husband's mysterious past.[81] She discovered some tantalizing photographs in an old trunk. One picture showed the façade of a jewelry store with the name "Helmuth

Schmidt" over the door. Another showed her husband, Emil Braun, standing on a Berlin street. A third picture showed Braun's daughter. On the back the photo, in Braun's handwriting, was scrawled "Gertrude Schmidt."

The trunk also contained an incriminating document indicating that a "Helmuth Emil Max Schmidt" was wanted by the German authorities for "fraudulent bankruptcy." Curiously, Braun's silverware bore the monogram "H.S." When Adele asked Braun about it, he became enraged and refused to answer her. It appeared she had finally found the truth about "H.S."

Adele took the document and photographs to Lakewood police, who used the pictures to create a wanted poster and offered a reward of $100. While she waited for the poster to churn up leads, Adele continued to probe into Braun's mysterious past. She interviewed neighbors and opened a line of communication with the Berlin police, who confirmed that they issued an arrest warrant for "Helmuth Emil Max Schmidt."

She found out from the locals that she might have been just the last in a sequence of mistresses who lived at the farm. Braun first came to Lakewood with his first wife and another woman. Neighbors disagreed about the identity of this second woman. Some said she was Braun's sister, and some noted that she was his housekeeper, with a certain wry smile that hinted at a more intimate relationship. During the summer of 1914, Braun's first wife went back to Germany, where, Braun told neighbors, she became sick and died in a hospital in July. By the end of the month, the housekeeper had disappeared as well.

Adele Ullrich Braun managed to uncover a jaw-dropping history of deception, but she couldn't locate the culprit. For four years, she had hunted, but H.S. stayed under cover until the name "Helmuth Schmidt" made headlines earlier in the week. When she reached Detroit, she would find out for sure if her "H.S." was the Michigan "Bluebeard."

Adele looked down at her hands and realized that she had clenched her fists, crushing the wanted poster into a wadded ball of paper.

"I Am Glad He Killed Himself"

Pontiac, Michigan
Thursday morning, April 25, 1918

The next twenty-four hours were characterized by nervous anticipation. Gertrude and her stepmother rested uneasily at the Birmingham home of

the Kurths while possible criminal charges lingered above them; detectives and municipal workers waited at 418 Glendale Avenue for the word from Gillespie; and the chief prosecutor eagerly awaited the arrival of three women who were on their way to Detroit to assist in untangling the vines created by Schmidt's matrimonial advertisement swindle: Helen's sister, Mina Hofbauer; Agnes Domaniecki; and the mysterious "Mrs. Braun," whomever she may be.

Plummer's telegram suggested that Gertrude fibbed about Adele Ullrich. On Thursday morning, detectives grilled Gertrude again, this time in a room filled with investigators and reporters. One *Detroit Free Press* reporter, Carol Bird, eavesdropped on the interview, carefully jotting down the eighteen-year-old's words. Bird described her as an "extremely attractive girl, rather well developed for her age, and possessing a face alight with intelligence."[82]

This time, Gertrude condemned her father, portraying him as a womanizing control freak. "My own dear, 'truly' mother was, undoubtedly, murdered by the man I am forced to call 'father.' My stepmother and myself might have met the same fate eventually. Taking all the facts into consideration, I cannot help but say that I am glad he killed himself. It was his only way out of his crime entanglements."[83]

The reporters looked up from their notebooks and stared at Gertrude, who immediately recognized that her attitude stunned some in the room. "It sounds heartless and unwomanly for a girl to say that she is glad her own parent has ended his life, doesn't it? At first I was terribly grieved. Everything happened so suddenly—all those dreadful revelations right out of a perfectly clear sky. First to be informed that my father was a murderer, and not just the average sort of murderer, but a wholesale slaughterer. And, before I had completely recovered from that shock to be told that he was dead, and by his own hand."[84]

Gertrude paused to take a sip of water before continuing her statement. "Looking back through the years with my father I have been able to recall many circumstances which have convinced me that he was all that people say about him, and was guilty of the crimes with which he has been charged."

She echoed Gillespie's theory about her father's probable plan for Helen:

> *Do you know, I believe that my step-mother and I would have probably suffered the same fate those other poor women did had my father gone his way unmolested by the law. I have come to the conclusion, too, that my own dear "truly" mother was killed by him. At the time of her supposed "death," in Hamburg, when I was 12 years old, I never questioned my*

father's story regarding the way she had passed out. I was too young, of course, to be suspicious. He was my father, and I naturally trusted him. My mother had not been ill prior to her "death," but one day when I returned from school my father met me in the doorway, told me my mother was not feeling well, and asked me to run over and visit friends, and spend the night with them if I cared to, and then, the next day...

Gertrude struggled to keep her composure. She took a deep breath and continued. "The next day when I returned from our neighbor's house my father informed me that my mother had died the night before. Shortly after that we left Hamburg for this country. It seems too terrible, but I do believe now that my mother was a victim of my father."

Gertrude shivered as she recalled the evening of March 11, 1917, when she came home to find her father in the basement:

And just to think that I was talking to him while, perhaps, the blood of that unfortunate Steinbach girl was on his hands. I came home one day about the time the New York woman was supposed to have been murdered by him, and I couldn't find him in the upstairs room. I went downstairs in the basement, and he hurriedly met me. I remember that he appeared nervous and seemed to be annoyed at my entrance. Back of him lying near the open furnace door, I caught a glimpse of something—it looked like a big bundle—I couldn't say exactly what it was. He took me by the arm and said: "Run along Gertie and meet mamma at the car. She is coming from town." I did as I was told, though it did seem strange that I should be asked to escort her home. And now, to think that perhaps those smoke clouds issuing from our chimney that day were...

She began to bawl, her chest heaving as she swallowed gulps of air. After catching her breath, Gertrude concluded her statement by offering an explanation for their apparent complicity in Schmidt's scheming. Schmidt ran his household with the discipline of an army field officer, and the troops always followed his orders. "My father did many strange things and made many strange requests," Gertrude explained, "but we never questioned him, or asked the whys and the wherefores of his commands. He was a domineering man, stern and unrelenting. He demanded obedience from his women and he got it. That was why I never rebelled at the strange girls he used to bring to our home, nor asked him to go into detail about their sudden disappearances."

After the interview, Bird followed the two women to Birmingham, where she described them as they reposed in the Kurths' living room. Mrs. Schmidt

sat, dazed and confused, oblivious to everything, including the Kurth baby in a rocker by the fireplace. The "puzzled" infant "gazed, with questioning eyes, from one solemn-faced woman to another…but Mrs. Schmidt, if she caught the baby's puzzling glance, didn't even smile reassuringly at him as women the world over do when they see that particular wonder-look in an infant's eyes."

While Bird depicted Helen as numb and even unwomanly, she was much kinder to Gertrude, characterizing her as a woman with the innocence of a toddler: "Her cheeks tinged with the natural color of youth, her reddish-brown hair arranged in a simple pompadour, the braid hanging in curls at the ends, her eyes somehow reflecting the candid, questioning puzzled look of the baby's across the room—no one could attempt to picture her dabbling in such a pastime as burying bones of murdered women."[85]

Gertrude played the victim well, but detectives wondered if she was a naïve girl bullied by a tyrannical father or a talented ingénue. Her condemnation of Schmidt shocked some, but Gertrude understood that hell hath no fury like a woman scorned, and that woman was about to step off the westbound train.

WANTED!

Pontiac, Michigan
Friday morning, April 26, 1918

On Friday, a procession of women arrived on the westbound trains from New York and visited Gillespie's office in Pontiac, each with her own motives. Adele Ullrich Braun wanted to reclaim her purloined property, Agnes Domaniecki wanted to bring some sense of closure to the tragic affair and Mina Hofbauer wanted to help her sister, Helen. Helen was an emotional train wreck and facing the possibility of some time behind bars, so her sister came to comfort her and try to clear her name.

Gertrude also traveled to the prosecutor's office, leaving her Birmingham refuge to face her former stepmother, Adele Ullrich Braun. At about the time she climbed into Erich Kurth's car, Gillespie opened a letter from Ocean County prosecutor Richard C. Plummer. The letter contained a note from Plummer and a shocking enclosure: a copy of a wanted circular published by the Lakewood Police Department in 1914:

Downtown Pontiac, circa 1918. Three women came from New York to the Pontiac office of Glenn C. Gillespie to help the prosecutor unravel Schmidt's tangled web. *Author's collection.*

In reply to your telegram which I have answered by telegraph today, [I] would say that Emil Braun whose picture is enclosed on a clipping from a reward circular, married a girl named Adele Ullrich about Thanksgiving 1914 and lived in this town for several months afterwards working as a jeweler. In April 1915, he disappeared, taking with him all his wife's money of which she had about $2,500 saved by her while she was working as a book-keeper for some concern either in New York or the northern part of New Jersey. Although rewards were offered for Braun's apprehension, police were never able to locate him. Mrs. Adele B. Braun as stated in the telegram is at present living at 764 Dawson Street, Bronx, New York. The enclosed circular will give you any other information you wish.

The circular included photographs of a middle-aged man, Emil Braun, next to his fourteen-year-old-daughter "Gertie." Gillespie read the descriptions carefully:

[Braun:] *Five feet eight inches tall, weight about 160 pounds, age about 38 to 39 years, slender but wiry build, tanned complexion, brown eyes, dark brown hair, close cropped brown mustache, six prominent scars on left side of chin made by sword, also two scars on left side of forehead close*

84

to hair, wore dragon ring with small red stone, is a German, speaks poor English, scar on right thumb, second joint, very winning manners, in company of daughter, two gold crowned teeth, visible, one on each side, upper jaw. Very apt to return to Germany, first opportunity he has. Very apt to clip his hair, or remove mustache. Very apt to grow beard.

[Gertie:] Daughter answers to Gertie Trudchen, five feet nine inches tall, weight about 140 pounds, age 16 years, stout figure, much developed, light brown hair, brown eyes, broad stubby nose, two gold fillings in two front teeth, visible, one on each side, upper jaw.[86]

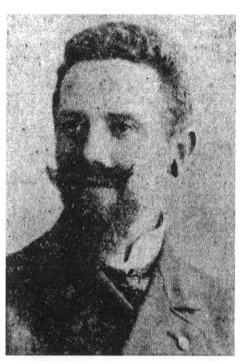

The body at Crosby's funeral parlor matched the circular's description of Emil Braun, and "Trudchen" was a dead-ringer, albeit a little thinner, for

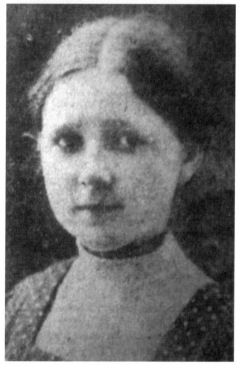

Top: Helmuth Schmidt, circa 1914. One of the only known photographs of Schmidt before he moved to Detroit, this portrait appeared in the April 23, 1918 *Detroit Times* under the caption, "Royal Oak Slaying Suspect And Daughter."

Right: Gertrude Schmidt, circa 1914. Gertrude would be about fourteen in this photograph, which appeared next to her father's, mug shot style, in the April 23, 1918 *Detroit Times*.

Gertrude Schmidt. Gillespie would quiz Gertrude on the photograph later when she arrived in Pontiac.

With the information provided by Lakewood authorities, Schmidt's use of multiple pseudonyms became a little clearer. He lived in Highland Park under the alias "Emil Braun" from the time he moved to the city in early 1915 with Irma Pallatinus to November 1916, at some point changing his name to "Adolph Ullrich"—a name he used at the Ford plant. To evade detection, the audacious Schmidt apparently adopted the name of his Lakewood wife.

When he married Helen and moved to Royal Oak in the spring of 1916, he changed his name again, this time to Schmidt, but he kept the name "Ullrich" at work. From 1916 to his capture, he remained Helmuth Schmidt but still answered to Ullrich at work, all the while masquerading in the newspaper classifieds as Neugebauer, Roloff and most likely others.

Gillespie reread two key lines of Prosecutor Plummer's letter. Braun "married a girl named Adele Ullrich," and "Mrs. Adele B. Braun as stated in the telegram is at present living at 764 Dawson street, Bronx, New York." There was no longer any doubt about it: the mysterious "Mrs. Braun" was Adele Ullrich Braun, not Irma Pallatinus, which meant that it was time for the county workers to do some digging. Under the supervision of Detective Dibble, excavations began immediately at 418 Glendale.

MINA AND THE LETTER

Pontiac, Michigan
Friday morning, April 26, 1918

Agnes Domaniecki checked into the Huron Hotel, but with her nerves frayed, she didn't want to leave.[87] While detectives attempted to coax the thirty-three-year-old domestic out of her downtown hotel room, Helen Schmidt's sister, Mrs. Mina Hofbauer, described how Helen fell into Schmidt's marriage-by-mail scam.

Mina explained that she and Helen emigrated from their native Anklam, Germany, in 1907. For the next eight years, they ran a successful dressmaking business in New York City. Everything changed in 1915 when Helen spotted a matrimonial advertisement in the *New York Revue* posted by a Herman Scharno. Against her older sister's better judgment, Helen sent a letter to Scharno in Detroit and began a brief correspondence.

Scharno described his fifteen-year-old "sister-in-law" Gertrude and a Hungarian housekeeper who worked days at his Highland Park residence. Gillespie nodded as he listened to Mina. The Hungarian housekeeper was almost certainly Irma Pallatinus.

In the fall of 1915, Mina said, she and Helen hopped onto a train to visit Scharno in the Motor City. Gertrude called Scharno "Papa," which was when they discovered that Scharno was really Schmidt. After two days, the Tietz sisters returned to New York.

Schmidt's deception didn't kill the romance, though, and the pair continued to pen love letters to each other. Schmidt amplified his efforts to woo Helen by sending her jewelry. "We thought he was crazy the way he sent jewelry to my sister," Mina told Gillespie. "He sent her a watch, and pins, earrings and a little horseshoe brooch. I can't remember all the things she got but I know there were many. We thought he must have lots of money the way he spent it on jewelry."[88]

The rich suitor proved too much for Helen to resist. Against Mina's advice, she traveled to Detroit and tied the knot with Schmidt in December 1915. After the wedding, Mina returned to the Motor City to visit Helen and stayed for five weeks. During this time, Schmidt made a few passes at his sister-in-law, which caused a rift between her and Helen. Mina retreated to New York but didn't talk to Helen for more than six months. Gertrude finally broke the feud by sending Mina some silver spoons.

While Mr. and Mrs. Schmidt forged a life together in Detroit, Mina Tietz fell for and married a New Yorker named Hofbauer. This bothered Schmidt, who apparently wanted Mina to relocate to Detroit and live with them. At first, this didn't seem odd to Mina, but with Schmidt's murder racket exposed, the invitation took on sinister overtones. Mina believed that Schmidt eyed her as the next Mrs. Schmidt once he had finally deprived Helen of her life savings.

When the Hofbauers visited the Schmidts in Detroit during the summer of 1916, the Hungarian housemaid was nowhere in sight. After a brief visit, the Hofbauers went back to New York, but the two sisters reconciled and regularly sent letters to each other.

A knock on the thick oak door of Gillespie's office interrupted Mrs. Hofbauer's narrative. The prosecutor opened the door to find T.H. Hetherington standing there with a small rectangle of paper in his hands. The old man's timing couldn't have been better. "I found that card I was telling you about," he said and handed the piece of mail to Gillespie. The prosecutor read the note, postmarked April 14, 1917:

Dear Mr. Hetherington: I would like to ask you if there is any mail for me to send it to Mr. H.E. Schmidt, 9 Oakdale boulevard, Royal Oak, Mich. Thanking you in advance, respectfully,

Augusta Steinbach[89]

The card was obviously Schmidt's attempt to cover his tracks and derail any inquiries from Augusta's friends and family by routing all of her mail to his address. The card predated the "Dear Worthy Mr. Schmidt" letter by a week; apparently, Schmidt felt the heat of Green's investigation and took steps to cover his trail.

Mina anxiously repositioned herself in her seat as Gillespie studied the postcard. He then handed it to Mina, who quickly read it. "Yes I know about it," she said in a matter-of-fact tone. "It was sent to me by my sister in an envelope. She asked me to mail it." Mina suddenly realized how the card implicated Helen in the scandal. "I asked her why I should do that and she said it was not important, but her husband wanted it done."[90]

At best, Helen mailed the card with complete ignorance of its purpose; she sent it because her autocratic husband told her to. At worst, she knew its purpose and abetted her husband's attempt to shelve Augusta's mail. Mina had come to Detroit to help Helen, but ironically, she provided Gillespie with an important piece of information that put her sister in greater jeopardy of a criminal charge.

Part III

THE EVIL EYE

THE WOMAN SCORNED

Detroit Michigan
Friday morning, April 26, 1918

Adele Ullrich Braun stepped off the train in Detroit dressed to kill. *Free Press* reporter Carol Bird described the forty-five-year-old as "of refined and intelligent appearance," decked out in "a well-tailored blue gabardine suit, a blue Milan hat trimmed with a stiff, smart, brown feather, a black fox fur neckpiece and dark gray suede shoes."[91]

Apart from her "smart" dress, the New Yorker was a real looker. Despite the gray strands in her ash-blonde hair, she looked thirty-five instead of forty-five and had mesmerizing blue eyes. She turned heads as she made a beeline to A.E. Crosby's undertaking establishment, where the county kept Schmidt's body pending the arrival of "Mrs. Braun."

Adele hadn't seen Emil since he abandoned her in April 1915, and she wasn't sure how to feel as she walked into the funeral parlor. Countless times since he left, even on the lengthy train ride west, she relived the nights with Emil, two bodies lying next to each other after climbing a mountain together and sharing in the ecstasy of reaching its apex. The memory always created conflicting emotions within Adele—arousal that peaked in a blinding rage aimed at Emil for taking everything she owned and leaving her with nothing but questions.

If the corpse under the sheet was her husband, perhaps she could bring closure to a chapter of her biography that lacked an ending and reclaim the small fortune he had stolen from her. As for the stolen nights, well, there was nothing she could do about that now except tell police and the press what kind of monster he was and how he systematically defrauded her—even if that meant the embarrassment of bringing her domestic affairs into public view. But if Emil looked like a fiend, perhaps she would look more like a victim and less like a fool. She had no choice now but to air her dirty linen for everyone to see. The dirtier, she thought, the better.

Adele closed her eyes and took a deep breath to steady her nerves as Crosby gently rolled back the sheet covering the body. She shuddered as she saw the massive gash in his head. The laceration had sliced open the scalp, revealing the reddish-pink skull underneath. After convincing herself to ignore the wound, she studied the man's facial features. She immediately spotted the three, thin scars running down his left cheek. There was no longer any doubt about it: Helmuth Schmidt was Emil Braun. With the identification complete, Adele traveled to the Detroit Police Station, where she would expose the monster she married as a deceitful rake, bigamist and fraud.

For years, she worked hard as a seamstress in New York, accumulating a nest egg of $3,500. The "teufel" Braun, with his impish sidekick Gertrude, made her life a living hell. He mocked her physical appearance and took a series of lovers. He didn't even bother to hide his extramarital trysts, instead boasting about his sexual prowess at the dinner table.

Emil did manage to keep one secret from her, though: while he acquired all her life savings, he carried on a correspondence affair with a woman from Philadelphia.[92] Once he had made arrangements with this woman, whom the papers called Pallatinus, he sold the chicken farm from under Adele's feet and disappeared with his new "wife." Adding insult to injury, the bodacious "Braun" assumed her maiden name, Ullrich, when he went to work in Detroit.

And then, Adele read, Pallatinus disappeared. She also read in the papers that Schmidt married again in late 1915 to a Helen Tietz of New York. That made him a bigamist as well as a thief, and she had the marriage license to prove it. She felt bad for this woman, Helen, whose background paralleled her own in so many ways. Helen had accumulated some money by working her fingers to the bone making dresses for wealthy New Yorkers. Feeling a sense of urgency typical of single women her age, Helen swallowed Braun's matrimonial pitch, succumbing to his considerable emotional and physical charms. And while defrauding Helen of her life savings, he began the routine again by courting Augusta Steinbach.

Pity gave way to indignation; she was, after all, the first "Mrs.," and she had a legitimate claim to Schmidt's estimated fortune of $20,000, or at least the $3,500 she had unwillingly contributed. And she wouldn't leave town without it, even if that meant a legal squabble.

From Crosby's, Adele made her way to Detroit's police headquarters, where she gave a lengthy and detailed account to Detectives Fred Dibble and John Reid of the Homicide Bureau. The two cops hoped that Adele Ullrich Braun could provide some clue as to the fate of Irma Pallatinus. Both men had spent years patrolling Detroit's mean streets. Dibble, a veteran of nearly two decades on the force, had collared some of the city's nastiest criminals, but he had never met anyone quite like Adele Ullrich Braun.

Adele detailed her life with the "Bluebeard" seemingly without inhibition. In an era when women kept their sexual selves under covers, Adele left little to the imagination. According to Adele, the women of Lakewood used to call Schmidt the "evil eye" for what she characterized as "his hypnotic gaze."[93] The "evil eye," Adele said, even tried to hypnotize her several times. The "eye" may have terrified the neighboring women, but according to his Lakewood wife, it didn't harm Schmidt's love life. If Adele's lurid account of Schmidt's affairs in Lakewood was accurate, then Schmidt possessed a charm bordering on the supernatural.

"Emil was a hypnotist and a consummate actor," she began. Schmidt turned on the charm before he met Adele in the flesh. "He wrote me the most wonderfully worded letters after I answered his ad for a wife," Adele recalled, "and when I met him I was greatly attracted by him. He had a fascinating personality. All women were fond of him."

After a barrage of colorful anecdotes detailing his dashing life back in Germany, Braun added a powerful piece of psychology designed to appeal to his target's maternal instincts. "He pictured most touchingly his lonely life with his little girl and said: 'Adele, my dearest, all we need is a mother in our home.'"

"Well," Adele sighed and shrugged her shoulders, "I married him." She was quick to add an accomplice to her husband's scheme. "But for six weeks before I became his wife, Gertrude, his daughter, lived with me at my home by his express wish. She spied upon me constantly. She was always a designing, tattling girl and I never trusted her. She told her father of every move I made, especially if I went to draw certain amounts of my own money from the bank."

Once Braun managed to deprive Adele of her life savings, he began to torment her. "Emil was deliberately cruel to me," Adele recalled. "He used to taunt me about my looks, tell me how homely I was and try to make me jealous about other women." He often needled the self-conscious woman about her appearance and strategically chose meal times to bully her

because, Adele said, "he knew I was of a nervous, worrisome temperament and that his jibings and taunts would spoil my appetite."[94]

Adele described a typical dinner with the "Bluebeard." As she leaned over to serve her husband the first course—a bowl of soup—he fired off the first in a volley of derisive comments; he remarked about her hair color, "Adele, I never noticed before what a funny shade of hair you've got. Can't you do something with it?" As his wife served up the main course, Braun dished out his most scathing comments. "Adele," he said, "your color's bad. Something must be the matter with your liver." He continued the barrage with a shot aimed right at her heart: "Lines are showing round your eyes. How old did you say you were when answering my advertisement?"

Braun grinned like a Cheshire cat, and Gertrude giggled. This was too much for Adele, who lost her appetite. As she stomped out of the room, she could hear Gertrude recite the jingle her father taught her: "If I can't get a husband in a regular way, I'll run an ad. for one and see if it will pay."[95]

According to Adele, though, Braun didn't need to run an advertisement for extramarital play. He carried on an affair with one of the neighboring women, whom he had lured with his "hypnotic gaze." The audacious Braun didn't even try to hide the tryst, flaunting it instead. "All things are clean and moral to the clean-minded," he told Adele when she complained about his extramarital liaison. "And I, my darling, Adele, am a high-minded man."[96]

In Adele's descriptions, Braun became a malignant caricature who even twirled his hair into horns and joked that the devil—a friend of his, he said—often brought him good luck.

Braun made for a strange bedfellow. Adele, who had stick-straight hair, often used a curling iron, but the smell sent her husband up the wall. "I can't stand that burning hair," he complained, "stop it, STOP IT!" He likewise despised the smell of burning matches and often said, "I don't like burned things lying around. They make me feel uncomfortable."[97]

Adele's anecdotes gave Detroit reporters plenty of fodder to fuel the rumor mill. Reporters immediately linked Braun's eccentricities to his confession and the missing Lakewood women. His strange aversion to the stench of burning hair could mean only one thing: he had disposed of others in the same way he had Augusta Steinbach. This fact prompted Reid and Dibble to question if they would ever find Irma Pallatinus.

After briefing the Detroit cops, Adele traveled to Pontiac, where she would meet with chief prosecutor Glenn C. Gillespie and her former stepdaughter. Sitting in the prosecutor's office, Gertrude Schmidt wrung her hands as she waited for her former stepmother's arrival.

FACE-OFF

Pontiac, Michigan
Friday afternoon, April 26, 1918

The pie-faced girl on the Lakewood wanted leaflet put Gertrude back on the hot seat. While Dibble and Reid escorted Adele Ullrich Braun to Pontiac, Gillespie confronted Gertrude. Almost a dozen reporters encircled the teenager as she sat next to the prosecutor's desk, poised to jot down her every word.

Gillespie placed the wanted circular on his desk in front of Gertrude. "Isn't this you?" he asked as he stood over her. Gertrude leaned forward and glanced at the picture as she twirled her index finger through her hair, forming a curl. She smiled and shook her head.

"This isn't you?" Gillespie asked again. Everyone in the room, a *Pontiac Press Gazette* reporter later wrote, agreed that the girl in the photograph was none other than Gertrude Schmidt.[98] Gertrude just shook her head and angrily shoved the paper to the side. A few minutes later, Dibble and Reid arrived with Adele Ullrich Braun. A smile spread across Adele's lips as she waltzed into Gillespie's office; she couldn't wait to see the expression on Gertrude's face. A group of reporters had gathered to witness the confrontation between Adele Ullrich Braun and her onetime stepdaughter. Adele sat down in a chair next to Gertrude's.

"Why hello, Gertrude," Adele said with the false sincerity of a cop who just caught a thief red-handed. "You do remember me, don't you?"

"Why yes," Gertrude stumbled, "I guess I do remember you. You are Adele."

"You surely know that I married your father in Lakewood."

Gertrude hesitated. "I didn't know that."

Adele grinned. She had laid a trap for the girl, and now it was time to spring it. "Why, Gertrude, you attended the wedding."

Gertrude smiled awkwardly. "I guess I do remember it now," she stammered. "Of course, you are older and would remember things better than I would because I was so young."[99]

"But Gertrude, you were fourteen in 1914, not four," one of the reporters in the room remarked. The others laughed. Gertrude smirked. It was pretty clear to everyone that she stretched the truth when it suited her.

Adele noticed the reward poster on Gillespie's desk. "This isn't you?" Gertrude slowly shook her head. "Don't you remember that waist and that jewelry?" Adele jabbed her finger at the photograph of the girl.

"I don't think so," Gertrude replied with an air of stolid indifference. Adele leered at Gertrude, and the room fell silent.

"How did you first meet Braun?" Gillespie asked, his question ending the pregnant pause.

Adele thumbed through the sheaf of papers she brought until she came to a newspaper clipping. "I answered an 'ad' appearing the *New York Revue* under date of November 8, 1914, which read 'Widower 39, daughter 14. Educated. In good circumstances. Owns seven-room house, large garden. Seeks suitable lady or widow for marriage. Only well-meaning offers with full description of circumstances. Emil Braun, 73 Cherry st., Lakewood, N.J.'"

Braun, Adele explained, replied immediately, sending photographs of himself. He also asked if he and his daughter could visit her in New York. She consented, and on Friday, November 20, 1914, Emil and Gertrude Braun made the drive north from Lakewood. "They both came and Braun told me he was impressed favorably, as was his daughter. Gertrude took a liking to me and told me she liked me best of all who had answered the ad. Gertrude pinned a diamond studded watch on me. In the course of the conversation, Braun told me his money was very much tied up, owing to the European war and questioned me regarding my property affairs. I was favorably impressed with him."

Braun continued to impress Adele by sending her lavish gifts that ranged from expensive jewelry to livestock. "In the course of a week a large case came by express containing three diamond rings and a quantity of other jewelry, some fresh eggs and chickens, and also a beautiful silver mesh-bag and some silver spoons," Adele recalled. "I remarked to my brother that I didn't know what to make of it all. The box also contained a very endearing letter telling me that he was coming on the following Friday again. Both he and Gertrude came and he stayed at night at a hotel and Gertrude stayed with me. On the following day they went home together. The day after Thanksgiving Gertrude came to my home alone and Braun promised to come Sunday, which he did. The girl seemed very affectionate but kept close watch on everything I did." She smiled as she remembered how much she enjoyed Gertrude's attention at the time.

"He told me he came to this country with his wife and sister and daughter in 1913 and went to Lakewood. I know people who were personally acquainted with the wife and sister. The man who sold the real estate to him also saw his wife. Her name was Anita. He told me that she went to Germany to visit a sick sister and that the sister died of heart failure." On another occasion, Adele said, Braun told her "that he was on a five-year

furlough from Germany on account of the ill-health of his wife and that she had died in the meantime."

All eyes turned from Adele to Gertrude. At various times and to various people, Gertrude Schmidt told differing versions of what happened to her mother. Her story evolved from a tale about her mother dying of disease to one in which she simply disappeared. But each tale shared one common element: Anita Schmidt never left Germany. Adele placed Gertrude's mother in New Jersey. If she told the truth, then Gertrude had lied.

Adele then added yet another name to the list of missing women linked to Helmuth Schmidt:

> *When I first went to the house at Lakewood in company with Gertrude and Braun there was a young woman there who they said was Greta Braun, a sister of Braun.*[100] *She was a mild-eyed creature about 28 years old with brown hair, blue eyes, weighed about 120 pounds and was about five feet five inches tall. She showed us about the place and opened the poultry yards at Braun's request, but he never let us exchange a word. She looked at me in a sort of appealing way as if she would have like to have told me something. I have often thought of that look since. Braun afterwards told me she had gone away with her fiancé from Denmark.*

Just after introducing his sister, Adele said, Braun, Gertrude and the woman went back into the house, where they discussed something in private. Gertrude later told her that this second woman was Margareta Baersch, a housekeeper who had had an affair with Braun in Germany. Schmidt probably introduced her as his sister to avoid raising Adele's suspicion.

Shortly after this, Braun's sister vanished. "Gertrude had been visiting me in New York for a week or more and on Dec. 20 he wired for Gertrude to come home and for me to stay in New York. He made the excuse that his sister had left him suddenly and he wanted Gertrude to keep house for him."

On Christmas, Adele traveled south to Lakewood to visit Braun. Her future residence impressed her. "The house was about 25 minutes walk from the station and appeared to have been recently improved with a new 40-foot porch and a new kitchen. Under this kitchen was a deep well. Braun claimed the well was closed up with boards because the water was unfit to use." Gillespie wondered if "Greta Braun," who dropped out of sight just before Braun covered the well, never left the farm.

Gillespie stared at Gertrude and cocked his head as if to say, "Tell the truth." Gertrude shrugged and began with a third evolution about the fate

of Anita Schmidt. She smiled and spoke with a surprising nonchalance for someone just caught in a lie. Her father, she explained, came to America ahead of her and her mother.[101] A week later, Gertrude came over to America alongside Anita Schmidt and Margareta Baersch. Schmidt had had an affair, Gertrude believed, with the Baersch woman in Germany.

Shortly after the move to Lakewood, Anita Schmidt dropped out of sight while Gertrude was at school. "When I came home my mother was gone and father said she had left in the morning and wouldn't be back. I never saw her again." Helmuth Schmidt said that Anita had returned to Germany, but "he didn't have enough money to find out what became of mother," Gertrude said.

"The girl who came over with us was still there," Gertrude continued. "Margareta didn't have any money and she moved [from New York to Lakewood, New Jersey,] with us. Father told me to tell everybody she was my aunt and his sister so I always did as he told me. I always had to do what he said. He just gave me one look and I knew."[102]

A few months after Anita vanished, Baersch also dropped out of sight. "Greta disappeared in December, 1914 while I was in New York and before father married Adele Ullrich. He said he heard Greta fell in the street in New York and was hurt so badly she died. I never knew what became of her." Gillespie nodded as he listened. The timing was right. If Schmidt courted Adele Ullrich in December, he probably dumped Baersch to make way for his new love.

Adele smirked and turned to Gillespie. Back in Lakewood, she explained, Gertrude told neighbors that her father never married her, but she possessed the paperwork to prove it.[103] "I was married to Braun Dec. 30, 1914, and lived there until April 24 of the next year," Adele said. She handed Dondero a copy of her marriage license.

With all eyes watching her, Gertrude recognized the chance to insult her former stepmother. "Adele was queer and she made my father do the washings." She leered at Adele, who just smiled. She explained that they lived with Adele for four months when, one day, they packed up and left in Schmidt's Overland car. This time, Schmidt offered an explanation. "When we left Lakewood, he gave me to understand that he had divorced her. We had an automobile and he told me he was going to leave her." This statement exposed another lie. Gertrude had led investigators to believe that Adele Ullrich Braun vanished—a deception that delayed the spade work at 418 Glendale until Gillespie could ascertain the identity of the "Mrs. Braun" who sent the mysterious telegram.

From Lakewood, Gertrude said, they went to Philadelphia to pick up Schmidt's next wife. "I went with him in the machine to Philadelphia where we met Irma Pallatinus who my father told me was the new house-keeper. We lived there for a time and then father borrowed $100 to get us to Detroit."

Detroit must have felt like déjà vu to Gertrude because just seven months later, Irma Pallatinus disappeared under eerily familiar circumstances. "We arrived in Detroit and lived at 418 Glendale avenue. I went to school and clerked in a store. One day father came to the store and said that Irma had left us. I never heard anything more from her. In a short time my present step-mother came from New York and married him." Gertrude folded her hands in her lap and smirked in a way that made Adele cringe.

Adele felt attacked and was quick to defend herself. "I had really loved him at the start and went to his home fully resolved to make him the best wife I knew how and love his daughter like a mother," Adele said in a tone that suggested her irritation with Gertrude. "He told me to make the girl Gertrude little gifts from time to time and thereby win her over until she would love me. That was really one of the considerations of the marriage. Soon after the wedding though I was given to understand that Gertrude came first in my husband's home."

Adele characterized Gertrude as her father's eyes and ears. She couldn't do or say anything that didn't get back to Braun through Gertrude. "Gertrude was my jailor. She watched me like a cat watches a mouse and she hounded my every footstep. If I said or did anything of which she did not approve she soon told her father and he would upbraid me at the first opportunity. Braun would go in and sit on Gertrude's bed at night to receive his daily report of my every word and act. She and her father were on in everything. She possesses his characteristics to a marked degree."

Adele explained that Gertrude's room was off-limits to her, but she sneaked in on one occasion and found some jewelry. Gertrude interrupted. "You were always allowed to go into my room," she said, defending herself. "If you found any jewelry there it must have been put there by someone else. I didn't do it." One of the reporters in the room chuckled at Gertrude's explanation. Given the treasure-trove of jewelry found in Schmidt's Royal Oak home, this remark seemed like a feeble attempt to remove suspicion that she profited from her father's plots.

Adele, realizing that she had touched a nerve, pointed at Gertrude. "This girl Gertrude isn't the meek, innocent appearing young girl that she seems. I know her to be a girl of more unusual intelligence and fully as cunning and resourceful as her father. She was developed way beyond her years even at

15. She was crazy about fellows and even back when I knew her, and her father urged me to invite some of my nephews down to the house because Gertie hadn't been kissed since the wedding."

The reporters scratched Adele's every word in their notebooks. Pleased, Adele went on with her saga:

> *The girl Gertrude was utterly devoid of feeling. I recall once seeing her cruelly beating a dog with a stick while her father held the animal. I begged her to stop but she said the dog couldn't feel it. She seemed particularly heartless with dumb animals. At one time she was showing the pictures and discovered one which she tried to hide. I insisted upon seeing it and was severely rebuked by her father, who accused me of interfering with Gertrude's affairs. I told Gertrude there were strange things going on in that house and she immediately reported this remark to her father and it made him very angry with me. He said he would not tolerate any interference from me.*

Her suspicion piqued, Adele explained, she poked around and made an odd discovery in one of the closets. "In looking over the house I came on to a film of a store in Germany with the name of Helmuth Schmidt over the door. It was a jewelry store. I had seen the name Schmidt in books and the initials H.S. on silverware, so I asked him one day if that wasn't his name. He immediately flew into a rage and said: 'Gertrude, do you hear that? You and I are nameless. This woman says your name isn't Braun.' He often twitted me about the remark."

Adele paused for dramatic effect and then dropped the bomb: Braun, she said, worked as an enemy agent. After living with him for a few weeks, Adele believed that her husband worked as a secret operative who gathered information for the imperial German government. On one occasion, Adele said, "[Braun] wanted me to steal my brother's citizenship papers which he said he could use for his brother, who was in the German army." It appeared that Schmidt wanted to bring his brother to the United States under a false identity, but Adele refused to steal her brother's papers.

Braun, Adele added, often ventured out at night and took an unusual interest in the fortifications around New York Harbor, particularly Fort Hancock on Sandy Hook—a sand finger jutting out into New York Bay just twenty miles north of Lakewood. The artillery battery at the fort provided a powerful deterrent for German U-boats attempting to enter New York Harbor, and the adjacent Sandy Hook Proving Grounds was a vital testing site for new weapons. On one occasion, Schmidt even tried to gain access to the stronghold.

Entrance to the Sandy Hook Proving Grounds, where the army tested new weapons. According to Adele, "Emil Braun" tried to gain entrance to this facility. *George Grantham Bain Collection, Library of Congress.*

"He told me that before he left this country he wanted plans of all fortifications," Adele explained. "He often went out in the harbor [Sandy Hook fortifications] equipped with telescopes and binoculars of which he had some very good ones. He told me he would draw the plans on such light paper that he could swallow them if he was detected and then re-draw them from memory." According to Adele, he had written and received letters from Germany in an elaborate code.[104]

When Braun wasn't busy sketching fortifications, he spent his time convincing Adele to give him her life savings. Adele described Braun as a master manipulator who knew what buttons to push. "On our first trip to the bank for the $1,000 I got 'cold feet' and he accused me of being distrustful of him and reminded me that he trusted me with $300 worth of jewelry the first time he ever saw me." She gave him the money but decided not to give him any more, but Braun's powers of persuasion overcame her.

"I had made up my mind that under no circumstances would I draw another cent of my money out of the New York bank and I had refused once or twice. One day I seemed to come under the spell of his evil eye and I sat down and wrote out a check for $1,700 and gave it to him. I fully believe

A map of New York Harbor produced by the U.S. Coast Guard in 1910. According to Adele Ullrich Braun, Schmidt took an active interest in New York Harbor and sketched maps of the fortifications, particularly Sandy Hook. *Wikimedia Commons.*

I was hypnotized when I gave him the money. He had threatened to shoot me if I didn't give him this money and on another occasion he said he would kill himself and Gertrude." Adele sighed. "Before he got through he had everything I owned except $29.80."

It took three weeks for Braun to divest his wife of her nest egg. Once her money was in his pocket, Braun made Adele's life miserable. She once

The guns of Sandy Hook protected the harbor from naval assault. *George Grantham Bain Collection, Library of Congress.*

again described the harassment she endured during meal times, pushing her until she couldn't take anymore. "After he got all my money he tormented me until I was almost insane," she said. "I threatened to kill myself, so he placed two loaded revolvers in the top drawer of my dresser and one day when I fled to my room in desperation and took out one of those revolvers and fingered it, trying to summon up courage enough to shoot myself, Braun crept up a ladder on the outside of the house and peered into the room grinning like the human devil he was."

When Adele couldn't bring herself to pull the trigger, Braun hatched a plot to kill her. Adele described the "accident" that occurred just about a month after the couple wed:

> It was on January 30, 1915, that Braun took us out in the automobile. It was a cold, windy day and I didn't wish to go, but Braun insisted. He took along Gertrude and a neighbor girl to whom Braun had paid considerable attention. We traveled over some fearful roads, but the automobile made them all right. When we came to a perfectly level stretch, Braun suddenly swerved the wheel first to one side and then to the other, causing the automobile to give such a jerk that I was thrown down in a heap on the

floor and was rendered unconscious. Gertrude had her collar bone fractured. The others escaped unhurt. When I came to I found I had fractured my hip. I fully believe he thought he could break my neck. The others were probably warned of what was coming.

Apparently, Braun wanted to deflect suspicion away from the "accident." "For weeks I was laid up in bed but my husband refused to allow me to go to a hospital," Adele said. "For several days he wouldn't let me see a doctor but one finally came and prescribed for me, but Braun tore up the prescription and threw away the medicine, saying I didn't need it. I should have had a nurse, but he wouldn't get anyone to assist me."

Afraid that Braun might make another attempt on her life, Adele tried to slip the doctor a note, asking him to contact her brother in the event of her death. But, Adele said, her sleight of hand didn't make it past Braun's spy. "Gertrude, as usual, was right at my elbow while I talked to the doctor and ran to her father afterwards to tell him."[105] After Gertrude told him about Adele's note, Braun realized that he couldn't engineer another "accident" without raising a few eyebrows, so he devised a more subtle plan. He told Adele that he planned to move the family back to New York, where it would be easier for him to find a job.

Believing his fiction, Adele traveled with Gertrude to New York on April 17 to look for lodging. "In the course of the week Braun said he would send on the household furniture, all that he could pack in boxes," Adele recalled. "He told me not to open any of the cases. Gertrude and I stayed at my brother's home and several times I went to see why the goods didn't arrive. Gertrude didn't seem at all worried."

The week that Adele and Gertrude stayed in New York gave Braun enough time to plot his next move. He made plans to sell his farm and skip town with Adele's money in his pocket and his next correspondence bride, Irma Pallatinus, on his arm. Braun hid the affair with the young Philadelphian so well that Adele first learned about Irma Pallatinus in the newspaper coverage of the Steinbach case.

A week later, on April 23, Braun sent word for Gertrude and Adele to meet him at the train station. He had managed to find a buyer for the farm. Braun didn't want Adele to go with him to Freehold to seal the deal with the lawyer, but she went along anyway. To her shock and dismay, Braun told the lawyer that he was a widower and introduced Adele as his housekeeper.

"The next day," Adele said, "Braun and Gertrude drove to Freehold to dispose of the automobile, he said. He took Gertrude along to drive the car

because he was tired. He kissed me goodbye and for all I knew they were to come right back. I never saw him again until I came here today and viewed his body at Highland Park."

After Braun abandoned her, Adele immediately went to the Lakewood police and offered a reward of $100.[106] They printed and distributed wanted leaflets, but Braun, it appeared, had vanished. Adele didn't know that "Emil Braun" had ceased to exist in the fall of 1915. Mack Hunt had learned from interviewing neighbors on Glendale Avenue that shortly after relocating to Detroit, Braun had changed his name to "Adolph Ullrich," adopting Adele's maiden name to dodge her attempts at finding him.

Adele went on to detail her private investigation concerning the photographs that she found in Braun's trunk and her correspondence with authorities in Berlin, who sent her a copy of Helmuth Schmidt's arrest warrant. She reached into her handbag and removed a sheaf of papers written in German. She plucked out the wanted leaflet and handed it to Dondero, who read it aloud in English:

> *Berlin Municipal Police Headquarters, January 20, 1914—Wanted—Schmidt, Helmuth Emil Max, watchmaker and jeweler. Born July 4, 1876, in Rostock. Last seen in Neukolln. Bert. 1.70 m., medium size and height. Hair, eyebrows, and mustache brown. Eyes and teeth complete. Speaks Mecklinburg dialect. Arrest and hold. First Investigator, Court No. 2, Berlin, Germany.*[107]

According to the information from Berlin, Braun's real name was Helmuth Emil Max Schmidt—a jeweler wanted on fraud charges—which explained the initials "H.S." that she found on some of his things. Apparently, he took flight when authorities came to arrest him and not to evade a military draft, as Gertrude told Gillespie. One step ahead of authorities, Schmidt fled Germany with a streamer trunk full of jewelry from his shop that he later used to woo lonely women, such as Augusta Steinbach, into his trap of seduction, theft and fraud.

By the time Adele received the letter from Berlin, she had heard the rumors about Braun's missing wife, so she whipped off another letter to German authorities, requesting information about the death of Anita Braun or Anita Schmidt.

Within days, she received another alarming note, this time from the first prosecutor of Berlin's Royal Land Court No. 2. After an exhaustive search through mortuary records, they failed to find any trace of the woman.

Gertrude's mother apparently did not go back to Germany. It now appeared likely that she never left Schmidt's chicken farm.

Although Schmidt was a wanted man in Germany, Adele still believed that he was a spy. While it would appear unlikely that he was on the payroll of the same government that held an outstanding arrest warrant for him, a lot had happened since Schmidt ran away from Berlin authorities. The war began, and the German government had use for loyal Germans inside the United States.

It was even more likely, Adele believed, that Schmidt gathered information and passed it along to contacts in an underground network of immigrants who colluded with imperial German diplomats. She also believed that the other two women associated with her husband may have been part of Schmidt's underground espionage network.

One way or the other, Gillespie reasoned, Schmidt's alleged espionage came to an abrupt end in his Highland Park jail cell. Any further investigation along that line would go to the Justice Department. The prosecutor's primary concern was to answer the questions Schmidt left with his partial confession. He dipped a fountain pen in the inkwell on his blotter and scratched out a rough timeline of Schmidt's known movements:

> *Dec., 1914: Anita Schmidt disappears*
> *Dec. 13–19, 1914: Margareta Baersch disappears*
> *Dec. 30, 1914: as "Emil Braun," marries Adele Ullrich*
> *April 24, 1915: abandons Adele; moves to Detroit with Irma Pallatinus and changes his name to "Adolph Ullrich"*
> *Sept., 1915: as "Herman Scharno," begins correspondence relationship with Helen Tietz*
> *Dec. 20, 1915: Irma Pallatinus disappears sometime before this date*
> *Dec. 22, 1915: as Helmuth Schmidt, marries Helen Tietz*
> *Feb. 9, 1917: as "Herman Neugebauer," meets Augusta Steinbach*
> *Mar. 11, 1917: Augusta Steinbach disappears*

Gillespie shook his head and looked at the skeleton outline. The confrontation he just witnessed raised a troubling question: what had happened to Anita Schmidt and Margareta Baersch? Perhaps investigators would find the answer concealed somewhere on the Lakewood chicken farm. The prosecutor immediately sent a wire to Ocean County prosecutor Richard C. Plummer requesting a search of the place. Adele's statement suggested one promising spot: the old well that Braun covered at about the

time the housekeeper disappeared. Gertrude also agreed to sketch a map of spots where she noticed her father had buried things.

Another question involved Gertrude's possible complicity in the Augusta Steinbach case. At first, Gertrude appeared to be an innocent teenager dragged into the seedy affair by her father, but then Adele Ullrich Braun walked into Gillespie's office. Her story made Gertrude look like an accomplice in her father's scheming—a spy's spy—but Gillespie wondered if her depiction of Gertrude was more of a character assassination than a pattern he could apply to the Steinbach case. Besides, Schmidt appeared to be a master manipulator; his every wish became his daughter's command. She did whatever he said, without question, including repeating his fictions about Anita and the Baersch woman. He trained her so well that Gertrude continued to fib during various interviews with the authorities.

Still, Adele's statements raised suspicion about Gertrude's role—if any—in her father's entrapment of Augusta Steinbach. Perhaps if detectives could convince her to leave her hotel room, Agnes Domaniecki would provide some insight.

Reporters who eavesdropped on the confrontation between Gertrude Schmidt and Adele Ullrich Braun scrambled from the prosecutor's office, and within hours of hearing Adele describe Braun's allegations of espionage, they had filed their stories. Schmidt wasn't just a Bluebeard anymore; headlines across the nation transformed him into an international superspy.

The *New York Times* ran a front-page story under the headline, "Says Slayer Was A Spy." The correspondent reported, "The Code of the Prussian spy, not fear of the consequences of Augusta Steinbach's death, drove Helmuth Schmidt to commit suicide…according to Mrs. Emil Braun."[108]

Adele's allegations set the rumor mill churning in Pontiac. People began to question Sheriff O.H.P. Green's suicide. They wondered if the spy shot the sheriff to stop the investigation. A *Detroit News* correspondent noted that what was once a laughable scenario, that "a slayer had crept into the room, fired the fatal shot and made his escape after changing the empty shell from his gun to that of the sheriff's," now appeared a more likely conclusion given Schmidt's new status as a superspy.[109]

An item in the *Detroit News* noted, "The actions of Sheriff Green shortly before he took his own life or was slain by Schmidt are being studied by the present authorities of Oakland County for possible further light on the Schmidt case."[110]

The new information about Anita Schmidt and the mysterious Margareta Baersch also led to headlines that indicted Schmidt for multiple murders.

Number 418 Glendale Avenue, Detroit, as it appeared in April 1918. *Sketch by R.P. Buhk.*

The front-page headline of the *Detroit Times'* four o'clock edition, in a massive font that consumed one-third of the entire page, declared what everyone now accepted as fact: "SCHMIDT SLEW FIVE WOMEN, IS BELIEF."[111]

While Adele Ullrich Braun confronted Gertrude in Gillespie's office, municipal workers continued to spade up Schmidt's Glendale Avenue property under the watchful eyes of Detectives Reid and Dibble.

Grace De Planta's statement provided a hot lead. Her husband had spotted a wheelbarrow of sand near the basement steps, and Gertrude told of her father removing a root cellar, although she didn't remember exactly where in the basement the original walls had been.

Since the cellar floor appeared undisturbed, investigators theorized that Schmidt may have removed some of the foundation blocks and buried something in a cavity outside the wall. This would explain the wheelbarrow of dirt Frederick De Planta spotted in the basement. So, they unearthed the entire foundation along the east side, creating a gigantic trench and a massive pile of sand. But they found nothing. While the kids of Glendale Avenue played in a gigantic sandbox created by the excavators, the work crew turned the garden upside down, but again, their efforts yielded nothing.

As the workers searched for traces of the missing woman at Schmidt's Detroit property, Pallatinus's sister, Minna Rederer, searched for traces of

her sister at his Royal Oak bungalow. She wandered through the house looking for some of Irma's belongings. "Ach mein lieber," she whispered, as she spotted one of her sister's dresses.

THE CHUM

Pontiac, Michigan
Friday evening, April 26, 1918

By late afternoon, Agnes had finally come out of her room and traveled to Pontiac, where she gave a detailed statement to Prosecutor Gillespie.

As Agnes walked into Gillespie's office, he handed her the postcard sent to Hetherington. Agnes carefully examined it. Although she wasn't sure about the handwriting of the text, she was certain that the signature was Augusta's. Apparently, Schmidt, posing as Neugebauer, asked Augusta to write out the card so her mail would go to his good friend Schmidt after the nuptials. The gullible woman with dreams of marital bliss wouldn't have thought twice about the request.

While Augusta had apparently inked the postcard, Helen Schmidt had written the letter asking Mina Hofbauer to mail it from New York. Either Schmidt had tricked his wife into abetting his scheme, or she did it with full knowledge of his intentions. Perhaps Agnes would be able to provide some clues about Helen's true culpability.

Agnes began by describing her best friend. "Augusta was always looking out for me. She was such a kind, generous-hearted girl. If there was anything she had which I wanted or which she believed would look well on me she always wanted me to take it. Whenever I went out evenings she would always warn me to be careful because she was afraid some harm would befall me."

Agnes smiled. "Even when we were in Paris she told me I should be more careful about going out nights because I couldn't speak French. I used to laugh at her and tell her that no one would molest me." Augusta, she said, spent most of her adult life taking care of other people's homes and desperately longed for one of her own, which made her a prime target for Schmidt's purple prose. "She was a great lover of the home and was content to remain there when others were going to the theaters or to dances," Agnes explained. "She often told me she found her comfort in the home. She wanted a husband and a family and a home of her own

and it was this feeling which led up to her answering Neugebauer's ad in the paper."[112]

Neugebauer's prose enchanted Augusta, but Agnes wasn't fooled. She begged Augusta to stay in New York, but Augusta didn't listen. Tears formed at the corners of Agnes's eyes as she recalled the morning of February 3, 1917, when she took Augusta to the train station. "I hated to have Augusta go so far away to live, but she comforted me by saying that she could come back if everything wasn't all right. Even in the train when she was leaving I cried on her shoulder and begged her not to go. She and I had been such good friends I hated to be separated from her."[113]

"Das heiraten teufel," Agnes moaned. "She married the devil."

Then, when Augusta arrived in the Motor City, things seemed to be all right:

> *When I got all her happy letters she wrote from her boarding house with the Hetheringtons at 45 Adelaide Street, I felt better. She told me how Mr. Schmidt had taken her out to a pretty bungalow in Royal Oak where they were going to live after getting married, and how she had met his two "fine sisters." She said one was a widow, and the youngest one, whose name she said was Gertrude, was so sweet and a fine musician. In one letter she wrote: "Now as I write his sisters are fixing a fine dinner. His oldest sister is a good housekeeper. They are planning a big wedding for me and I do not like it because I want a quiet one. They are going to fix the house up before we get married, because they want it all in good order for me. His big sister thinks I look pale, and she wants me to take a good rest."[114]*

Gillespie leaned forward in his chair. Agnes made a similar comment a few months earlier in New York, but with Neugebauer now unmasked, the "sisters" assumed a new, more sinister significance. If Augusta Steinbach met Neugebauer's sisters, there was only one logical explanation: the "sisters" must have been Helen and Gertrude Schmidt, which meant that Schmidt used them to trick her. This contradicted Helen's previous statements—she had steadfastly denied ever meeting Augusta Steinbach—and hinted at her possible complicity in the murder.

But Agnes had discarded the letters, so she was going from memory. And as Gillespie knew from countless hours of examining and cross-examining witnesses, memories often become distorted. As far as evidence, it amounted to uncorroborated hearsay.

Agnes continued. "Then Augusta wrote about the fine furniture, piano, sewing machine, etc. in the house. She said he had lots of fine jewelry and silver which his mother left when she died in Pommen, Germany, and he was

going to give it all to her. She kept on writing to me until the 10th of March. Just before then she wrote and asked for her linens and her trunks to be sent to Royal Oak and I shipped them by express to her."[115]

Augusta wrote one final letter, dated March 10, 1917. Augusta, Agnes recalled, said that "between the 10th and the 17th of March she was going with Neugebauer to his brother-in-law's home to be married by a priest friend of theirs. She didn't say where this friend lived, but asked me not to write for four weeks as she would be away that long on a wedding trip. Her handwriting in that letter and the last few I got from her looked so scrawly and funny not at all like the careful way she used to write."[116] Gillespie wished Agnes had kept at least one of these letters for the sharp eye of Francis Courtney.

"That was the last I heard from my dear, best friend. All of my other letters addressed to 45 Adelaide Street were returned to me. She was a good, clean, honest girl, and it is terrible to think she met such a frightful end. I was coming out to visit her. Maybe he would have done away with me, too."

When her letters came back stamped "return to sender," Agnes became worried and started making inquiries. "A married woman friend of mine whom I asked for advice when I didn't hear from Augusta, wrote to a relative of hers, who worked in Detroit, and asked him to look her up." A few weeks later, Agnes received word from Detroit. "She wrote back that he found out that up to May 5, Augusta was keeping company with Schmidt. I don't know where he found this out."[117]

By this point, Agnes knew that something was wrong. "I had a presentiment that all was not right from the first and it grew on me until I used to lay awake nights and dream the awfullest things about Augusta and Neugebauer. I remember one night that I dreamed I saw a big savage man standing over Augusta and he was hacking away at her with a big sword."[118] As investigators had discovered a few days earlier at 9 Oakdale, though, it wasn't a sword—it was a meat cleaver.

THE FIFTH WIFE

Pontiac, Michigan
Friday evening, April 26, 1918

By Friday afternoon, investigators had discovered the identities of the four women Schmidt had allegedly married (formally): Anita Schmidt, Adele

Ullrich Braun, Irma Pallatinus and Helen Schmidt. On Friday evening, they discovered a possible fifth.

Detroit chief of police Remember Kent received a telegram from New York attorney Marion Gold Lewis, who saw Schmidt's photograph in a news item about the case. Kent brought the telegram to Glenn Gillespie in Pontiac. Gillespie just shook his head as he read the note.

"I have been trying for many months to locate a man known in New York as John Switt who married a client of mine," Lewis wrote, "and after staying with her three days took $1,400 and departed to purchase, as he said, railroad tickets for Detroit, Michigan. This was in December, 1914, and since which 17 day of December she has been looking for him. He said he was a machinist and had great prospects in Detroit."[119]

According to Lewis, Switt's things contained a clue that at first went unnoticed but later hinted at an alias. "He left his trunk with napkins, tablecloths, etc., in a furnisher room, but the initials on the napkins, etc., were not J.S. Of course, after his desertion my client knew she had been tricked." Gillespie thought of Adele, who found items marked "H.S." among her husband's things. Did the "H.S." initials also appear on "John Switt's" napkins? He continued reading.

"I write now to ascertain if this could have been the same man known to your people as 'Helmuth Schmidt,' alias Neugebauer, alias George Rolof, alias Brown. The man I am after claimed he came from Bohemia, and was the son of Joseph and Maria Haids and was about 40 years old, quite tall, fair hair with dark eyes, and slender."[120]

Gillespie set the telegram on his desk and fingered through a pile of papers until he found the county's record of Schmidt's marriage to Helen Tietz. The record listed the groom's father's name as "Julius" and his mother's name as "Marie Benzin."[121] The names were not identical to the parents of "John Switt," but they were close—not beyond the possibility of a clerk's error or a mistranslation. Of course, Schmidt may have lied about their names in the first place if Switt *was* Schmidt.

The prosecutor smiled as he recognized the irony in the next line of Lewis's telegram: "I wrote to the Ford Motor Works asking if they had the man in their employ but they could give me no information." Schmidt was known as "Ullrich" at the Ford plant, and it was not until Jonathan Welch linked "Adolph Ullrich" to his neighbor in 1917 that anyone knew that Ullrich and Schmidt were one and the same. Schmidt's work alias proved to be a dead end to anyone looking for a "Switt."

Lewis continued: "If my description in any way tallies with the man who was known as Schmidt, I could get my client to start west at once, or if you

had a photograph likeness of him, I wish you would send it to me, as we are trying to have some trace of whether our man is alive or not."[122]

The letter's description only partly fit Schmidt. The Highland Park cops described him as thirty-eight years old and five-foot-seven, with a swarthy complexion and dark hair. John Switt, according to Lewis's letter, had "fair hair." But the Lakewood "wanted" leaflet noted that Schmidt was likely to dye his hair, and Schmidt did leave New Jersey and take a machinist job in Detroit. New York was a short trip due north from Lakewood. Did Emil Braun travel to the Big Apple for a weekend tryst and come away with the life savings of a woman named Anna Hocke?

Gillespie looked at the timeline he made and inked in two new dates.

Dec. 13–19, 1914: Margareta Baersch disappears
Dec. 14, 1914: as "John Switt," marries Anna Hocke in New York
Dec. 17, 1914: abandons Anna Hocke Switt
Dec. 30, 1914: as "Emil Braun," Schmidt marries Adele Ullrich
April 24, 1915: abandons Adele; moves to Detroit with Irma Pallatinus and changes his name to "Adolph Ullrich"
Sept., 1915: as "Herman Scharno," begins correspondence relationship with Helen Tietz
Dec. 20, 1915: Irma Pallatinus disappears sometime before this date
Dec. 22, 1915: as Helmuth Schmidt, marries Helen Tietz
Feb. 9, 1917: as "Herman Neugebauer," meets Augusta Steinbach
Mar. 11, 1917: Augusta Steinbach disappears

Investigators believed that Schmidt had constantly run matrimonial advertisements through German-language newspapers for years before his capture. It looked like they were right. Since the story broke, national newspapers had been running front-page stories containing a head-and-shoulders photograph of Helmuth Schmidt, and each day, it seemed, led to new revelations about the Royal Oak Bluebeard.

Gillespie immediately sent a photograph to Lewis. As he licked the envelope, he thought about the six golden lockets found in Schmidt's Royal Oak "murder plant" and the cop's remark about a fishing lure.

THE TREASURE HOUSE

Royal Oak, Michigan
Saturday morning, April 27, 1918

On Saturday morning, there was a flurry of activity at 9 Oakdale in Royal Oak. Glenn Gillespie had asked Agnes Domaniecki to tour the treasure-trove and identify articles that belonged to Augusta Steinbach. At first, she didn't want to go, but eventually she agreed. She knew that investigators would never find the rest of Augusta's body, but perhaps somewhere in the house she would find Augusta in spirit, which would help her say goodbye.

She trembled as she climbed the porch steps. Gillespie held out his arm, and she grasped on to it as she made her way across the threshold and into the front room, all the time imagining Augusta—poor, dumb Augusta—waltzing through the front door with the deluded belief that marriage with Herman Neugebauer waited on the other side.

Inside the bungalow, she stopped shaking and unhooked herself from Gillespie's arm, steeling herself for the discoveries she knew she would make inside. She patted him on the forearm as if to say thank-you. She was ready. Gillespie wondered, as he noticed tears forming at the edges of Agnes's eyes, if the woman's nerves would hold as she went through "das teufel's" lair. Then again, he thought as he watched her examine some jewelry, Agnes had done more than anyone else to bring down Michigan's Bluebeard. If there were any trace of Augusta, she would find it. The domestic immediately found bits and pieces from Augusta's trousseau.

Each new discovery came with a gasp and then a whimper as Agnes choked back the tears and uttered an occasional "Das heiraten teufel." But she kept looking, eventually identifying several items of jewelry that belonged to her chum: a gold watch, a golden locket and chain and a diamond ring. She also found several pieces of clothing that Augusta brought from New York, including a black fox wrap. Looking through Gertrude's closet, Agnes spotted a fancy pink bathrobe that she herself wore on occasion. In Helen's closet, she found Augusta's blue silk gown.

Trailing behind Agnes, Gillespie collected each item identified as property of Augusta Steinbach and gently laid it on the kitchen table. By the time Agnes finished sweeping the bedrooms, the table was covered with things Schmidt lifted from Augusta's trunks.

Agnes wanted to see one last thing before she left: the furnace where Schmidt cremated Augusta's remains. She wanted to say goodbye. She

started trembling again when Gillespie led her down the steep flight of steps into the cellar to a dark corner where the furnace stood. Tears streamed down her cheeks as she peered inside the inky blackness. "Das heiraten teufel," she whispered in a barely audible tone and then raced back up the stairs and out the front door. Within the hour, Agnes Domaniecki was on an eastbound train.

Adele Ullrich Braun was the next to go through the house. Unlike Agnes, Gillespie didn't have to twist Adele's arm. This was the next step in reclaiming the valuables Schmidt pilfered from her. She grew angrier with each new discovery. A gasp followed each time she recognized a piece of her jewelry: the diamond-studded gold watch that Gertrude gave her as a gift in New York, a necklace of amber beads and several pairs of gold earrings and finger rings. She uttered "Mein gott" when she noticed her two gold lockets. Schmidt didn't even have the decency to remove the pictures inside. On a bureau in Gertrude's room, she found her silver wristwatch. In all, she identified sixty-two different pieces of jewelry as hers.[123]

Fuming, Adele demanded Gertrude's arrest as an accomplice in her father's schemes. She reminded Gillespie that Schmidt, with sweet little Gertrude in tow, left her destitute when he abandoned her. She also noted that on the wanted poster produced by the Lakewood police, Gertrude's picture appears next to Schmidt's as a fugitive from the law. True, Gillespie acquiesced, but this was not Ocean County, New Jersey. It was Oakland County, Michigan. If Lakewood police wanted Gertrude, they would have to pursue her through their legal system. Gillespie refused to take Gertrude into custody. He just didn't believe that she was anything other than one of her father's dupes.

Adele, meanwhile, had done so much talking that she started to worry that she might have said something incriminating. Acutely aware of the political situation, Adele spoke with a reporter from the *Detroit Free Press*. Schmidt, she had told Gillespie, wanted her to lift her brother's citizenship papers so he could give them to his brother, a German soldier, to escape the war and come to America. Now it appeared that Schmidt wanted the identity papers so he could masquerade as a naturalized citizen, but Adele did not want there to be any question about her loyalties.

"She was anxious," wrote *Free Press* reporter John T. Wallace, "that it might be made plain that she and all her brothers and sisters, save one, were children when their parents came to America, that her father was naturalized while they were yet minors, and that all of them are therefore citizens of the United States."[124]

While municipal workers turned over the earth at 418 Glendale Avenue in Detroit and relatives unearthed clues about their loved ones in the Bluebeard's bungalow, a parallel dig began on Schmidt's former chicken farm in Lakewood New Jersey.

Prosecutor Plummer decided not to wait for Gertrude's map to arrive in the mail. He traveled to Lakewood to study the farm for places that could hold hidden graves. A cursory examination revealed a few possible spots. Schmidt had cemented over the basement, and a depressed portion of the barn's dirt floor—about fifteen square feet—suggested that he might have buried something there. Plummer found the most promising spot under the floorboards of the kitchen, where Adele said Schmidt had concealed an old well: the perfect hiding spot for something.

At the crack of dawn on Saturday, April 27, Constable William Mason, acting under Plummer's orders, showed up with a work crew to begin excavations. A crowd of curious onlookers gathered to watch. "While Ocean County is accustomed to fox hunts and paper chases," a *New York Sun* reporter noted, the people seldom have "the opportunity of witnessing a real skeleton hunt."

The reporter captured the mood as the diggers dragged the well with grappling hooks. When one of the laborers appeared to have hooked something, "the spectators surged forward spasmodically while the searchers leaned tensely over the well. Then the man who wielded the grappling hooks gave a little slack to his rope and jerked quickly. The clanking sound that came forth made it perfectly obvious to every one within hearing distance that if the hook had caught on to a skeleton it must have belonged to someone with an iron constitution."[125]

For six hours, the workers dragged the well but came up empty-handed. They then dismantled a small shed that Schmidt used as an icehouse and dug down about four feet beneath it, but they didn't find any skeletons there, either. At about four o'clock, they stopped work for the afternoon.

THE ENIGMATIC GERTRUDE SCHMIDT

Saturday afternoon, April 27, 1918

The *Royal Oak Tribune* described her as "18 years of age with large, brown eyes, and an open countenance. Her hair hung loose down her back. Her

features are rather coarse except for her mouth which is of a delicate mould. Her hands and the frame of her body are large. She appeared unsophisticated and simple."[126] But Gertrude Anna Maria Schmidt was anything but simple.

Adele Ullrich Braun's sordid tale of love and betrayal made investigators eye Gertrude with greater suspicion than before. Even press reporters, who just a few days earlier had depicted the coy teenager as another of her father's victims, began to question Gertrude's culpability in Schmidt's entrapment of lonely women. Some described her as a manipulative accomplice and a compulsive liar.

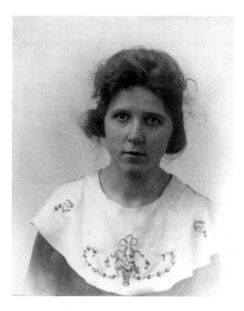

Photograph of Gertrude from a passport application she submitted in 1920. *National Archives and Records Administration, image by Photo Response.*

Carol Bird, the *Detroit Free Press* reporter who compared Gertrude to an innocent child in an earlier article, now described Gertrude as a "shrewd" and "sagacious" character who used sex appeal to handcuff the hardened cops questioning her.

"Sex lure is a powerful and useful weapon in the hands of a woman if she uses it with just the proper amount of delicacy and restraint," Bird wrote in her profile of the "Bluebeard's" daughter. "[Gertrude] is an expert in the use of it. With its subtle aid this wise maiden is baffling legal inquisitors by her nonchalant manner, her guarded replies to all questions they put to her, and by her general poise and bearing."[127]

Bird, one of the reporters who grilled the suspects along with the investigators, studied her subject with the eye of a psychologist. Gertrude "understands well that she is exercising her woman's prerogative to smile and pout, weep a bit, and 'baby stare.' Her eyes are large and of the deep, lustrous melting brown which so many southern women possess."[128]

In her profile of the puzzling teenager, Bird described an instance when a reporter's question hit a nerve with Gertrude. The reporter asked her why she lied so much. "Why do I lie all the time? That's none of your business what I do," she snapped, and then turned to Lieutenant John Reid of the

Detroit Homicide Squad. Appalled but curious, Bird watched as Gertrude "ran one small finger up and down the buttons of his vest, whimpered a bit, and then with her great soulful brown eyes on his face, she begged piteously 'Take me out of here, please. They tire me with questions. I have told all I know. I will talk to you alone, in one of the other offices, but I don't want to stay here and be puzzled any more.'"[129]

Gertrude apparently felt comfortable talking to Cross and Gillespie, although Bird hinted that her answers were evasive and even disingenuous. "'Yes,' she says, amiably, 'I'll try and remember that date. Let me see, what was it? No, I don't exactly remember. I'm sorry.'" Bird ended her profile with a line that captured how many felt about the enigmatic teenager: "Hers is the picture of tears, and smiles, and ingenuous girl mannerisms."[130]

A writer for *Pontiac Press Gazette* who witnessed the confrontation between Gertrude and Adele Ullrich Braun in Gillespie's office described Gertrude as "a clever framer of words. When asked why she had told so many conflicting stories about her mother, she said 'Oh, I was only talking to you newspapermen and I didn't think it necessary that I tell you everything. I told the prosecutor the real truth.'"[131]

Other reporters depicted Gertrude as an unwitting accomplice caught up in her father's web of lies and deception. An article in the *Detroit News* seized on the anti-German sentiment of the time and characterized her as a "Victim of Her Father's Prussianism." Schmidt, according to correspondent Buda Stephens, belonged to the "soul-destroying school of Prussian militarism" that "lured women with matrimonial advertisements to gratify his insane ambitions for power, money, and jewels."

Gertrude, Stephens explained, became just another one of Schmidt's victims and couldn't help the occasional fib because her father taught her to do it. "[T]aught by her father to spy on her various stepmothers and cover her father's ruthless tactics with lies, [she] stands alone to speak for the dead man and face shadows with pointing fingers of accusation from the past. Is it any wonder that the young girl tangles her stories?" Stephens went on to blame Schmidt's victims: "The women in the case are typical of the meek hausfrau willing to sacrifice body and soul for the materialistic or they would not have fallen into the traps of the autocratic Schmidt."[132]

Just how many "hausfrau" had become ensnared in the malignant Prussian's net remained a mystery, and Detroit cops believed that Gertrude Schmidt was the key to solving it.

THE BLUEBEARD'S BODY

Detroit, Michigan
Saturday evening, April 27, 1918

Although he was dead, the ladies in Schmidt's life still wanted his body, literally. In a morbid twist, the corpse became a bone of contention between Adele and Gertrude, each of whom felt that she had the right to Schmidt's remains.

The pending struggle had more to do with Schmidt's five-figure fortune than sentimentality. Adele was confident that as his first living legal spouse, she had a legal right to Schmidt's remains and thus, his bank accounts. "God knows I don't care anything about it [Schmidt's remains] if it isn't necessary," she told reporters. "I just want to establish my interest in his estate and get what rightfully belongs to me."[133] Adele added that she had no interest in attending Schmidt's funeral. Gertrude, as Schmidt's only surviving heir, felt that she had an equally strong claim.

In the meantime, Highland Park justice of the peace John Austin ordered the body held at the undertaking establishment of Alfred E. Crosby pending an inquest, which was standard procedure for any jailhouse death. Since there was never any doubt about the cause and manner of Schmidt's demise, the inquest was a formality. According to criminal procedures of the time, Justice Austin needed six competent people to view the body. Austin had no problem rounding up the required number of eyewitnesses who, one by one, shuffled past the body, which they identified as Helmuth Schmidt. Dr. Kenneth Dick proclaimed that Schmidt died from "compression of the skull." With the procedure complete, the body would remain at Crosby's until a legal claimant arranged for a burial.[134] The undertaker hoped that it wouldn't take too long.

That night, Michiganders attended a citywide funeral of a different sort: the demise of John Barleycorn. As the terminal date of Michigan's alcohol prohibition laws approached, people flocked to the taverns for one last public round. Saloon owners expected the "funeral dirge" to begin early and go all weekend as the taps would run dry at midnight on Tuesday, May 1.

Across the state, more than three thousand watering holes prepared to pass out of existence after the weekend binge, almost half of them in Wayne County. As expected, patrons crammed Detroit's tonier establishments. Dozens of unescorted women flocked to the "peacock alley" at the Pontchartrain, drowning their loneliness in long-stemmed flutes that would soon be replaced by water glasses. A *Detroit News* reporter who eavesdropped on their conversation overheard a comment that

Saloon patrons enjoy one last drink before wartime prohibition dried out New York City in 1919. Scenes like this took place all over the United States during World War I. Detroit had gone dry one year earlier, becoming the first major city to undergo the "noble experiment." *Library of Congress.*

captured the gloomy mood of the evening. "'But what's the difference, the boys are just about all gone,' said a pair of red lips which contrasted with the blue of a French cape.'"[135]

To the shock of those who expected a bacchanalian sendoff to John Barleycorn, the city's saloons passed a quiet evening, with only a handful of regular customers enjoying the last legal pull on the tap.

"There was no need for a downtown debauch on the last holiday evening," wrote a *Detroit News* reporter, because people all over the state had begun hoarding barrels of beer and bottles of booze.[136] The hoarding became so intense that liquor suppliers couldn't keep up with the demand. They gave priority to orders from individuals over the atrophying saloons, and as a result, many of the taverns dried up well in advance of the May 1 deadline. When liquor was available, some tavern owners didn't want to invest their money in the soon-to-be-illegal commodity, choosing instead to close their doors.

Without a Trace

Lakewood, New Jersey
Sunday, April 28, 1918

On Sunday morning, the excavations resumed in Lakewood. An expert well digger rappelled his way down the dark shaft of the well. After hours of sifting through the muck, he found no trace of the missing women.

By the time William Mason's men pulled the mud-caked man from the well, Plummer had Gertrude's map in hand. One of the spots Gertrude marked was the area under the barn where Plummer noticed a change in ground level. The searchers immediately began to unearth the patch. Just under the surface, they found a layer of quicklime—an ominous sign. The chemical was used to mask the foul odor or rotting matter. Under the quicklime, however, they found bits and pieces of trash, indicating that Schmidt had used the floor of his barn for waste disposal.

The workers toiled late into the afternoon, but despite an exhaustive search, the New Jersey property proved to be a dead end. The two women remained missing, found only in newspaper articles about the dig. A *New York Times* correspondent, quick to pick up on the espionage theme first introduced by Adele Braun, subtitled his article "Officials Fail to Find Any Evidence of Murders by Lakewood Spy."

"Helmuth Schmidt is thought to be a German spy and is believed to have killed his first wife, Anita, and Greta Darsch, a German girl, who lived with them," the reporter noted. "The police think he feared the women would divulge his spy connections."[137]

Back in Detroit, the Sunday edition of the *Free Press* featured a front-page story entitled "Schmidt's Kin Sent for Mail of Slain Girl."[138] The article summarized the weekend's developments in the case, citing several key sources, including Lena Welch and T.H. Hetherington. Welch "emphatically" insisted that she watched Augusta Steinbach walk arm in arm with Schmidt into the Royal Oak house a week before her disappearance, and she also believed that the Schmidt women were home at the time. The article then offered corroboration by citing Agnes Domaniecki, who recalled letters in which Augusta described the sisters she met in Royal Oak.

The *Free Press* correspondent quoted Hetherington, who stated unequivocally that Augusta Steinbach visited Neugebauer's Royal Oak home on Sunday, March 4, 1917, the week before she disappeared. And, Hetherington added, when Augusta returned from Royal Oak, she talked

about meeting Herman's "sisters." Augusta, he said, liked the younger sister but said she didn't care much for the older one.

Undersheriff Harry Cryderman, like most officers involved in the case, followed the news carefully. His mouth dropped open when he spotted the bit quoting Thomas Hetherington. Hetherington's alleged remarks amounted to a startling revelation; until now, the landlord had said nothing of this March 4 visit or Augusta's description of Neugebauer's sisters.[139]

Cryderman immediately recognized the significance of this new information. Hetherington was the third person to assert that Augusta mentioned these mysterious sisters. Individually, the statements amounted to little more than hearsay. But taken together, they added up to one logical conclusion: both Gertrude and Helen met Augusta Steinbach at least once, despite their repeated denials. And it appeared that they masqueraded as Neugebauer's sisters when Augusta Steinbach came to visit. Gertrude must have known, or at least suspected, what her father was up to. After all, Schmidt had pulled this same con in New Jersey. Adele Ullrich Braun said that she met "Greta Braun," who was in all likelihood Margareta Baersch, and Gertrude herself said that Schmidt told her to always refer to the housekeeper as her aunt. Schmidt, posing as Herman Scharno, also introduced Gertrude as his sister-in-law when he courted Helen, according to Helen's sister, Mina.[140]

That evening, Cryderman phoned Gillespie. Exasperated, the undersheriff wanted to drag Gertrude and Helen back to Pontiac for another interrogation, but after reading the story, Gillespie decided to wait. This new information, if true, provided important corroboration for Lena Welch's statement. But during two different interviews, including one in his office on Friday, Hetherington failed to mention this vital piece of information, causing the prosecutor to wonder about the landlord's memory or the accuracy of the report (or both).

In any event, Gillespie now believed that Gertrude knew more than she was saying, but as far as evidence of complicity in a crime, he didn't have enough. Welch didn't see the Schmidt women with Steinbach; Domaniecki and now Hetherington repeated things they supposedly heard more than a year earlier without anything backing their claims. Besides, the evidence indicated that Schmidt murdered Steinbach on March 11, so Gertrude and Helen—if they played along as "sisters"—only helped in the concealment of a confidence game, not murder, and Michigan legal statutes insulated spouses and children from helping with the concealment of misdeeds.[141] To successfully prosecute Gertrude, Gillespie needed proof that she actively, willingly took part in her father's crimes. Hearsay alone wouldn't do it.

Last Rites

Detroit, Michigan
Monday, April 29, 1918

Once Gillespie explained to Adele that her rights to Schmidt's estate had nothing to do with his remains, she no longer wanted his body. She gave the nod to Gertrude, who made funeral arrangements. On the day of the burial, Adele visited Crosby's for one last glimpse at the man she knew as Emil Braun.

"He looks as though he had suffered greatly," she remarked to Crosby, with a hint of sadness in her voice. It was an unexpected turn in emotion. She expected to feel utter revulsion at this second examination of her former husband's corpse. But instead of disgust, she felt a deep sense of pity as she leaned toward the body and studied the deep creases that time had grooved into Schmidt's face. It had been three years, but "Emil" looked like he had aged ten. "When I first knew him there were not so many lines about his face. He was a fine looking man."[142]

Undertaker Crosby looked at his pocket watch. Gertrude Schmidt was two hours overdue to pick up the body. Crosby couldn't wait. Embalming and ice could only do so much to keep the stench of death away, and the "Bluebeard" was getting riper by the hour. Tired of waiting, he grabbed the telephone. It was a brief conversation.

"I can't come," Gertrude said.

"Why can't you come to your father's funeral?" Crosby asked, irritated.

"I am too busy," she snapped and promptly hung up on the undertaker. So Crosby went ahead without her.[143] Schmidt's corpse had been on ice for almost a week when, finally, on April 30, 1918, he received a burial at Forest Lawn Cemetery.[144] There was no ceremony, no minister and no last words, just a few pallbearers to carry the coffin from hearse to hole.

Only one mourner showed up to watch as the body went six feet under: Adele Ullrich Braun, the New Jersey wife who shocked investigators with stories about Schmidt's draconian treatment of her. Gertrude had other plans. She told the undertaker that she was just too busy to attend, but in reality, she may have begun to distance herself from her "Bluebeard" father. At eighteen, she had her own life to live. At this point, she had caught the eye of Erich Kurth, the Birmingham native with whom she and her stepmother had taken refuge during the investigation, and the couple had begun a romance of their own.

The pallbearers slowly lowered the coffin into the grave and then removed their hats for a few moments before tossing dirt back into the hole. Adele covered her face with her hands and sobbed—a cathartic moment for the woman who, despite it all, felt something for the man she knew as Emil Braun. She managed to utter one last goodbye. "May God rest his soul in peace," she mumbled.[145]

Never at a loss for words, Adele gave a statement to reporters after she gained her composure. The "woman scorned" had an entirely different demeanor following the burial. Adele's various and detailed reports to detectives worked like an emotional colonic; they allowed her to shed her acrimony for Schmidt. "I never dreamed I would be the only person to follow him to his grave. I can't imagine he ever thought I would be the one of the women to attend his funeral. He should be forgiven. I believe in forgiveness at death." She felt relieved that she went to the proceedings, she added, since no one else attended.[146]

Adele's relief didn't last long. The same day as Schmidt's interment, Gillespie issued a press release. The statement represented the culmination of several restless nights tossing and turning over the facts in the case. The evidence suggested that the Schmidt women had met Augusta Steinbach at least once and played along as Neugebauer's "sisters." Helen played an even more active role when she helped Schmidt shelve Augusta's mail. But a Michigan criminal statute provided an aegis for Schmidt's kin. Gillespie explained his reasoning in a second, public exoneration of the Bluebeard's family.

"There is not sufficient evidence to justify me in issuing a new warrant for the arrest of Schmidt's daughter, Gertrude, or in asking the court to take any further proceedings against the wife at the present time," Gillespie began. He then explained that Helen and Gertrude were questioned separately, with every detail of their statements scrutinized. "We have carefully certified their stories, and find their statements corroborate the other facts gained from other sources, which we have in our possession," he noted.

Gillespie went on to characterize Schmidt as "a stern and uncompromising husband and father" who "permitted no interference with his personal affairs." He even managed to keep Adele Ullrich, whom Gillespie called "one of the shrewdest women I have ever met," in the dark about the alleged Lakewood murders.

"My investigation thus far has satisfied me," Gillespie continued, "that Schmidt's requests upon his wife and daughter were actually commands, and were unquestioningly obeyed by them. While both had a suspicion that

all was not right about the house yet they had no idea that such a terrible crime had been committed by Schmidt. They thought that a great deal of his peculiar actions were due to his mysterious connection with the German government but just what it was they never understood."

The prosecutor then outlined the legal justification for releasing Helen and Gertrude. "We have a statute in this state designed to punish any person who after the commission of a crime by another aids or assist the guilty part in its concealment. This statute, however, expressly excepts from its provisions any person standing in the relation of wife or child to the guilty party because the law recognizes that persons standing in such a relationship should not be held to the same strict accountability as an outsider. The only way therefore to justify further proceedings against either the wife or the daughter would be to show that they were active participants in the commission of the crime and there is no proof whatever of such a fact."

The investigators working the case, Gillespie said, believed that "justice was satisfied when Helmuth Schmidt died by his own hand after making his confession. His last words to me as he was being led back to his cell was that his wife and daughter knew nothing about the crime, and I now believe that he told the truth. Unless there are new developments in the case or we can gather some new facts, there will be no further warrants issued."

Newspapermen across the nation had sensationalized the case, which led Gillespie to praise the one rag that didn't stretch the facts. In a jab aimed at the midsection of Detroit correspondents who vilified Gertrude and Helen, Gillespie lauded Oakland County's largest newspaper.[147] "The *Press Gazette*," Gillespie, said, "is to be congratulated upon the able manner in which the facts of this very complicated case have been printed without any attempt at exaggerated or sensational articles which had no foundation from the facts in the case. You have printed a full and complete history of this most sensational murder case since the time of Schmidt's arrest."[148]

The prosecutor ordered Helen released on her own recognizance pending a preliminary examination scheduled for May 2. He also released Gertrude and noted that she would not face any legal repercussions from New Jersey authorities either, since Adele had not initiated any formal complaint there. Gertrude, it appeared, was off the hook.

Gillespie's statement left little doubt about the Oakland County prosecutor's intentions, but Detroit authorities weren't as certain. "We are not satisfied with the statements made in Pontiac, in view of some of the information we have," Detroit chief of police Fox told the press, referring to Gillespie's press release. "[Gertrude] will be held and questioned."[149]

Detective Reid took Gertrude to Detroit police headquarters for further questioning about the disappearance of Irma Pallatinus. After extensive grilling, however, Fox and Assistant Prosecutor Merriam could pry no new information from her.

As Gertrude walked out of police headquarters in Detroit, Undersheriff Harry Cryderman placed a call to T.H. Hetherington. While he waited for the connection, Cryderman reread the portions of the *Free Press* article quoting the landlord.[150]

Sounding somewhat flustered, Hetherington verified the statements he made to the *Free Press*. After a long pause, he also admitted that he failed to mention these facts to Gillespie, but he didn't offer an explanation for this unbelievable omission.[151] That afternoon, Cryderman broke the news to Gillespie. Again, the undersheriff recommended bringing the two Schmidt women into Pontiac for another grilling, but Gillespie wanted to wait. Hetherington's statement didn't change the fact that Michigan law protected spouses and children under certain circumstances. Besides, in just a few days, he would put Gertrude on the stand in the preliminary examination of Helen Schmidt.[152] If he shook her hard enough in court, perhaps some new details would drop out of the witness box. If not, then perhaps her on-the-record testimony would satisfy the Detroit cops and end the matter once and for all.

In an ironic twist, Gertrude would be the key witness in what the prosecutor hoped would be the final chapter in the murder case: the examination of Helen Schmidt as an accomplice in the murder of Augusta Steinbach.[153]

Part IV

THE WEB HE WOVE

THE SERIAL HUSBAND

Detroit, Michigan; Pontiac, Michigan
Tuesday, April 30, 1918

By Tuesday, April 30, the hunt for Irma Pallatinus had lasted for a week, and despite digging up most of the property, detectives still had not found even one piece of the missing housekeeper. But they hadn't looked under the garage. They had ignored the outbuilding, believing that it was constructed before Pallatinus disappeared, but since the dig began, various neighbors commented that they had seen Gertrude and Helen help Schmidt shingle the garage roof—a fact suggesting he built the structure at a later date.

In the midafternoon heat, the work crew smashed the cement floor with sledgehammers. The men pried up the concrete shards and began scraping away layers of dirt underneath. It was exhausting labor, but after a few hours, they hit pay dirt. About three feet down, they discovered a cluster of twenty-two tiny bone fragments. The bones went to a chemist, who dashed the hopes of investigators when he proclaimed that they came from a chicken and not a missing housekeeper. So, the diggers turned their attention to the one spot on the property they had bypassed as a probable dead end: the cellar floor.

While detectives probed the ground of Schmidt's Highland Park address for signs of Irma Pallatinus, three more alleged wives surfaced. Less than a week after

Helmuth Schmidt, circa 1918. This head-and-shoulders portrait of Schmidt appeared in the *Pontiac Press Gazette*, the *Detroit News* and newspapers all over the country during the week of April 22, 1918, prompting several alleged wives to claim that they married him under various aliases.

sending attorney Marion Gold Lewis a photograph of Schmidt, Gillespie received a reply. Anna Hocke Switt had fingered Schmidt as her husband, "John Sw017," making her Schmidt's fifth unofficial spouse following Anita Schmidt, Adele Ullrich Braun, Irma Pallatinus and Helen Schmidt.

Forty-three-year-old Anna Hocke met "Switt" through the mail in the winter of 1914. Following a three-week courtship, the pair tied the knot on December 14, 1914, and planned to relocate to Detroit, where Switt worked as a machinist. The affair never passed the honeymoon stage. After just three days of marriage, the newlywed bolted with $1,400 of his wife's cash.[154]

Switt's claim fit in with the time line supplied by the other characters in the drama. According to statements made by Adele and confirmed by Gertrude, Gertrude traveled to New York to visit Adele during the week of December 13, 1914.

This new information led detectives to imagine a scenario in which Gertrude schmoozed her soon-to-be mother-in-law in the Bronx while Schmidt allegedly rid himself of Margareta Baersch and then traveled from Lakewood to Manhattan to consummate the relationship with Anna Hocke and con her out of her life savings. A few days later, "John Switt" abandoned his wife and sent a letter to Gertrude, explaining that Baersch had returned to Denmark. Gertrude returned to her father's Lakewood chicken farm on December 19. Less than two weeks later, she accompanied her father back to the Bronx, where "Emil Braun" wed Adele Ullrich on December 30, 1914.

Lewis also represented a client from Paterson, New Jersey, who claimed that the man she married in 1914—Mr. "John Steinruck"—looked like

CITY, COUNTY AND STATE OF NEW YORK: ss:
 ANNA HOCKE SWITT being duly sworn, deposes and says:

 1. That the estate of said Hellmuth Schmidt, de-
ceased is justly indebted to deponent in the sum of Fourteen
hundred dollars and interest thereon from the 18th day of
December, 1914; that said amount of money was entrusted to
Hellmuth Schmidt, known to her however as John Switt.

 That the said sum of Fourteen hundred dollars is now
justly due and owing to deponent and that no payment thereon
has been made and there are no offsets thereto, and the same
is not secured by judgment or mortgage upon, or expressly
charged on, the real estate of said deceased or any part there-
of.

Sworn to before me this :
7th day of June, 1918 : *Anna Hocke Switt*

Marion Gold Lewis
Notary Public # 118, N.Y.

Anna Hocke Switt swears that she married Schmidt as "John Switt" in this affidavit signed June 7, 1918. *Oakland County Probate Court, Michigan.*

Schmidt. The union lasted just under a month; "Steinruck" deserted her after a few weeks, pocketing $400.

The lineup of Schmidt spouses became a little more crowded when Gillespie received another inquiry, this time from the Chicago police. Mrs. Hellmuth E. Schmidt of Chicago had read about the Schmidt case in the *Chicago Daily Tribune* and contacted the police, who immediately wired Gillespie, requesting a photograph. The woman, who worked as a governess for an affluent Chicago family, wanted to keep a low profile and didn't even give her maiden name to the police, choosing instead to present herself as "Mrs. Hellmuth E. Schmidt."

Schmidt spun a tangled web with so many different identities that it would take months to sort them all out. Gillespie also received a curious letter from a Mrs. Freidel, who lived on a farm in Murrysville, Pennsylvania. Like Mrs. Hellmuth Schmidt of Chicago, she had read about the Royal Oak

Bluebeard. The Freidels employed a farmhand named Lansing Shirley who, Mrs. Freidel suspected, was in some way connected to Schmidt. Shirley had traveled to Detroit to purchase a tract of land from Schmidt.

After reading about the case, Mrs. Freidel began to wonder if Schmidt was Shirley. She whipped off a note to the Justice Department, requesting a photograph of Schmidt. The boys at Justice passed the note to Gillespie. "I will be glad to give any information I can but will have to know to whom I am talking for there are aliens around us that could injure our property," Mrs. Freidel said at the end of her letter.[155] The news of the Schmidt case had tapped into paranoia about the "enemy within."

UNEARTHED

Detroit, Michigan
Thursday morning, May 2, 1918

Most the digging crew had stripped down to the waist, their dirt-streaked torsos glistening with sweat. A jury-rigged string of bulbs provided the only light as they hacked at the concrete with pickaxes and sledgehammers. The basement of 418 Glendale in Highland Park was their last chance to find the remains of Irma Pallatinus.

After a week of digging, the property at 418 Glendale looked more like the Western Front than an arts and crafts–style bungalow in a middle-class, urban neighborhood. A six-foot-deep trench ran along the entire east side of the house, and the backyard was pocked with craters.

Detective Dibble was on the verge of giving up. His crew had turned over most of the yard, unearthed the garden, exposed the foundation and chipped through the garage floor, but all they managed to find were a few chicken bones. There was only one place they hadn't looked: under the cellar floor. Before the excavations began, experts carefully examined the cement and declared it free from any patched spots, so the diggers explored other, more likely hiding places on the property. Now the basement was the only spot left untouched.

The crew began at the back end of the basement and worked its way toward the front, pummeling the slab with sledgehammers, prying up the cracked pieces and jabbing shovels into the earth underneath. The backbreaking work took the rest of the night and stretched into the early

hours of the next morning. They had taken up almost the entire basement floor when one of the diggers' spades struck something solid at the front corner—the spot where Frederick De Planta noticed a wheelbarrow full of sand and where, Gertrude said, her father removed a root cellar.

The workman managed to get the tip of his spade under what he thought was a large rock and, using his body as leverage, pried it loose. The "rock" rolled across the excavation and came to stop when it struck the side of the trench. It was human skull.

The others raced over to the spot, threw down their shovels and began clawing out handfuls of the black earth. After half an hour, a human form appeared at the bottom of a cavity about six feet long, two feet wide and four feet deep. The body had been wrapped in a canvas tarp.

Wayne County physician Dr. Kenneth Dick conducted the postmortem at 4:00 a.m. on the morning of May 2, 1918. Dr. French, who assisted, gently snipped through the tarp as Dibble and Reid looked on. The detectives leaned over the bundle as the canvas came away to reveal the decomposed remains of a female. On the autopsy report, French jotted down an "Apparent Age" of twenty-eight, with an "Apparent Weight" of 165 and a height of five-foot-six.

A length of clothesline was knotted around the victim's neck, and another piece fastened at the knees kept her legs together. The tight wrapping combined with the dry soil preserved the remains somewhat, although not enough to consider the body "mummified," as one imaginative *Detroit Times* writer described it.[156]

Next, Dr. Dick examined the head. The mouth was open and the lips drawn back into a grotesque smile, revealing several cracked teeth in the lower jaw. He leaned down and spotted a hairline fracture running from the broken teeth down the lower jaw. The murderer likely slugged Pallatinus hard enough to send her to the floor and probably render her unconscious. With his victim on the floor, the killer wound the clothesline around her neck and twisted it. After his brief examination, Dr. Dick concluded that Irma Pallatinus died from "asphyxia by strangulation."[157]

Irma's sister visited the morgue to identify the body, but to spare her the pain of seeing her sister's corpse, the assistant brought a strand of auburn hair to the waiting room. Minna Rederer gasped as she eyed the clump of hair and nodded.[158]

After Dr. Dick concluded his study of Irma Pallatinus's leathery remains, Wayne County coroner Morgan Parker made it official, ruling that Irma Pallatinus died from asphyxiation by strangulation, garroted with the clothesline.[159] The postmortem, investigators believed, also presented a

S. 1 Form 1. 2m-5-14-17

REPORT OF AUTOPSY

On the body of *Irma Pallantinus*

held at *Wayne County morgue* in the City of Detroit on the

2nd day of *May* 191*8*, between the hours of

4 9 M. and *4:30* 9 M.

NAMES AND ADDRESSES OF ALL PERSONS PRESENT

NAME	ADDRESS	OCCUPATION	IN WHAT CAPACITY PRESENT
Kud Dibble	*D P O , , , ,*		

Operator, *Dick*

Assisted by *French*

Notes taken by *Dick*

INSPECTION OF BODY IN SITU

Sex *Female* Color *White* · Apparent Age *28* Color of Hair *brown* Eyes ———

Height *5 ft 6 in* Apparent weight *165* · Marks and deformities

External wounds ———

Nutrition ———

Condition of body *decomposed*

Identified by

As the body of

LOCATION AND DESCRIPTION OF WOUNDS

legs bound rope around neck

Dr. Kenneth Dick's notes on the autopsy report of Irma Pallatinus, indicating the condition of the corpse as "decomposed." Reporters described the body as "mummified," but this was likely an invention of overactive imagination. *Office of the Wayne County Medical Examiner, Michigan.*

I *Kenneth M Dick.* M. D., certify that I performed the autopsy herein mentioned and the foregoing description of said Postmortem appearance is correct and that in my opinion the cause of death was

asphyxiation by strangulation

The cause of death in the Irma Pallatinus case was based in part on the length of clothesline still around her neck. *Office of the Wayne County Medical Examiner, Michigan.*

more likely scenario for Augusta Steinbach's death than the suicide Schmidt described. To them, suicide seemed so incongruous with the bubbly, happy-go-lucky domestic that it bordered on incredulous.

Schmidt appeared to be guided by routine—using personals to lure unsuspecting women into his honey trap to liquidate their savings—so it seemed a likely conclusion that he used a similar modus operandi when he murdered his victims. They envisioned him luring Steinbach into the basement, probably using her trunks as a pretext. At the base of the steps, he bashed her in the face or head. With her dazed or unconscious, he looped a rope around her neck and twisted it. Or he throttled her. Schmidt was a strong man—strong enough to lift the hinged bed of his jail cell to arm's length above his head. He could have easily strangled Steinbach with little or no resistance and in a way that prevented her from screaming for help.

Parker's ruling on Pallatinus's cause of death changed the mood at the Pontiac Courthouse. Initially intended as a formality, the preliminary hearing took on an entirely new context. The mutable nature of Hetherington's statement forced Gillespie to use the hearing as a public venue to interrogate Gertrude about Neugebauer's sisters. Now the prosecutor would also quiz her about the woman Schmidt murdered in Highland Park before Helen Tietz even came to Michigan. When the eighteen-year-old testified, Detroit cops would be listening very closely.

THE PEOPLE V. HELEN SCHMIDT?

Pontiac, Michigan
Thursday, May 2, 1918

The news of a body found in Highland Park hit the streets at about the same time that Helen Schmidt walked into the Oakland County Courthouse to face a possible charge as an accomplice in the Steinbach murder. The *Pontiac Press Gazette* described the remains, sparing none of the graphic detail: "Under four feet of clay in the basement of the place diggers came upon a woman's body encased in a tarpulin. A piece of clothes line knotted around the neck gave evidence of the manner in which Schmidt disposed of his victims."[160]

Helen and Gertrude were told about the macabre discovery when they entered Gillespie's office. Helen fainted, but Gertrude appeared unfazed

by the news. "It is a complete surprise to me," she uttered as a doctor worked to revive her mother-in-law.[161] After Helen regained her composure, Gillespie led the Schmidt women to Judge Frederburgh's Justice Court, and the preliminary examination got underway. Gillespie called four witnesses: Thomas and Louise Hetherington; Helen's sister, Mina Hofbauer; and Gertrude Schmidt, the key witness in the case against her stepmother.

Thomas Hetherington took the stand first. He described the courtship. "Miss Steinbach was sitting with my wife and I when Neugebauer called," he recalled. Hetherington smiled as he remembered his shy tenant. "Great big country girl that she was she stood up in front of the book case and acted afraid to go in and see the man with whom she had corresponded. She had previously told us she had met him in New York but we didn't believe it from the shy way she acted." Hetherington thought Augusta fibbed about meeting Neugebauer in New York to cover up her embarrassment about agreeing to marry a man she never met.

He met Neugebauer just once. "She gave us an introduction. After that he came about twice a week but never on Sunday. He would remain until about 9 or 9:30. They would sit in Miss Steinbach's room with the door ajar and talk in German. Miss Steinbach was very respectable."

Then Hetherington came to the crux of his testimony. "She went out on Sunday afternoon March 4 and on her return said she had been out to Neugebauer's bungalow and had seen his sisters. She said, 'I like the little one. She is a sweet girl but I don't like the oldest one.' She told us she liked the bungalow but that there was a lot of work to be done to get the floors in shape. She showed us her bungalow apron and laughingly told us it was her wedding gown. I asked Neugebauer if his bungalow was on the Ten mile road and he said it was."[162]

According to Hetherington, on Sunday, March 11—the day she disappeared—Augusta said that she was going to Neugebauer's house, "where his sisters are giving me a big dinner." Following the meal, she said, she and Neugebauer were going "to drive through the country and get married at a poor ministers' who has lots of children and needs the money."[163]

Louise Hetherington testified next. The few minutes she spent on the witness stand established that Schmidt tried to isolate Augusta from her friends and family. She testified that Augusta once remarked that Herman would kill her if he knew she confided in her landlord's wife. Louise also described the frustrating dead end they reached when they drove out to Royal Oak to deliver a belated wedding present. Helen Schmidt flatly denied

ever hearing about Augusta Steinbach only to show up at the boardinghouse later that evening with a much different story.

"I have come to tell you the truth," Mrs. Hetherington remembered Helen telling her, visibly shaken at the time. "Miss Steinbach has gone back to New York. She didn't marry that man Neugebauer. He don't work at Fords and they didn't have money enough to get married."

At this point, Louise Hetherington said, she became enraged. She demanded that Helen leave immediately and watched as she climbed into a car with a man who looked like Neugebauer and was, in fact, Schmidt. It became obvious to everyone in the courtroom that Helen had lied to help her husband cover up the disappearance of Augusta Steinbach. She told investigators that she believed in the existence of Neugebauer. If she was one of Neugebauer's sisters whom Augusta described to Louise Hetherington, then she had to have known that Schmidt *was* Neugebauer. But did she have a choice, or did her husband bully her into helping him?

Mina Hofbauer took the stand next. She did her best to keep her sister from prison by depicting Schmidt as a martinet whose commands went unquestioned by Gertrude and Helen. These three witnesses were just a prelude to the finale. The one person whose testimony could make or break a complicity case against Helen Schmidt was the other "sister."

A correspondent for the *Pontiac Press Gazette* described Gertrude's grand entrance onto the courtroom stage. "When Gertrude was called as a witness every eye in the court room was strained to catch a glimpse of the attractive young woman who came in and took the witness chair…she wears her hair down her back in school girl fashion and appears quite girlish."[164]

During the first part of her testimony, Gertrude rehashed the various statements she made to investigators and gave a brief biography of her father, which was fraught with statements like "don't exactly remember" and "don't know." "I don't exactly remember what he did. He had a factory where they made wood work to finish elevators. I believe it was for the Otis Elevator Company. We were well off in Germany." Some in the courtroom found her lapses in memory difficult to believe since she was already thirteen when she arrived in America.

Gertrude contradicted an earlier statement when she testified about their reasons for leaving Germany. "I don't know why it was we came to this country," she said. "I don't remember whether he gave any reason not." Yet just after her arrest, she told Gillespie that Schmidt said he fled Germany to dodge a draft. Over the previous week, reporters had become accustomed to such inconsistencies.

According to Gertrude, the Schmidt family emigrated in separate groups. The patriarch came first to secure employment and housing before sending for the rest. "He left a month before we did. He left in October 1913," Gertrude recalled. "Margareta Baersch was living with us and I believe was the bookkeeper at the factory." They lived in a New York City apartment until Schmidt bought the chicken farm. Baersch moved to Lakewood with the family.

"Mother didn't like Margareta very well," Gertrude said, and provided a possible reason why the two women didn't get along. "[Schmidt] had introduced her as his sister from the beginning," but the ruse didn't fool Gertrude. "I think he must have had a love affair with her in Germany. My mother [Anita] never liked to have her around."

Four months later, Anita Schmidt disappeared. Gertrude described the circumstances. "It was in the latter part of March, 1914, that mother was missing. She told me before I went to school in the morning that we were short of money and that she was going to go to New York to see if she couldn't pawn or sell some of her jewelry. She said she would have taken me but didn't have money enough," Gertrude testified. "At dinner time mother had not returned and we all went to the train at night and waited for her. Father and all of us appeared alarmed because she didn't come. I cried and so did Margareta. We never saw her again."

Gertrude then offered an explanation that served as her primary defense when someone pointed out a discrepancy in her stories. She always did as her father told her, without question, even if that meant telling the occasional lie. And she had become so used to telling the same lies that she just repeated them without thinking. "Father told me to tell everybody she had gone back to Germany. I was getting so used to telling everybody so that I told the officers the same story," she explained. She then added, "I think mother died in New York," although she didn't expound on her theory.

Margareta was the next to disappear. "She continued to live with us and wanted father to marry her but he refused because he said my mother hadn't liked her and he wouldn't marry her on that account. She lived there until she disappeared while I was in New York in December 1914." Schmidt also provided a cover story to explain. "Father said he had given her $500 and she had returned to Germany."[165]

The next woman to appear and then disappear was Adele Ullrich Braun. "Father was married to Adele Ullrich at the home of her brother and we had a wedding dinner," Gertrude explained.[166] "A little while later father told me he couldn't live with Mrs. Braun and that he was going to divorce her. One

morning we drove away and left her after all the things in the house had been packed up." Gertrude did not describe the car accident that her father allegedly engineered to rid him of his second wife.

Gertrude continued. "We drove the machine to Philadelphia to Mrs. Rederer's place where we met Irma Pallatinus. Father seemed to know her well. I believe she had been at Lakewood to help him pack up our things while we were in New York. Irma rode with us to Pittsburg where in going down a hill our brakes didn't work and our machine hit a bridge. I was thrown out and broke my collar bone for the second time. The rest were only slightly cut.[167] On arriving in Detroit we went to live in a place on Hendrie avenue and I attended the business institute on Cass avenue. We moved to 418 Glendale avenue in May, 1915."

Then, Gertrude explained, Irma Pallatinus disappeared. With the discovery of the body just hours before, Gertrude's testimony took on an entirely new significance. Detroit detectives listened very carefully as Gertrude testified about the circumstances surrounding her housekeeper's exit. "Irma was with us there all the time until the day he came to the store and told me she had left and had taken some of his money. She used to get my breakfast and put up my lunch. On the day she disappeared she did that as usual. We always treated each other like strangers. Father came to the store at 5 o'clock and said she had gone. I can't remember the date but it must have been either October or November, 1915. There was no other woman in the house until my present stepmother came."

As for the corpse found concealed under the cellar at 418 Glendale, Gertrude said that she knew nothing about it. "I know he fixed the basement. The sewer backed up and flooded the floor and he had to fix that. He ordered some cement and sand. He was home from the time he quit work at 3:30 until I arrived at 6:30."

The time frame provided by Gertrude, if accurate, exonerated Helen from any wrongdoing in the Pallatinus affair. Schmidt married Helen on December 22, 1915. If Irma Pallatinus disappeared as early as October or November, as Gertrude testified, then Helen wasn't in Detroit at the time. But Irma's friends and relatives believed that she vanished just before Christmas, which caused some to question whether Gertrude told another lie to shield Helen from further charges.

Gertrude added an ominous note that depicted Helen as more of a potential victim than a perpetrator. "Father told me one day that he was going to get him another wife so we would have someone to keep house." That someone, investigators believed, was Augusta Steinbach, although

somehow, Schmidt's plan went awry. If all had gone according to script, Helen—not Augusta—would have been the next to disappear.

Gertrude provided more cover for Helen by describing Schmidt as a mentally deranged tyrant whose word became law. "Father was always so funny anyhow," Gertrude said. "He couldn't get along unless it was quiet. If he wanted to buy something he bought it whether you wanted it or not. You couldn't argue with him. If I would ask him anything he would say 'Be quiet and mind your own things.' He was good in a way but I didn't like him. He used to look at us so angry. I don't believe he had the right mind at times."

After Gertrude finished her monologue, the prosecutor got right to the point. He asked the crafty teen the one question on which hinged Helen's guilt or innocence as an accomplice: "Were you and your step mother at home on March 4, 1917, when Augusta Steinbach came out to your place?" According to both Thomas Hetherington and Agnes Domaniecki, Augusta said that she met Neugebauer's two sisters at that time.

Gertrude paused, pondering the question. "I presume that was one of the two Sundays we went away. They were the only Sundays on which my step-mother and I went away alone. We were not in the habit of going out together without my father. We went to the show and I am positive it was Sunday because there were no stores open. We left soon after dinner."

"Did you ever meet Augusta Steinbach?" Everyone in the courtroom sat silently watching the teenager.

"No." Gertrude said the word slowly for emphasis. With this testimony, Gertrude denied playing a role as Neugebauer's sister. T.H. Hetherington just shook his head in disbelief.

Given the importance of this testimony, Gillespie decided to press the point. "Did you ever know her?" he asked.

"No. I had heard her name spoken in connection with some man who was going to marry her. Father said she had so many clothes she was going to give some to us."

"Didn't you think it peculiar your father brought so many things to the house?" Gillespie asked.

"He said this girl had so much. I wasn't sure whether those were her trunks or not. He told us the girl didn't want to pay storage and sent them up to be kept for her."

"Weren't you suspicious when you learned the officers had searched the house?"

"He told me that they were searching the houses of all Germans."

"Didn't you think it strange that he kept those trunks there?" Again, Gertrude shook her head.

Still stinging from Gillespie's refusal to arrest Gertrude, Adele Ullrich Braun asked to address the court. The hearing was about Helen Schmidt's alleged complicity in the Steinbach case, but Adele once again targeted Gertrude. In her brief remarks, she said that Gertrude was present at the bank when she withdrew money and gave it to Braun.

Gertrude, recognizing Adele's feeble attempt to slander her in open court, laughed out loud as Adele described the trip to the bank. She didn't remember the incident, but she did, she said, recall giving a diamond-studded gold watch to Adele as a wedding gift in 1914—the same watch Adele spotted in Schmidt's Royal Oak house.[168]

After this line of questioning, Gertrude stepped off the witness stand and walked away from the hot seat for the last time. The discovery of Irma Pallatinus's remains prompted Gillespie to ask Detroit authorities if they wanted to take Gertrude into custody, but they lacked evidence of any kind linking her to the slaying. She believed, as her father told her, that Irma had gone back to Philadelphia, and no shred of evidence indicated otherwise.

As Gillespie had anticipated, the examination produced no startling revelation to incriminate either Gertrude or Helen Schmidt in any wrongdoing. Helen maintained all along that she believed in the existence of Herman Neugebauer and never questioned her tyrannical husband. These two factors explained much of what at first appeared to implicate her as an accomplice. Schmidt ordered her to go to the Hetheringtons and tell them that "Augusta didn't marry that man," and she obeyed. Schmidt ordered her to send the postcard to her sister in New York, and she didn't question it.

The presence of Neugebauer's "sisters" threatened to shatter the image of an innocent housewife bullied into abiding her husband's every command. If Helen played the role of Neugebauer's older sister, how could she still believe the Neugebauer fiction? Yet Gertrude not only contradicted Hetherington's hearsay testimony about the sisters but also provided an alibi for the Sunday when Augusta allegedly visited Schmidt in Royal Oak.

Hetherington's testimony, which suggested that Augusta was concerned with social etiquette, gave rise to a new theory. Investigators mulled over the possibility that Steinbach spent the afternoon of March 4, 1917, alone with Neugebauer. To avoid the appearance of intimacy before marriage, Augusta told others that his sisters were home during the visit, describing the two women based on what Neugebauer told her about them. This scenario would explain how and why Hetherington and Domaniecki heard about the

sisters while, at the same, Helen and Gertrude never actually met Steinbach. Others, however, were convinced that Augusta met the sisters in the flesh. Her descriptions to Agnes Domaniecki were too vivid, too detailed to have been gleaned from secondary knowledge.

Helen avoided a criminal trial, but the drama would continue later in the Oakland County Probate Court, when she and Gertrude would square off against Adele and Anna Hocke Swit for their share of the Bluebeard's treasure-trove. Adele decided to take up residence in Wayne County, Detroit, while she prepared to battle the other claimants.[169]

Meanwhile, after two years and four months in a hidden grave, Irma Pallatinus received a proper burial. Like her slayer's, the ceremony was small and simple and, ironically, at the same cemetery.[170] Irma's two sisters joined Reverend Harry Midworth of St. Peter's Episcopal Church and an undertaker's assistant at Forest Lawn Cemetery for the brief service on the afternoon of Saturday, May 5, 1918. The *Detroit Free Press* closed the chapter on Irma Pallatinus with four paragraphs under the headline "Schmidt's Detroit Victim Buried with Church Rites."[171]

A few days after the funeral, Gillespie received word from Chicago. After studying the photograph, Mrs. Hellmuth Schmidt tentatively identified Schmidt as the man she met through the classifieds and allegedly married in the fall of 1915. They lived together for just four days when the he lit out with $1,500 of her money. Adding to the legitimacy of her claim, she told Chicago police that her man was missing a piece of his left middle finger—an accurate anatomical detail about Schmidt never described in any of the newspaper stories about the case. Gillespie glanced at his skeleton outline of Schmidt's suspected movements. If there was anything to Mrs. Hellmuth E. Schmidt's claim, then Schmidt's dalliance in Chicago occurred sometime after he began correspondence with Helen Tietz and before Irma Pallatinus vanished.

The various widows were poised to battle for Schmidt's estate, valued at more than $20,000. Oakland County's probate court would face a tangled web of epic proportions as the alleged wives queued up for a piece of Schmidt's "coin."

The court had initially appointed George Dondero as the officer in charge of the estate, but Adele objected to the obvious conflict of interest since he was also Gertrude Schmidt's court-appointed guardian. The court acquiesced, replacing Dondero with John Baldwin, but Dondero would remain Gertrude's legal guardian and later, in probate court, her guardian angel.

WHO SHOT THE SHERIFF?

Pontiac, Michigan
May 9, 1918

After Helen walked away from the courtroom a free woman, the Schmidt case abruptly disappeared from the front pages. The same reporters who covered every facet of the case seemed just as eager to forget the sordid affair. Then, just one week after Helen's examination, a chance discovery put Schmidt's name back in the headlines. On May 9, 1918, the *Free* Press ran a page-one item: "PONTIAC SEES CLUE IN SCHMIDT'S DOG." The *Pontiac Press Gazette* ran a parallel article entitled, "SCHMIDT'S PET DOG REVIVES DEATH OF FORMER SHERIFF."[172]

The stories stemmed from a chance discovery made by a Pontiac resident named Mrs. Belliczky. In December 1917, a dog followed Belliczky's daughter home from church. The dog had a tag with the names "Helmuth Schmidt" and "Royal Oak." No one claimed the animal, which became part of the Belliczky family. Mrs. Belliczky didn't think twice about the dog until she read about the Schmidt case in the papers and contacted the police.

"How did Helmuth Schmidt's pet dog get to Pontiac at about the time Sheriff O.H.P. Green was found dead in the supervisor's room at the court house?" asked a *Pontiac Press Gazette* correspondent. "This is the newest element injected into the Schmidt case and while slight, might be the slender clue which would throw light on the manner in which the late sheriff came to his death."[173]

For weeks after Green's death, rumors circulated that Green had met with Schmidt in early December during his investigation into the Steinbach case. There was no record of any such meeting, but the discovery of Schmidt's dog in Pontiac provided a tangible piece of evidence suggesting that the two did come in contact sometime around the time of Green's death.[174]

While both *Free Press* and *Press Gazette* reporters were quick to point out that officials never doubted Green's suicide, some began to whisper that Schmidt shot the sheriff.[175] Schmidt's alleged espionage gave even more momentum to the rumors. People speculated that Schmidt iced the lawman to prevent discovery of his shadowy spy network or to derail the investigation into the Steinbach disappearance, or both.

At the newsstands, on street corners and in the area's saloons, armchair detectives hashed out surreal scenarios of murder. They envisioned Schmidt finagling a private meeting with Green, sneaking up behind the sheriff,

shooting him in the side of the head and then exchanging the spent cartridge from his gun with a live round from the sheriff's revolver. Schmidt then tiptoed out of the Oakland County Courthouse without being seen.

The absence of an official inquest abetted the rumormongers, but the circumstances and evidence all pointed to suicide. Green was found lying in a pool of blood with a single gunshot in his right temple. Wedged under Green's body, investigators found a county-issued ".38 special" revolver with a single shot missing from the magazine. If Schmidt shot Green and exchanged bullets in the two guns, he would have had to push the gun underneath the corpse—an unlikely possibility.

The forensic evidence supported suicide. Oakland County coroner O.C. Farmer examined the body and concluded that the wound was consistent with the type of weapon found at the scene, although without the actual bullet, this was an educated guess. During his examination, Farmer also noticed charred hair and scorched skin around the entrance wound—evidence that the gun barrel was in close contact with the scalp. While not an absolute certainly, Farmer knew that a gunshot suicide typically pressed the barrel against the head, which left the telltale scorching he found around the entrance wound.

Farmer suggested conducting an inquest, not to determine if Green had committed suicide, but rather to uncover why he had decided to swallow his gun barrel. He first needed the go-ahead from Gillespie, but Farmer told a *Pontiac Press Gazette* reporter that an inquest would be easy to arrange without an exhumation. At least six people had seen Green's body before burial, and several witnesses could testify about the sheriff's mental state.[176]

Topping the list of potential witnesses would be Green's wife, Josephine, and daughter, Grace, who could provide authorities with a key piece of missing information. Green left them sealed letters—possible suicide notes that the grieving widow and daughter refused to reveal. A public hearing would force these letters out of locked dresser drawers or at least require the two women to discuss them. If the sealed envelopes did contain suicide notes, the mystery behind why the sheriff killed himself would be solved.

In the end, however, Gillespie decided to let sleeping law-dogs lie and didn't order an inquest.

WILL THE REAL "MRS. SCHMIDT" PLEASE STAND?

Pontiac, Michigan
July 1918

During July, the Second Battle of Marne raged as the German army began its last major offensive of the war. In Michigan, a different sort of war raged. Throughout June and July, organized bands of smugglers played cat and mouse with the Michigan State Constabulary by carting whiskey across the Ohio border. They purchased whiskey at Toledo saloons, stashed it in secret compartments of their Model Ts and sold it in Michigan for a profit.

The situation had become so rampant that liquor wholesalers and saloon owners began warning their customers about the dangers of bringing booze into Michigan. Despite patrolling the Ohio-Michigan border, the constables could not keep the dyke between the two states from leaking whiskey into Michigan. National prohibition wouldn't come into effect for more than a year, but already the Motor City had become the bootlegging capital of the world.

In Pontiac, the various Schmidt "widows" faced off in the Oakland County Probate Court of Judge Ross Stockwell. While several claimants had stepped forward after the Schmidt case appeared in the national press, in the end, just four women vied for a piece of Schmidt's estate, valued at the princely sum of $20,000: Gertrude Schmidt, Helen Schmidt, Adele Ullrich Braun and Anna Hocke Switt. "Mrs. Hellmuth Schmidt" of Chicago apparently decided to drop out of the fight.

Stockwell faced a multifaceted problem. Schmidt used some of the same pieces of jewelry as bait, essentially regifting a former bride's jewelry to the next "Mrs." As a result, Gertrude, Helen and Adele all laid claim to some of the same items on the estate inventory. Schmidt also pilfered items from Adele and gave them to Helen and Gertrude.

In her petition to the court, Adele claimed as her property some sixty-two pieces of jewelry, furniture and clothes from the inventory of Schmidt's Royal Oak bungalow. Her lengthy list of jewelry included strings of amber and pearls, as well as the diamond-studded, gold lady's watch that Gertrude gave her when they first met in New York.[177] Since Schmidt purchased the Glendale Avenue property with funds purloined from her bank account, Adele also laid claim to the rental payments and asked for an allowance of eight dollars per week to be paid from Schmidt's estate.

Both Helen and Gertrude submitted petitions "contesting the petition of Adele M. Braun." Gertrude's petition contained a list of thirty-one pieces of jewelry that she wanted excluded from the inventory as her property. Among various other pieces, her list contained the same necklaces of amber and pearl beads that Adele claimed as her property, as well as the "lady's gold watch, diamond setting" that she gave to Adele in New York.[178]

Helen, unlike the other alleged wives, didn't have much of a legal leg to stand on. Adele's marriage license exposed Schmidt as a bigamist and nullified Helen's union to the same man a year later. She did, however, want to keep her hands on some of the property she brought into the marriage, so her petition also contained a list of items to be excluded, which was much shorter than Adele's and Gertrude's; she claimed only thirteen pieces of jewelry along with three rugs and two pieces of furniture.[179]

Before Stockwell could divvy up the Bluebeard's property, however, he had to determine which woman was Schmidt's lawful wife: Adele M. Ullrich Braun or Anna Hocke Switt.

George Dondero, Gertrude's court-appointed legal guardian, represented her at the proceedings. He also represented her stepmother, Helen. Since Dondero handled all of Gillespie's questioning during Helen's interviews, a sort of bond had formed between interrogator and suspect. Helen trusted him implicitly, and he knew the ins and outs of her case, which made him the ideal champion for her in court.

During the last week of May 1918, the Schmidt women and George Dondero squared off against the formidable Adele Ullrich Braun and her attorney, Harry Keidan, who spent several years as an assistant prosecuting attorney in Wayne County before going into private practice. Adele was the only one of the three to testify at the hearing. Keidan focused his line of questioning on his client's life with the man now infamous as the Royal Oak Bluebeard. He began with what would have been a simple question in any other case.

"You are a widow of the deceased Helmuth Schmidt?" Keidan asked.

Adele thought for a moment. "I am a widow, yes," she responded.

"How long did you live with him?"

"From December 31, 1914 to April 24, 1915."

"Practically four months."

Adele nodded. "Four months."

"Did you live as husband and wife?"

"As husband and wife," Adele said as she fidgeted in the chair, "lawfully married."[180] She then described how Schmidt sent her to New York with

Gertrude under the guise of searching for an apartment. The couple, Schmidt said, would be happier in New York, where he could find steady employment.

"During that time," Adele explained, "he claimed he would pack up the furniture and our belongings which he preferred to do and I should look for rooms and he would send the furniture, etc. to the place, but nothing ever came except letters from him telling me he had a great deal of trouble and that he couldn't sell the place." Back in Lakewood, Schmidt packed up anything and everything with value and made plans to skip town with Gertrude and Irma Pallatinus.

Adele continued. "On the 23rd I got a letter to go to Lakewood to meet him and bring Gertrude with me that both of us to come." Schmidt and Gertrude disappeared the next day, April 24, 1915.

"Was that the last day you saw him?" Keidan asked.

Adele nodded. "Yes, sir."

"Did you see him after that ever?"

"I never saw him after that."

Keidan corrected Adele. "You never saw him *alive* after that." Adele had identified Schmidt's corpse as her husband, Emil Braun, and the estate hinged on her claim as his legal spouse.

Adele leaned forward in her chair, realizing her faux pas. "I never saw him *alive* until the 25th day of April I came to Detroit and I saw him *dead* and identified him as my husband."[181]

Keidan entered into evidence "Exhibit A"—Adele's marriage certificate and license to Braun—before asking one final question: "Is Helmuth Schmidt indebted to you in any amount of money?"

"He is indebted to me over $3,500," Adele insisted.[182]

George Dondero focused his cross-examination on the $3,500 Adele said Schmidt stole from her.

"What did you do with it [the $3,500]?" Dondero asked.

Irritated, Adele repeated the question. "What did I do with it?"

"Yes."

"Why he got it from me," Adele said.

"And what did he do with it?"

"I couldn't tell you," Adele snapped. Schmidt kept his financial cards close to his vest, and she didn't know exactly how he spent her cash.

"Did he buy this Lakewood, New Jersey home with this money?"

"No, he had this long while before I married him; he bought that when he came to Lakewood."

"You gave him all this money?"

"I gave him all my money."

"He asked you for it, did he?"

"He certainly did," Adele said. She explained that he didn't use the money to buy the Lakewood residence; he used it to improve the property by purchasing eight adjacent lots with money from her bank account. After he bought the real estate, Adele testified, "he said, 'You are owner of the property as well as I and you are my wife and it is yours as well as mine.'"

"And at that time you gave him the $1,000?" Dondero asked.

"Yes, sir."

"He bought these eight lots."

"I don't know; he showed me a paper and claimed he had bought these 8 lots." Adele said that she caught a glimpse of another paper indicating that Schmidt paid just $100 for the additional lots, which meant that he pocketed the rest of the money she gave him.

Dondero asked her if she financed any of the building Schmidt did on the property, but she said he had completed it before she arrived in Lakewood. She also claimed that Schmidt had skimped on the household expenses, so her money didn't go into feeding the family, either. It became more apparent as the testimony progressed that Adele's life savings went straight into Schmidt's pocket, a fact that he covered up with a series of crafty deceptions. The most grandiose deception came when Schmidt sold the Lakewood house from under his wife's feet. Once again, Schmidt lied, telling Adele that he was going to rent it while they moved to the apartment Adele and Gertrude found in New York.

"[W]ere you in the room with him when the deal was closed?" Dondero asked.

"No. I was in the room with the parties but later on they went into the other room and there is where the deal was closed."

"You later discovered that it wasn't a lease of the property but he actually sold it?"

"Yes, sir." Adele went on to explain that she didn't receive "one cent" from the sale, even though she obtained "the agreement of sales" after her husband bolted. She tried to collect from the current tenant, Mr. Heim, but he didn't pay her because he was misled about her status as Schmidt's spouse. "Why Hr. Heim who is on the premises now and Mrs. Heim," Adele explained, "claimed that the reason that they did not consider it necessary to ask me, was that Gertrude told them I was only living with the man."

Dondero was quick to protect Gertrude. "Well, that isn't the question I was trying to get at, have these people that purchased the Lakewood home

from your alleged husband, have they made any payments to anybody since the time that Schmidt left the premises?"

"I couldn't tell you."

Dondero's final line of questions involved Schmidt's Overland car. After the accident, which Adele called "deliberately provoked," Schmidt claimed that the repair bill amounted to a whopping $1,100. In fact, as Adele discovered after her husband abandoned her, the bill totaled just $150, which Braun never paid in the first place. Adele was left to settle the bill with the mechanic. Braun planned the accident to get rid of her, Adele said, and then, adding insult to injury, literally, she had to pay for the damages to the car.

Although Adele's testimony contained numerous uncertainties, one fact emerged from the proceedings: although she lived to tell about it, Adele was in every other way a victim of the Royal Oak Bluebeard. She appeared strong-willed, even petulant at times, but her ordeal with Schmidt left emotional scar tissue that became obvious to everyone in Stockwell's court.

After Adele stepped down from the witness box, Stockwell considered Anna Hocke Switt's side of the story. Anna didn't make the trip from New York, instead presenting her argument through her attorney, Marion Gold Lewis, and a series of affidavits.

Switt claimed that she married Schmidt under the alias "John Switt" on December 14, 1914—a few weeks before he tied the knot with Adele as "Emil Braun."[183] Lewis presented the court with marriage papers signed by "Switt," photographs of Anna's husband, some of the clothes he left behind and six affidavits from acquaintances and neighbors who lived in the same tenement as the Switt couple. Each statement contained a detailed description of the mysterious "John Switt."

On paper, the two men were virtually twins. Schmidt described himself as a thirty-nine-year-old engineer on his marriage license; Switt described himself as a thirty-eight-year-old machinist. Gertrude examined some of the things Switt left behind and identified the man in one of Hocke's photographs as Helmuth Schmidt.

In the flesh, however, the two didn't measure up. None of Hocke's friends mentioned the scars on Schmidt's face—a striking feature not easily missed. Sergeant Daniel McLaughlin, one of the officers who measured Schmidt at the Highland Park police station, testified about seeing the scars after the arrest. Detective Fred Dibble also testified to seeing the scars when he viewed the body at the morgue.[184] A photograph showing Schmidt in a hunting outfit was entered into evidence; the photo clearly showed three thin marks on his left cheek.

Known signature of "Emil Braun" from his 1914 marriage license to Adele Ullrich. *New York City Municipal Archives.*

Known signature of "John Switt" from his 1914 marriage license to Anna Hocke. *New York City Municipal Archives.*

John Switt's height also didn't match Schmidt's. Anna's friends described Switt as about six feet in height, but Sergeant Mclaughlin testified that Schmidt was only five foot seven.[185] Most damning of all was "Switt's" signature on the marriage papers. Stockwell placed it next to a known sample of Schmidt's handwriting, and the two did not appear to match.

On July 30, Stockwell tossed out Switt's claim and declared Adele Ullrich Braun to be Schmidt's legal widow. Adele had finally won the legal vindication she so evidently desired. By mid-August, much of the contentiousness among the litigants had evaporated, and the three women decided to bury the hatchet. On August 15, they inked an agreement "to avoid [the] litigation, trouble, and expense" arising from the "unusual circumstances surrounding the estate."[186]

They split Schmidt's property three ways. Gertrude received some of the furniture and a set of fine silver that had been in her father's family for years. The Royal Oak property went to Helen, while Adele received the deed to 418 Glendale Avenue, which, a *Pontiac Press Gazette* reporter noted,

State of Michigan,

The Probate Court for the County of Oakland,

At a session of said Court held at the Probate Office in the __City__ __of__ __Pontiac__ on the __30th__ day of __July__ A. D. 19.18,

PRESENT, HON __Ross Stockwell__ Judge of Probate.

In the Matter of the Estate of __Helmuth Schmidt, Deceased.__

<div align="right">Deceased.</div>

__The thirtieth day of July, 1918__ having been appointed for hearing the petition of __Adele M. Braun__ the widow of said deceased, praying for the assignment to her of her statutory allowances out of said estate, and due notice of the hearing on said petition having been given to the __administrator__ of said estate, the said petitioner appeared__And after taking proofs as to who is the lawful widow of the said Helmuth Schmidt, deceased, __ __It is hereby declared and found that Adele M. Braun is the lawful widow of the said Helmuth Schmidt, (also known as Emil Braun), deceased.__ It is Ordered, That said widow be allowed the personal property of said deceased selected by her not exceeding in value the sum of two hundred dollars

and also all her articles of apparel and ornaments, and all of the wearing apparel and ornaments, and the household furniture of the said deceased;

Joss Stockwell

Judge of Probate

Oakland County Probate Court judge Ross Stockwell ruled that Adele Ullrich Braun was Schmidt's legal widow. *Oakland County Probate Court, Michigan.*

by the other parties to this stipulation, and that the real estate as inventoried in said estate is to be sold for the purpose of paying any such claim as may be allowed in favor of said Adele M. Braun (Schmidt) but in no case shall any deficiency judgment or amount be taxed against or charged against the other parties to this stipulation if the proceeds from the sale of real estate from said estate shall not be sufficient to pay any such claim so allowed.

5. It is hereby further stipulated and agreed that possession of the household furniture of the deceased shall be delivered and given over to the said Adele M. Braun (Schmidt) not later than August 30th, 1918.

6. It is hereby further understood and agreed that if any property, real, personal or mixed shall hereafter be discovered which may have rightfully belonged to the deceased, then in such case, it is hereby expressly understood that the said Adele M. Braun be entitled to have the same applied to satisfy her unpaid claim against said estate and also to apply to her distributive share thereof.

7. It is further understood and agreed insofar as the parties of the second and third part are concerned that the said party of the first part shall have the right of possession of the Glendale Avenue property at once and upon the signing of this stipulation.

8. It is further agreed that a copy of these stipulations shall be filed with the Probate Court upon the proper execution hereof of all of the parties hereto.

IN WITNESS WHEREOF the said parties have hereunto set their hands and seals this ___15___ day of August, A.D. 1918.

x *Adele M. Braun (Schmidt)*

Helen Schmidt

ESTATE OF GERTRUDE SCHMIDT, a minor,

By *Geo. A. Donders*
Guardian.

Curiously, both Helen Schmidt and Adele Braun retained their "married" names, although Adele added "Schmidt" in parenthesis. *Oakland County Probate Court, Michigan.*

was a white elephant. The diggers left the property in shambles, and no one wanted to buy a house used by the Royal Oak Bluebeard to stash the body of Irma Pallatinus.

Dondero signed on behalf of his ward, Gertrude. Curiously, both of Schmidt's wives retained their married names on the court documents. Helen signed as "Helen Schmidt" and Adele as "Adele Braun (Schmidt)."[187]

The women faced just one final obstacle before the agreement became official: Anna Hocke Switt could appeal Judge Stockwell's dismissal of her claim. Apparently content to drop the affair and move on with her life, she didn't file an appeal, and the distribution of Schmidt's estate began.

The case of the Royal Oak Bluebeard had finally come to an end.

Epilogue

If pictures are worth a thousand words, then before and after photographs of Gertrude tell a sad story of an emotionally drained teen anguished by the ordeal. The youthful eighteen-year-old in photographs circa 1918 looked like a woman of thirty-five in her 1920 passport photograph. Perhaps, in some sense, she became her father's final victim—pressed into service as Schmidt's "sister," blasted by the press and dogged by police and reporters alike.

After the probate court fracas, Gertrude Schmidt returned to the Royal Oak bungalow, where her father had incinerated Augusta Steinbach. On April 20, 1919, nineteen-year-old "Trudy" Schmidt wed her sweetheart, twenty-year-old Erich O. Kurth, son of the widow who sheltered Gertrude and Helen in her Birmingham cottage during the press circus surrounding the case. Still considered a minor at the time, Gertrude Schmidt-Kurth remained officially under Dondero's wing until Judge Stockwell discharged him as her court-appointed guardian just after her twenty-first birthday.[188]

The Kurths remained together for thirty-three years, but their happily-ever-after ended prematurely. Tragically, Gertrude Schmidt-Kurth committed suicide on November 19, 1952, at the age of fifty-two.[189] Her obituary notes, among the list of her survivors, her "mother" Helen Schmidt.[190]

Helen Schmidt remained close to her stepdaughter, living at the Birmingham, Michigan residence of the Kurth family for more than a decade. In the early 1940s, she moved out of the Kurth household and into an apartment, where she worked as a dressmaker. She spent her last few

years at the Southfield Nursing Home, dying of kidney failure on July 2, 1964, at the age of eighty-four.[191]

Adele Ullrich Braun remained in Detroit, where she found work as a bookkeeper for the Detroit Printing Company. She made one final appearance in the 1918 Detroit City Guide as Mrs. Adele "Brown" (she apparently Anglicized her married name) before exiting stage left, never again to appear under the limelight. According to probate court documents, estate agent John Baldwin managed to sell the Glendale Avenue house in November 1918. After the sale, Adele may have moved back to New York.[192]

In 1918, Glenn C. Gillespie ran for a second term as Oakland County prosecuting attorney. He won the election and continued a string of important victories in court. In one year, he won every single case he argued. In 1921, Gillespie became the youngest circuit court judge in Michigan history when Governor Groesbeck appointed the thirty-five-year-old to fill a vacancy on Oakland County's Sixth Circuit Court. Over the next decade, he

Glenn C. Gillespie, outdoorsman, circa 1917. *Glenn C. Gillespie Papers, Bentley Historical Library, University of Michigan.*

left his mark, authoring several key decisions. He literally wrote the book on criminal jurisprudence in the Great Lake State; *Gillespie's Michigan Criminal Law* became standard reference for criminal courts.

Gillespie left public service in 1934 and returned to his private law practice, where he took up civil suits, arguing several landmark cases before the Michigan Supreme Court. He and Leola spent their summers at their second home in Pasadena, California. On their return drive to Michigan on March 11, 1959, Leola fell asleep at the wheel, and the car veered into a concrete abutment. Leola survived the accident with a fractured hip and broken arm, but seventy-three-year-old Glenn C. Gillespie died in the wreck.

George Anthony Dondero devoted the rest of his life to public service. He remained an assistant prosecuting attorney until 1919 and the attorney for the village of Royal Oak until 1921, when he was elected mayor of Royal Oak. In 1932, the small-town farm boy from Greenfield Township, Michigan, won a seat in the United States House of Representatives. He served a dozen terms, finally leaving the Washington political scene in 1957. He died in Royal Oak on January 29, 1968, at the age of eighty-four.

Convicted of murdering Hope Alexander, Allan Livingston maintained his innocence of any wrongdoing in the crime. In 1944, he appealed his conviction based in part on alleged trial errors and in part on an affidavit signed by a fellow inmate alleging that police propositioned him to participate in a frame of Livingston (he refused).[193] It had been nearly three decades since the crime, memories of the event had faded and the stenographer had died before his notes could be transcribed, so there was no formal record to review either. The county decided to not to pursue the case, and Livingston was released. Terminally ill, he died that same year.

After nearly two decades of policing the mean streets of Detroit, Detective Fred Dibble became chief of police for the city of Hamtramck in 1918. For the next twenty years, he served first as mayor and then as member of the Hamtramck Board of Supervisors. He died of kidney failure in 1937 at the age of sixty-one.

Agnes Domaniecki remained in New York and faded into obscurity—a place, Captain Willemse said, where she felt most comfortable. "To the best of my knowledge," Willemse wrote in 1931, "Agnes is still here, happily married to a steady industrious man who appreciates her. If he didn't, he'd be a jackass."[194]

Captain Cornelius Willemse remained on the prowl as a homicide detective in east New York until he hung up his handcuffs in 1925. New York's finest didn't fade out of the spotlight, however. He became a sought-

Metropolitan Police Department

DETROIT, MICHIGAN

$500 REWARD

On the night of July 4th, 1919, the Gents' Furnishing Store of Hughes and Hatcher, located at 333 Woodward Ave., was entered by thieves, entrance being gained through the skylight. They tried to enter the safe, but could not gain entrance. They then stole a quantity of Silk Shirts and other goods. Following is the list:

SILK HOSIERY.			Wholesale Cost.		
10 dozen Interwoven and Trueshape Brands	$ 6.00 to $ 6.85	Average $ 6.42	$ 64.25		
20 dozen Interwoven & Truesh. Brands, asst. colors	11.00 to 14.00	Average 12.50	250.00		
SILK SHIRTS.					
18 dozen Normandie and Hughes & Hatcher Brands	72.00 to 84.00	Average 78.00	1,404.00		
GLOVES.					
2 dozen Mocha Gloves—Hayes Brand	36.00		72.00		
6/12 dozen Silk Pajamas—Hughes & Hatcher Brand	78.00		39.00		
1 dozen Silk and Cotton Union Suits, H. & H.	24.00		24.00		
1/12 dozen Bathing Suits	73.50		24.50		
6/12 dozen Belts with Silver Buckles	15.00		7.50		
8/12 dozen Panama Hats, "H. & H." in sweat band	18.00		32.00		
1/12 dozen Panama Hats, "H. & H." in sweat band	12.00		14.00		
4 Leather Bags $13.50, $14.00, $15.50, 16.50			59.50		
14 Men's Suits	Average cost $35.50		497.00		
		TOTAL	$2,487.75		

Huges & Hatcher offer a reward of $500.00 for any information leading to the arrest and conviction of thieves and recovery of property.

Wire and address all information to

WM. P. RUTLEDGE,

Supt. of Police.

As Detroit grew to 1 million residents, the crime rate continued to climb. This rare wanted poster describes the robbery of a Woodward Avenue clothing store. *Author's collection.*

after lecturer and later penned two memoirs about his life on the streets: *Behind the Green Lights*, published in 1931, and *A Cop Remembers*, in 1933. A sharp mind when it came to collaring deviants, Willemse used his chapter on the Schmidt case as a cautionary tale to single women who searched

HIGHLAND PARK POLICE DEPARTMENT

WANTED FOR THE ABANDONMENT OF HIS WIFE

We hold a warant for one **WILLARD T. GUY** on the charge of abandoning his wife, Irene S. Guy, on the 15th day of December, 1918.

This man is described as follows:

Fifty-seven years old, 160 lbs. in weight, 5 feet 7 inches tall, brown eyes, brown hair mixed with gray, florid complexion, very course skin, long heavy eye brows, very large ears, mouth drops at corner when talking, hands and arms are very hairy, has a birth-mark on left hip, rubs his nose and eyes very frequently with right hand, carbuncle scar on back of neck, dark streak under each eye, wart on second joint of right fore finger, very nervous and excitable temperment. When last seen was wearing a gray suit, black soft hat, gray overcoat with gray velvet collar, black shoes, wears watch fob with initials "W. T. G." engraved on same in script.

The above picture is a good likeness of Willard T. Guy, except, that he was 30 lbs. lighter when he left and had a smooth face. He may be found living with some woman who is not his wife. This man is a good electrician by trade, but does not belong to the the Electrical Union. He may be found working in an automobile factory at his profession, or selling automobile accessories. He was with the Maxwell Motor Company of this city for a considerable time, and is thoroughly acquainted with the automobile business.

We hold a warrant for this man, and if found would request that he be arrested and held. We are very anxious to locate this man and have him apprehended.

Wire or write all information at my expense to

CHARLES W. SEYMOUR,
Chief of Police,

February 20th, 1919. Highland Park, Mich.

In the late 1910s, Highland Park chief Charles Seymour had his hands full with all sorts of miscreants, from murderers to men who ran away from their wives—a vigorously prosecuted offense in the early twentieth century. He published this wanted leaflet to find Willard T. Guy, a Detroiter who allegedly abandoned his wife. *Author's collection.*

Captain Cornelius Willemse, standing beside Deputy Police Commissioner John Leach, watches beer go down the drain in New York during the Prohibition era. *New York World–Telegram and the Sun Newspaper Collection, Library of Congress.*

for mates through the classifieds. "I've got to say when it comes to the 'lovelorn,'" he said, "keep your money in the bank. You're safe as long as you do even against a criminal of the Schmidt type."[195] Willemse died in July 1942 at the age of seventy.

Helmuth Schmidt is buried in an unmarked grave at Detroit's Forest Lawn Cemetery. Six feet beneath the surface of section 32 lies the shattered skull of Michigan's original lonely hearts killer, who took his many secrets with him when he committed suicide in his Highland Park jail cell.

UNANSWERED QUESTIONS

A *Detroit News* reporter captured the essence of the Schmidt saga in a headline article from April 24, 1918: "Pieced together bit by bit the evidence makes a mosaic colored with the blood of women and in it is the sinister shadow of a man accused of having lured them to their death through matrimonial advertisements."[196] The mosaic, however, is full of holes. There are several unanswered questions about Helmuth Schmidt and his alleged crimes.

He was Braun, Neugebauer, Roloff, Ullrich, Scharno and others, but who was he really? Pulling back the curtain exposes the wizard of Oakdale Boulevard as Helmuth Emil Max Schmidt, born on July 4, 1876, in Rostock, Germany. Little is known about his early years. He abandoned his Berlin jewelry shop in 1913 and immigrated to the United States aboard the steamship *Bremen*, arriving at the Port of New York on November 6 under the name of "Max" Schmidt.[197] A week later, his daughter, Gertrude, alongside two other women, joined him there.

Almost from the time the *Bremen* docked, Schmidt began his warped version of the American dream by bilking desperate women out of their life savings. Schmidt conned women for profit, but statements from the various characters who interacted with him suggest that he was a complex individual with more than money on his mind.

One contemporary news report labeled Schmidt a "sex pervert," but sex doesn't appear to have been his primary motivation, either. Detroit, like most major U.S. cities, had a healthy red-light district. He didn't need to advertise for love when he could find it for sale around the corner. He apparently

wanted women from the "servant class" who hadn't spent much time on their backs—vulnerable women with limited social options whom he could control and perhaps even own. Adele, Helen and Augusta were all middle-aged spinsters when they met Schmidt. None of them had been previously married. Irma was the odd woman in the group: at twenty-eight, she was comparatively young, and New York marriage records indicate that she had been married once before, in 1913.

A *Pontiac Press Gazette* writer speculated that "there may have been a more subtle motive due to a disordered mind. It is possible he had a mania for trifling with the affections of women."[198] This may have been closer to what made the Royal Oak Bluebeard tick.

For Schmidt, the climax of such liaisons may have resulted not from the sex but from the control itself. Adele Ullrich Braun, Gertrude Schmidt and Helen Schmidt all characterized Schmidt as a control freak who reveled in dominating the women in his life. According to Adele, he even claimed that he could control women with his hypnotic gaze—a belief in extreme control he shared with Raymond Fernandez, one half of the infamous "Lonely Hearts" duo. Fernandez believed that he could seduce women from afar by casting a voodoo spell over them.

The ultimate fantasy for Helmuth Schmidt may have come when he remained, literally and symbolically, on top of Augusta Steinbach. Only when discovery appeared imminent did he relinquish her body, disinterring and subsequently destroying it.

If, as investigators believed, Schmidt murdered Augusta Steinbach, the climactic moment of their relationship may have occurred when he throttled her—a moment when his control over her became absolute. Convicted lonely hearts slayer Harry Powers once remarked that watching his victims die provided more pleasure than a night at the local bordello. Like Schmidt, Powers strangled his victims and then buried their bodies under a structure on his West Virginia property.

A consummate raconteur, Schmidt became very adept at role-playing. He played imperial German officer Captain Ullrich at east side beer halls and then fooled Ford's Sociological Department by slipping into his domestic alter ego, "Adolph Ullrich," loving husband and father. He tricked countless women with his suave exterior. "His face and appearance," Captain Willemse wrote, "were such that most women might trust. There was nothing about his manner of actions to suggest 'the fiend' or the degenerate."[199] The few surviving photographs of Schmidt suggest that, with a full head of hair, an olive-complexion and a square jaw, he was probably a real lady-killer.

Schmidt effortlessly glided from one identity to another, sometimes engaging in a form of identity theft by stealing names. After he robbed Adele Ullrich Braun, he assumed her last name, living and working in Highland Park as "Adolph Ullrich." A few years later, he sent out matrimonial advertisements from Royal Oak in the names of "Roloff" and "Neugebauer"—both surnames of Royal Oak residents in 1917. Intelligent, a master manipulator and an expert dissembler—hallmarks of what twenty-first century psychologists refer to as a sociopath.

Another unanswered question involves the number of women duped by Schmidt's lonely hearts game. In addition to his two known wives, Adele Ullrich and Helen Tietz, two others (Anna Hocke and "Mrs. Hellmuth Schmidt") claimed that they married him, and Minna Rederer insisted that her sister, Irma Pallatinus, went through some type of marriage ceremony. There could have been others, but the scope of his swindle is obscured by the very nature of his crimes. The shame of a weekend fling may have kept some women from stepping forward, particularly in an age when most women kept such affairs tucked away in diaries. Adele Ullrich Braun, in her willingness to discuss her private affairs in public, was rare.

Gillespie once referred to Schmidt's Royal Oak house as a "murder plant" and compared Schmidt to Belle Guinness, who notched more than two dozen murders in a killing spree that spanned decades. The hard evidence indicates that Schmidt was no Belle Guinness, but the fates of at least two women known to be associated with Schmidt remain unknown.

According to some sources, both Anita Schmidt and Margareta Baersch vanished down the rabbit hole of Schmidt's Lakewood, New Jersey chicken ranch. Anita Schmidt's fate is obscured by Gertrude's evolving story. At first, she said that Anita disappeared in Germany. The presence of Adele Ullrich Braun in Detroit forced Gertrude to tell Gillespie that her mother emigrated from Germany with her, which would have been on the steamship *Amerika* on November 15, 1913.[200] But the *Amerika*'s passenger manifest contains no entry for an "Anna" or "Anita Schmidt." If Gertrude told the truth, then her mother must have traveled under another name.

According to the manifest, Gertrude walked through Ellis Island alongside Margareta Baersch and a woman named Minna Gülzow, who identified herself as Schmidt's sister and Gertrude's aunt. In an interview with Gillespie, Gertrude said that Schmidt typically referred to his wife, Anita, as his sister.

If true, it was just one of several similar deceptions. After this first woman vanished, Schmidt subsequently passed off Margareta Baersch as

Two excerpts from the November 1913 passenger manifest for the SS *Amerika*. The top excerpt includes the three women en route to meet Helmuth Schmidt. The identity of the woman listed in line fifteen, Minna Gülzow, remains a mystery. The bottom excerpt includes Schmidt's address in New York. Notice "friend" crossed out and "brother" in parenthesis. Schmidt had a tendency to represent his intimates as his sisters. Were these two women victims of Schmidt's "murder plant"? Their fates remain unknown. *National Archives and Records Administration.*

his sister, "Greta Braun," when Adele Ullrich visited in the fall of 1914. Gertrude later told Gillespie that her father directed her to tell others that Baersch was her aunt. Schmidt subsequently introduced Gertrude as his sister-in-law when he met Helen Tietz, and the evidence suggests that, two years later, he presented Helen and Gertrude as his sisters while he courted Augusta Steinbach.

It is possible that Anita Schmidt likewise playacted as Schmidt's sister, although her reasons for doing so remain obscure. Whoever she was, after "Minna Gülzow" left Ellis Island, she disappeared. An extensive search failed to turn up a single piece of documentary evidence indicating that she lived, married or died in the United States under that name.

If Minna Gülzow was anyone other than Schmidt's sister, the surname may have been a pseudonym that Schmidt kept up his sleeve. At least one other time, he used the name "Gülzow" in a false context. On his New York marriage paperwork, Emil Braun listed "Amanda Gülzow" as his mother.

This raises an intriguing question: why would Schmidt's intimates stand by while he introduced them to his paramours? If Helmuth Schmidt was a sort of malignant Svengali with an uncanny ability to manipulate women, then perhaps he browbeat Anita and his subsequent wives into posing as his sisters to facilitate his marriage-for-profit scheme. It's not as far-fetched as

it sounds—Raymond Fernandez once introduced his mistress to his legal wife. Later, when Martha Beck became both his partner in the bedroom and his partner in crime, he introduced her as his sister, a ploy designed to lend legitimacy to his alias, "Charles Martin."

If Schmidt murdered Anita Schmidt, as investigators feared in 1918, he did so in a way that left no trace. Despite an exhaustive search, Lakewood authorities didn't find a single bone shard. The lack of any remains doesn't mean that the women escaped Schmidt's "murder plant." Adele Ullrich Braun offered an interesting clue as to their potential fate: she said that Schmidt reeled from the stench of burning hair and forbade her to use her curling iron. Adele may have embellished a bit to demonize Schmidt, but it is also possible that Steinbach's cellar cremation wasn't Schmidt's first. This would explain why authorities found no bodies in Lakewood. Schmidt may have simply scattered the ashes in New York Harbor during one of his nocturnal trips.

Whatever the truth about Anita Schmidt's demise, Gertrude obviously believed that she died sometime before 1918. On several official documents, such as the probate court guardianship papers, she listed her mother as deceased.

Detroit detectives uncovered two additional names linked with Schmidt: housekeepers who allegedly worked at Schmidt's Glendale Avenue residence. The name Mae Murray first appeared in a statement made by bartender Frank Rhode, who worked at a drinking hole frequented by Schmidt. For a brief time, journalists considered her another victim, but Rhode's description of the woman matched Irma Pallatinus.

The second name, Emma Berchoffsky, emerged during Schmidt's confession. Schmidt said that he employed the woman as his housekeeper after Irma Pallatinus ran off with his money. This could be the woman Grace De Planta spotted at the Glendale Avenue residence during one of her visits in late 1916. Mrs. De Planta described her as an attractive blonde who sat by the window, knitting. Neither Pallatinus nor Tietz—women known to be associated with Schmidt in Detroit—had blond hair.

Yet the name Emma Berchoffsky appears only once or twice in the voluminous news coverage about the case. Either investigators managed to eliminate her as a possible victim, or they reached a dead end. Apparently, they did not have all the answers they wanted. Not long after the discovery of Irma Pallatinus's remains, Oakland County sheriff deputies probed Schmidt's Royal Oak property in an attempt to find bone fragments of other possible victims.[201] The discovery of Schmidt's safety deposit box led

to high hopes for more clues, but it turned out to contain nothing more than mundane paperwork. Perhaps one day, someone will be doing excavations on the property of a World War I–era house and stumble across an unwritten chapter in the Schmidt saga.

In *Behind the Green Lights*, Cornelius Willemse wrote that Schmidt murdered eight women before Augusta Steinbach, although he didn't name names.[202] He also said that after the case broke, he opened lines of communication with the authorities in all of the places where Schmidt advertised for brides. Willemse claimed that he learned of a police officer from an East Coast city who located a property owned by Schmidt. Under the basement floor, the detective discovered an unidentified, decomposed body.[203]

If Willemse's account of Schmidt's crime is valid, the Royal Oak Bluebeard would be one of the most prolific lonely hearts killers in American history, eclipsing Powers, who murdered five, and Beck and Fernandez, who together murdered three and possibly a fourth. But Willemse's credibility is marred by the inexplicable factual errors in his chapter about the Schmidt case. For example, he stated that Gertrude was twelve at the time of her father's arrest and that Sheriff Green shot himself because he felt embarrassed about the shocking disclosures Schmidt made during his confession.

Curiously, Cornelius Willemse is silent about one of the most fascinating facets of the case: Schmidt's alleged espionage. He described Adele Ullrich's story in detail but did not mention her allegations, perhaps because he felt they lacked substantiation or because he wanted to focus on the lonely hearts aspect of the case.

There is no smoking gun tying Schmidt to any known espionage ring. The primary source for the allegations was Adele Ullrich Braun, so any discussion about Schmidt as a spy hinges on her credibility.

Unlike other characters in the Schmidt saga, Adele's story didn't change with each retelling. The first statement she gave to a reporter—a correspondent from a small-town New York newspaper who interviewed her in August 1915—is consistent with those she made almost three years later in Detroit. In both instances, she spoke about Schmidt's interest in Sandy Hook, the maps he drew and the coded messages that he apparently sent and received.

One could say that she had an axe to grind, but fabricating stories of a superspy would just be overkill. She already exposed him as a con artist whom, she said, tried to murder her. Besides, she spoke about Schmidt's suspicious activity at the height of anti-German sentiment. Denouncing her husband as a spy came with great risk that others might question her loyalty.

She evidently recognized this danger when she later made a point of telling the press that she and her siblings were all naturalized citizens.

According to Adele, during the five-month span from December 1914 until April 1915, Schmidt made maps of fortifications around New York Harbor. The time and place tallies with other efforts by German agents. When Schmidt lived in Lakewood as "Emil Braun"—from 1914 to late April 1915—northern New Jersey was the epicenter of German espionage. Most of these early efforts involved the destruction of war matériel. In the early days of the conflict, German authorities wanted to keep United States–produced munitions from going to their enemies. Their spymasters recruited transplants from the old country to carry on a war of sabotage and subversion.

Saboteurs experimented with explosive devices in the Jersey woods before using them on targets in and around New York Harbor, where ammunition and high explosives were gathered for shipment. According to one interesting albeit unproven conspiracy theory, German agents used a U.S. Navy–controlled radio tower at Tuckerton—just miles from Lakewood—to sink the *Lusitania*. As the story goes, the powerful radio tower sent the message, "Get Lucy" after the steamship left New York Harbor on May 1, 1915. Six days later, *U-20* torpedoed the liner.

Throughout that spring, a series of attacks on munitions caches and outbound ships occurred within geographic proximity of Schmidt's Lakewood, New Jersey farm. Captain Henry Landau, whose 1937 book *The Enemy Within* documents sabotage during World War I, even mentioned that one ring of saboteurs worked out of Lakewood, but he offered no names or specifics.[204]

Adele told Gillespie and a room full of reporters that Schmidt made overtures about stealing her brother's identity papers in 1914—a time frame that coincided with a large-scale attempt to send German officers in the United States back across the Atlantic in a scheme Landau refers to as "passport fraud."[205] When hostilities began in 1914, imperial German authorities wanted to send the thousands of reserve German soldiers living abroad back to Europe, but the Allies didn't want these men to find their way to Europe's battlefields. They imposed more stringent travel requirements to prevent this mass movement.

To step over this block, German authorities tried to obtain passports from American citizens for use by their officers. Since passports of the era didn't contain photographs, it was a simple switch; German reserve officers could return to Germany by masquerading as American citizens traveling abroad.

DON'T TALK

THE WEB
IS SPUN
FOR YOU
WITH
INVISIBLE
THREADS

KEEP OUT OF IT
HELP TO DESTROY IT
STOP = THINK
ASK YOURSELF IF WHAT
YOU WERE ABOUT TO SAY
MIGHT HELP THE ENEMY

SPIES ARE LISTENING

"DON'T TALK," this circa 1917 poster warns. "Spies are listening." Such propaganda led to exaggerated fears about enemy agents lurking in the shadows and caused many to eye their German American neighbors with greater suspicion than ever before. *Library of Congress.*

Adele, unaware of this shadow play, believed that Schmidt wanted the papers as an inroad to a new identity with which to entrap another victim, and this is one possible scenario, but once again, Schmidt was in the right place at the right time. The center of the "passport fraud" scheme was New York City, where Adele's family lived.

"She [Adele] is convinced," wrote a *Detroit Times* reporter, "that the man was a dangerous German spy and acted in that capacity here in Detroit."[206] Coincidentally, Schmidt moved to Detroit at about the same time that Albert Kaltschmidt's group began its sabotage operations. In the spring of 1915, Schmidt stole Adele's maiden name and fled west to the industrial heartbeat of America. Throughout the summer and fall of 1915—when Schmidt lived at 418 Glendale Avenue as "Adolph Ullrich"—Kaltschmidt and his gang targeted Canadian munitions factories.

Schmidt himself admitted to knowing spies, although when Sheriff Green and the Justice Department agents came knocking on his door in the spring of 1917, no one believed him. At the time, they believed that the devious Schmidt simply tried a Machiavellian maneuver to divert their attention away from the missing New Yorker. But it is possible that Schmidt had more than a passing knowledge of espionage in Detroit.

Sketches of airplane parts found at 9 Oakdale suggested that Schmidt collected information about new gadgets. If Schmidt was interested in military technology, he was once again in the right place at the right time. Several area factories, including Ford and Packard, experimented with cutting-edge aviation technology. At Ford's Highland Park factory, workers

built the experimental Whippet Tank. The new armored vehicle was tested on a series of artificial hills and trenches located on the factory's grounds.

The idea that Schmidt worked as an enemy agent is an enticing theory, but there is another, more mundane explanation. The debonair "Captain Ullrich"—a man of intrigue and romance—may have been just another set of clothes in Schmidt's wardrobe of fake identities. The dashing Heidelburg graduate who fought honor duels and gathered intelligence for the empire presented a more attractive façade than the underlying reality of Helmuth Schmidt, machinist at an automobile factory.

The espionage ruse also would have provided a way for Schmidt to exert control over the women in his life. They were less likely to go to the authorities if they feared prosecution as accomplices in a spy ring. Helen said that she wanted to leave Schmidt because she suspected him of wrongdoing but remained by his side out of sheer fear. As Gillespie noted in his statement of May 2, 1918, both Gertrude and Helen were convinced that Schmidt was involved with some shady business, which the prosecutor described as a "mysterious connection with the German government." This "mysterious connection" might have intimidated the women into going along with his demands, possibly even playing along as Neugebauer's sisters.

Adele evidently believed that Braun was an enemy agent. She told Detroit detectives that she warned him about the possible consequences if he was caught: "They both [Schmidt and Gertrude] used to sneer at me because I warned him against arrest for making those maps."[207] This statement suggests that Adele knew and understood the danger, which was perhaps all Schmidt needed to keep her under his thumb.

Perhaps espionage was Schmidt's most grandiose deception.

NOTES

PREFACE

1. *Pontiac Press Gazette*, April 22, 1918.

PART I

2. Like thousands before her, Augusta Steinbach's gateway to America was Ellis Island. The manifest of the *Kronprinz Wilhelm*—a document noting key information about the passengers prepared for immigration officers on the island—described her as five feet, five inches tall with brown hair and blue eyes.

3. Agnes (under the name Agnes Domoiecker) arrived at Ellis Island on board the SS *Metapan* on April 16, 1914. "Passenger and Crew Lists," roll 2298, 177.

4. These advertisements originally appeared in the German-language newspaper the *New York Herald*. All of the major Detroit-area newspapers reprinted English translations: the *Detroit News* on April 22, 1918; the *Detroit Times* on April 23, 1918; and the *Detroit Free Press* on April 23, 1918. See also Willemse, Lemmer and Kofoed, *Behind the Green Lights*, 207.

5. There is no evidence that Neugebauer ever received this letter. The correspondence between Augusta and Neugebauer no longer exists, likely

incinerated by Schmidt to destroy evidence that could link him to Augusta Steinbach. The basic content of their letters is known only through what Agnes Domaniecki relayed to authorities when her friend disappeared. Ironically, the "randy" note did survive, in a way. When the Schmidt case made headlines in April 1918, the *Pontiac Press Gazette*, as well as two of Detroit's major newspapers, the *Detroit Free Press* and the *Detroit Times*, ran articles about the note accidentally being delivered to Nelgebauer.

6. Carol Bird, "Chum of Slain Girl Involves Women in Case," *Detroit Free Press*, April 27, 1918.

7. *Detroit News*, April 27, 1918.

8. A positive lifestyle, as defined by the Sociological Department, was a precondition to earning a portion of the wages.

9. *Detroit Times*, February 5, 1917.

10. According to T.H. Hetherington's testimony at the preliminary hearing of Helen Tietz Schmidt, Augusta Steinbach first checked into his boardinghouse on February 9, leaving a three-day period during which her whereabouts were unknown. Detectives believed that she may have stayed at the city's YWCA before checking into Hetherington's place.

11. The 1917 Detroit City Guide lists Hetherington's trade as furniture and antique furniture sales.

12. *Detroit Free Press*, April 29, 1918. T.H. Hetherington made a similar comment a few days later at the preliminary hearing of Helen Schmidt.

13. Ibid.

14. *Detroit News*, April 27, 1918.

15. *Detroit Free Press*, April 27, 1918. The original letters were discarded, but Agnes later described their content to Gillespie and reporters.

16. Ibid.

17. *Detroit Free Press*, April 29, 1918.

18. Schmidt began the naturalization process by submitting his "first papers" on October 15, 1915, in Detroit, but evidently he never finished. Gertrude also didn't complete the process. On Gertrude's 1920 passport application (completed, in part, by her ward George Dondero since she was still considered a minor), Dondero added a handwritten notation that Gertrude was a naturalized citizen "by marriage only." Thus, under Wilson's edict, they were both considered "enemy aliens"—a fact not missed by the era's news correspondents, who typically refer to Schmidt by the epithet "enemy alien." Unfortunately, their records no longer exist. In 1920, Congress approved the destruction of these "enemy alien" records, and very few survive today.

19. Later news coverage indicates that the "spy story" was merely a ruse to open Schmidt's front door.

20. According to the *Detroit Free Press* of April 26, 1918, the letter was addressed to T.H. Hetherington; according to the *Pontiac Press Gazette* of April 27, 1918, the letter was addressed to Louise Hetherington.

21. *Detroit News*, April 22, 1918; *Pontiac Press Gazette*, April 22, 1918; Willemse, Lemmer and Kofoed, *Behind the Green Lights*, 209.

22. *Pontiac Press Gazette*, April 22, 1918.

23. Testimony of Elizabeth Stilber, July 31, 1917, in *The People v. Allan Livingston*.

24. Dr. William S. Gass and Dr. James S. Morrison both examined Alexander's body in the morgue. Dr. Gass, in an interview with Gillespie, said he believed that the perpetrator raped Alexander. Testimony of Dr. William S. Gass, July 31, August 28, 1917, in *The People v. Allan Livingston*, 14–15.

25. *Detroit Free Press*, July 9, 1917.

26. Ibid.

27. *Pontiac Press Gazette*, January 8, 1918. There is no transcript of the court proceedings. The court stenographer died shortly after the trial, and none of his colleagues could decipher his shorthand. The only testimony contained in the court file is that of Elizabeth Stilber, O.H.P. Green and Dr. Gass, taken by Glenn Gillespie on July 31 and August 28, 1917. Livingston based his 1944 appeal partly on the basis of the missing trial transcript, arguing that the jury considered the statements of fellow prisoners even though the judge instructed them to disregard this testimony. Without a transcript, Livingston argued, the impact of the statements could not be properly assessed. *The People v. Allan Livingston*.

28. *Pontiac Press Gazette*, January 8, 1918.

29. Quoted in Willemse, Lemmer and Kofoed, *Behind the Green Lights*, 206.

30. *The People v. Allan Livingston*, 7.

PART II

31. Willemse, Lemmer and Kofoed, *Behind the Green Lights*, ix.

32. Ibid., 202.

33. *Pontiac Press Gazette*, April 22, 1918.

34. Willemse, Lemmer and Kofoed, *Behind the Green Lights*, 208.

35. Biographical information from Fuller and Catlin, *Historic Michigan*, 224.

36. *Pontiac Press Gazette*, December 10, 1917.

37. *Pontiac Press Gazette*, January 8, 1918.

38. *The People v. Allan Livingston*, 7.

39. *Pontiac Press Gazette*, January 12, 1918.

40. Livingston always maintained that he had an alibi and that his conviction was the end result of a framing. In 1943, he appealed his conviction based in part on the testimony of a fellow convict who claimed that a Pontiac officer offered him money in exchange for providing bogus testimony about Livingston. The convict, Walter J. Godfrey, refused the offer. Affidavit of Walter J. Godfrey, January 15, 1943, in *The People v. Allan Livingston*.

41. The only evidence that Agnes laid this trap comes from Willemse, who noted that Agnes shied away from publicity. As a result, the newspapers missed a few vital aspects of the case, including Agnes Domaniecki's behind-the-scenes investigation. According to Willemse, before setting her trap, Domaniecki made two trips to Detroit, where she interviewed various people associated with the case. Willemse, Lemmer and Kofoed, *Behind the Green Lights*, 202, 209–10.

42. Accounts vary about when the trunks were first opened. According to Willemse, he and Agnes opened and searched the trunks before the Detroit authorities arrived in New York. Later press accounts of the case indicate that the trunks lay unopened until Gillespie and Cryderman arrived in early March.

43. Willemse, Lemmer and Kofoed, *Behind the Green Lights*, 209.

44. *Pontiac Press Gazette*. March 21, 1918.

45. Hetherington told Gillespie, during two separate interviews, that Augusta left the boardinghouse just once. *Pontiac Press Gazette*, April 27, 1918, and *Detroit Free Press*, April 27, 1918. He later changed his story when he gave an interview to a *Detroit Free Press* correspondent that was published on April 28, 1917.

46. According to some news reports, Gertrude was seventeen in April 1918, but this is an error. Gertrude Schmidt was born on January 15, 1900, making her eighteen at the time of her arrest.

47. *Pontiac Press Gazette*, April 23, 1918.

48. Ibid.

49. Ibid.

50. An article published in the April 28, 1918 edition of the *Detroit News* refers to this watch as the key clue in the investigation into Schmidt's crimes. An article in the *Detroit Free Press* of April 27, 1918, describes some

of the etchings. In addition to March 11, 1917, the watch contained the dates of July 17, 1916; October 23, 1913, with the letters "A.B.C."; and November 6, 1913, with the inscription "A. Bremen."

51. *Pontiac Press Gazette*, April 23, 1918.

52. Ibid. Schmidt apparently fulfilled the requirements of Ford's Sociological Department and earned the full five-dollars-a-day wage, sometimes working six days a week.

53. There is no official transcript of Schmidt's confession. Schmidt agreed to give a formal statement in front of stenographer if they gave him a lunch break. Gillespie agreed and sent for a stenographer, but Schmidt's suicide prevented a formal record of his statements. Parts of Schmidt's confession, albeit in fragments, made it into the newspapers through statements Gillespie gave to the press. According to an article in the *Pontiac Press Gazette* on April 24, 1918, Schmidt asked for a translator because he didn't understand the questions, but they denied him this request.

54. *Pontiac Press Gazette*, May 2, 1918.

55. *Detroit Free Press*, April 24, 1918.

56. This portion of Schmidt's confession was kept from the press at first, pending the discovery of "Emma's" identity. Detectives later identified her as Emma Berchoffsky.

57. *Detroit Free Press*, April 24, 1918.

58. *Detroit Free Press*, April 22, 1918.

59. *Detroit Free Press*, April 25, 1918.

60. *Detroit Free Press*, April 24, 1918.

61. Ibid.

62. *Pontiac Press Gazette*, April 23, 1918.

63. *Detroit News*, April 24, 1918.

64. Twenty-four-year-old Helene Tietz arrived in the United States aboard the passenger ship *Blucher* on October 6, 1907. According to the ship's passenger manifest (page 243, lines 1 and 2), Helene (later "Helen") traveled with her sister, twenty-six-year-old Elise Tietz, who was a resident of New York and had lived in the United States since 1887. Helen's entry is found on page 242, line 2 of the manifest. "Passenger and Crew Lists," 105, lines 1–2.

65. According to her sister, Helen corresponded with "Herman Scharno." When she and her sister visited Scharno in Detroit, they discovered his true identity and his alleged reason for adopting the name Ullrich. See statement of Mina Hofbauer, "Mina and the Letter." A few days after her arrival in Detroit, Helen wed Schmidt. Marriage license record no.

125343, Wayne County Clerk, Wayne County, Michigan, contains the details of the marriage. Justice of the Peace Fred E. DeGaw presided over the marriage of Helen A. Tietz, thirty-five, and "Hellmuth" E. Schmidt, thirty-nine, on December 22, 1915. Under the column of previous marriages, Schmidt reported "one." The document lists the witnesses as Henry A. Schiller and Schmidt's daughter, Gertrude, and gives "engineer" as Schmidt's profession.

66. *Pontiac Press Gazette*, April 25, 1918.

67. *Detroit Free Press*, April 26, 1918

68. *Pontiac Press Gazette*, April 23, 1918.

69. Minna Rederer's statement is quoted from the *Detroit Free Press* of April 24, 1918. The Detroit City Guide of 1916 lists the resident of 418 Glendale Avenue as "Adolph Ullrich."

70. Ibid.

71. Frederick De Planta worked as a machinist for the Ford Motor Company and probably first met Ullrich at the Highland Park factory.

72. Marriage license record no. 125343, Wayne County Clerk.

73. *Detroit Free Press*, May 3, 1918.

74. *Detroit Free Press*, April 24, 1918.

75. *Pontiac Press Gazette*, April 24, 1918.

76. Ibid.

77. *New York Tribune*, April 24, 1918.

78. *New York Times*, April 24, 1918.

79. *Pontiac Press Gazette*, April 25, 1918.

80. Ibid.

81. As early as August 1915, news accounts linked "Emil Braun" with Helmuth Schmidt. An item titled "Bride Plays the Spy on Husband: Mrs. Emil Braun Becomes Suspicious and Does Some Detective Work," published on August 18, 1915, in the *Clyde (NY) Herald*, details Adele's early investigation into her husband's disappearance.

82. Carol Bird, "Bluebeard's Daughter Now Glad He's Dead," *Detroit Free Press*, April 26, 1918. At the time, reporters were occasionally allowed to sit in on interviews, take notes and even pose questions to the accused. This wasn't a common practice, but the news coverage of the Schmidt case indicates that members of the press were given access to the suspects during some of the interviews. For example, Bird later described Gertrude's flirtatiousness with her interrogators. See "The Enigmatic Gertrude Schmidt."

83. Ibid. Gertrude's statement is quoted in Bird's article.

84. Ibid.

85. Ibid.

86. *Pontiac Press Gazette*, April 25, 1918. Plummer probably sent the letter with the circular at the same time he sent the telegram.

87. Willemse described Agnes as extremely reticent, and his characterization is evident in the fact that detectives had to coax her out of her hotel room when she reached Detroit. He also noted that she shunned publicity. Like with Gertrude, then, many of her statements evaded print.

88. *Pontiac Press Gazette*, April 26, 1918.

89. *Pontiac Press Gazette*, April 27, 1918.

90. *Detroit Free Press*, April 28, 1918.

Part III

91. Carol Bird, "'Emil Hypnotist and Actor; He Was Idolized by Women,' Says Schmidt's Second Wife," *Detroit Free Press*, April 27, 1918. While other area newspapers invariably refer to Adele's surname as "Braun," the *Detroit Free Press* Anglicized her surname, calling her "Adele Ullrich-Brown." This is consistent with the anti-German sentiment of the time. By the time the story of Bluebeard broke in April 1918, the United States had been at war with Germany for more than a year, and Germans across the county rechristened themselves with Anglicized versions of their surnames.

92. Schmidt sent Adele away for a day when Edward Rederer came to visit on behalf of Irma Pallatinus. See the statement of Minna Rederer.

93. *Detroit Free Press*, April 29, 1918.

94. Bird, "Emil Hypnotist and Actor."

95. *Detroit Free Press*, April 29, 1918.

96. Bird, "Emil Hypnotist and Actor."

97. Variations of this portion of Adele's statement appeared in several area newspapers, including the *Detroit Free Press*, April 29, 1918, and the *Pontiac Press Gazette*, April 27, 1918.

98. *Pontiac Press Gazette*, April 27, 1918.

99. The *Detroit Free Press*, the *Detroit Times*, the *Detroit News* and the *Pontiac Press Gazette* all sent correspondents to cover this scene. Portions of Adele's statement appear in Bird, "Emil Hypnotist and Actor." A transcription of Adele's complete statement appeared in the April

27, 1918 edition of the *Pontiac Press Gazette*. Most of the quotes in this chapter come from this transcription.

100. Gertrude emigrated from Germany with two women: a "friend" of Schmidt's named Minna Baersch and a "sister" named Minna Gülzow. "Greta Braun" could have been either of them. According to Gertrude, Minna Baersch disappeared in late December just before Adele married her father, so Baersch probably played the role of "Greta Braun."

101. Ellis Island records indicate that Schmidt arrived in New York on November 6, 1913, aboard the SS *Bremen* (passenger manifest, line 5). The timing is curious. He departed from Bremen and arrived in the United States just a week after Gertrude, who departed not from Bremen but Hamburg. The German immigration files from vessels departing from the port of Bremen were destroyed during World War II.

102. Ellis Island records indicate that fourteen-year-old "Gertrud" Schmidt (passenger manifest line 17) came through Ellis Island on the *Amerika* alongside twenty-six-year-old Minna Baerch (line 16) and thirty-three-year-old Minna Gülzow (line 15) on November 13, 1913. The passenger manifest lists "Helmuth Schmidt" as Gertrud's father and Minna Baerch's "friend." According to the manifest, Minna Gülzow (line 15) was married. The notation "Aunt to No. 17" appears next to her name on the roster. "Helmuth Schmidt" is listed as her American connection, with the word "friend" crossed out and replaced (in parenthesis) by the word "brother." The manifest indicates that the three were traveling together and clearly going to meet Schmidt, but Minna Gülzow's relationship to Schmidt remains obscure. "Passenger and Crew Lists," roll 2222, page 107, line 15–17.

103. Testimony of Adele Ullrich Braun, May 27, 1918, Probate Court for County of Oakland, Michigan, "In the Matter of the Estate of Helmuth Schmidt, Deceased," case file 14376.

104. The article "Bride Plays the Spy on Husband" in the *Clyde (NY) Herald* hints that Braun was a spy with a not-so-subtle subtitle: "Fondness for Night Journeys, Views of American Forts and His Skill at Penning Code Letters, Had Military Significance." Although the writer carefully avoided using the word "spy" to describe Braun, he characterizes him as deft in writing code "with the ease and rapidity of a stenographer. His code is practically undecipherable in that each character represents a word." In referring to the "bride" playing "spy" on her husband in the article's title, the writer also alluded to Braun's alleged espionage.

105. Bird, "Emil Hypnotist and Actor."

106. Criminal abandonment was vigorously prosecuted at the time.

107. *Pontiac Press Gazette*, May 3, 1918.

108. *New York Times*, April 27, 1918.

109. *Detroit News*, April 26, 1918.

110. *Detroit News*, April 28, 1918.

111. *Detroit Times*, April 26, 1918. The five women were Pallatinus, Steinbach, Berchoffsky, Murray and "Mrs. Helmuth Schmidt No. 1."

112. *Pontiac Press Gazette*, April 29, 1918.

113. Ibid.

114. Quoted in Bird, "Chum of Slain Girl."

115. Ibid.

116. Ibid.

117. Ibid. This letter apparently convinced Agnes that Augusta lived in Royal Oak for as long as two months, but the facts don't support this idea. Lena Welch, who kept close tabs on her neighbor, saw Augusta just twice.

118. *Pontiac Press Gazette*, April 27, 1918.

119. According to the marriage certificate, Anna Hocke married John Swift on December 14, 1914, in the Bronx. The groom signed his name as "John Switt," but official sources (including court documents) refer to "John Swift" as "John Switt," and Anna Hocke signed her affidavit as Anna Hocke Switt, so the spelling on the marriage license is probably a clerical error.

120. The marriage certificate lists Switt's father as "Joseph" and his mother's maiden name as "Marie Hajda." City of New York Municipal Archives, certificate and record of marriage, John Swift to Anna Hocke, certificate number 30961.

121. Marriage license record no. 125343, Wayne County Clerk. The marriage record lists only the first names of the bride and groom. On the passenger manifest from the SS *Bremen*, Schmidt's nearest kin in Germany is listed as his father, "Julius Schmidt," and fourteen-year-old "Elizabeth"—almost certainly a reference to Gertrude Schmidt, who would have been about that age.

122. *Pontiac Press Gazette*, April 26, 1918.

123. Statement of Adele M. Braun, May 27, 1918, "In the Matter of the Estate of Helmuth Schmidt, Deceased."

124. *Detroit Free Press*, April 28, 1918.

125. *New York Sun*, April 29, 1918. This article provides an excellent example of how Schmidt's multiple identities confounded journalists, leading to confused news reports about the case. The anonymous *New York Sun*

correspondent reported that Schmidt had been arrested "alongside" George Roloff and his wife, but Helmuth Schmidt *was* George Roloff.

126. *Royal Oak Tribune*, May 3, 1918.

127. Carol Bird, "Gertrude Schmidt in Varying Moods, Smiles, Then Weeps Way out of Difficult Situations," *Detroit Free Press*, April 28, 1918.

128. Ibid.

129. Ibid. While the other principals in the case—Adele Ullrich in particular—had no problem speaking in front of the press, Gertrude appears to have distrusted reporters. As a result, her off-the-record statements never made it to print.

130. Ibid.

131. *Pontiac Press Gazette*, April 27, 1918. Evidently, Gertrude didn't tell the prosecutor "the real truth" at first. During his first exoneration of Gertrude, Gillespie stated that investigators had reason to believe that Schmidt "did away" with his first wife in Germany. See "Gertrude and Helen."

132. Buda Stephens, "Daughter of Schmidt Victim of Prussianism," *Detroit News*, April 27, 1918.

133. *Pontiac Press Gazette*, April 24, 1918.

134. In April 1918, A.E. Crosby's "undertaking establishment" was located at 2873 Woodward Avenue.

135. *Detroit News*, April 28, 1918.

136. Ibid.

137. *New York Times*, April 29, 1918.

138. *Detroit Free Press*, April 28, 1918.

139. *Detroit Free Press*, April 30, 1918.

140. Schmidt may also have passed off Anita Schmidt as his sister, although the investigators were unaware of this at the time. See the "Unanswered Questions" chapter.

141. According to a *Detroit Free Press* item published on April 27—the day before Hetherington's revelation—Gillespie believed that even if Helen and Gertrude were at home and played along as Neugebauer's sisters, Michigan law would shield them from prosecution.

142. *Detroit Free Press*, April 30, 1918.

143. Ibid.

144. Schmidt, record number 3941, is buried in an unmarked grave in section 32, space 611.

145. *Detroit Free Press*, April 30, 1918.

146. Ibid.

147. It is conceivable that Gillespie's praise of the *Press Gazette* was a veiled criticism of the page-one article from the Sunday, April 28 edition of the *Detroit Free Press*. The tone and content of this article, containing the statements of Domaniecki, Welch and Hetherington, hinted at complicity on the part of Helen and Gertrude, but Gillespie had publicly commented that even if they were home on March 4 when Schmidt brought Augusta Steinbach to Royal Oak, the law shielded them from prosecution. Gillespie also made this comment lauding the *Press Gazette* after he read the article containing Hetherington's statement about Augusta's sisters but before Cryderman verified it later that afternoon. Based on Hetherington's earlier statements, Gillespie worked on the assumption that Augusta left the boardinghouse just once, so he may have considered the *Free Press* story unreliable and perhaps irresponsible.

148. Gillespie's statement to the press quoted in the *Pontiac Press Gazette*, April 29, 1918. The *Free Press* also ran Gillespie's statement, but it came one day later, in its April 30 story—the same edition that described Cryderman's telephone call to Hetherington. The *Press Gazette* printed Gillespie's statement in entirety, while the *Free Press* only printed a portion of it, omitting the paragraph praising the *Press Gazette*.

149. *Pontiac Press Gazette*, April 30, 1918.

150. *Detroit Free Press*, April 28, 1918.

151. News of Mrs. Welch's statement appeared in a *Detroit Free Press* item printed on Saturday, April 27. It is possible that Hetherington read the report, which reminded him of the earlier visit that Augusta made to Royal Oak.

152. In a *Detroit Free Press* article published on May 1, 1918, Gillespie said that he didn't know if he would call Gertrude to testify. It is probable that the new information from Hetherington prompted him to put the teenager on the stand.

153. According to an item in the May 1, 1918 *Detroit Free Press*, Prosecutor Gillespie "has apparently abandoned his intention of making the arraignment a mere formal dismissal of the charge and will have testimony taken, if for no other purpose, he says, than to make a record of it." In light of Hetherington's revised statement, Gillespie evidently wanted to question Gertrude Schmidt in an official venue. It is also possible that Gillespie wanted to answer criticism from Wayne County officers by having Gertrude's story made official during a court proceeding.

PART IV

154. Deposition of Anna Hocke Switt, June 7, 1918, "In the Matter of the Estate of Helmuth Schmidt, Deceased."

155. *Pontiac Press Gazette*, May 8, 1918.

156. Office of the Wayne County Medical Examiner, autopsy report for Irma Pallatinus, May 2, 1918. In his autopsy notes, Dr. French described the body as "decomposed." Under favorable conditions, bodies may become mummified, but in this case, this characterization was probably an invention of reporters. The body remained wrapped in canvas until it reached the morgue, and the only witnesses present during the postmortem were Drs. Dick and French and Detectives Dibble and Reid, so reporters didn't even see the body.

157. Ibid. The examination lasted thirty minutes.

158. This was the only identification of the remains done at the time.

159. Autopsy report for Irma Pallatinus. In 1918, Michigan employed coroners, who were elected officials but typically not physicians. The coroner would issue an official report after a county doctor conducted an autopsy and determined cause of death. In the Pallatinus case, Dr. Dick conducted the autopsy, and Wayne County coroner Morgan Parker signed Dick's report and announced a cause of death.

160. *Pontiac Press Gazette*, May 3, 1918.

161. *Pontiac Press Gazette*, May 2, 1918.

162. Testimony of T.H. Hetherington, May 2, 1918, quoted in the *Pontiac Press Gazette*, May 3, 1918. The *Press Gazette* was the only area newspaper to provide a partial transcript of testimony at the hearing. The *Detroit Free Press*, in a page-one item on May 3, 1918, provided synopses.

163. Hetherington quoted in the *Pontiac Press Gazette*, May 3, 1918.

164. Ibid.

165. Testimony of Gertrude Schmidt, May 2, 1918, quoted in the *Pontiac Press Gazette*, May 3, 1918.

166. Alexander Ullrich and his wife, Sophie, signed the marriage certificate as witnesses. City of New York Municipal Archives, certificate and record of marriage, Emil Braun to Adele M. Ullrich, December 30, 1914, certificate number 14.

167. Gertrude appears to be offering an alternate explanation for the accident that Adele alleged was a murder attempt. In this version, Gertrude swapped Adele with Irma, and everyone walked away from the crash unscathed.

168. Inventory of the estate of Helmuth Schmidt, May 15, 1918, "In the Matter of the Estate of Helmuth Schmidt, Deceased."

169. According to Oakland County Probate records, Adele lived at 66 Edmund Place.

170. Irma Pallatinus, record number 3960, is buried in an unmarked grave in section 17, space 194.

171. *Detroit Free Press*, May 5, 1918.

172. *Detroit Free Press*, May 9, 1918; *Pontiac Press Gazette*, May 9, 1918.

173. *Pontiac Press Gazette*, May 9, 1918.

174. Willemse offered his explanation for the presence of this dog. Schmidt, he said, gave Green a "fine police dog" after the two met to discuss the Steinbach case. Willemse, Lemmer and Kofoed, *Behind the Green Lights*, 209.

175. *Pontiac Press Gazette*, May 9, 1918; *Detroit Free Press*, May 9, 1918.

176. Ibid.

177. Petition of Adele M. Braun, ND, "In the Matter of the Estate of Helmuth Schmidt, Deceased."

178. Petition contesting the petition of Adele M. Braun by George Dondero, legal guardian of Gertrude Schmidt, ND, "In the Matter of the Estate of Helmuth Schmidt, Deceased."

179. Petition contesting the petition of Adele M. Braun by Helen Schmidt, June 7, 1918, "In the Matter of the Estate of Helmuth Schmidt, Deceased."

180. City of New York Municipal Archives, certificate and record of marriage between Emil Braun and Adele M. Ullrich, December 30, 1914, certificate number 14.

181. Adele is mistaken regarding the date. She first arrived in Detroit on the Morning of Friday, April 26, 1918.

182. Testimony of Adele M. Braun, May 27, 1918, "In the Matter of the Estate of Helmuth Schmidt, Deceased." The trial transcript is in question-and-answer form. It has been formatted as dialogue here to create a more readable narrative.

183. City of New York Municipal Archives, certificate and record of marriage between John Swift and Anna Hocke, December 16, 1914 certificate number 30961.

184. According to the *Pontiac Press Gazette*'s coverage of the case, Gertrude testified in probate court about her father's physical characteristics, specifically the dueling scars on his face. The court record, however, does not contain a transcript of Gertrude's testimony, the testimony of McLaughlin and Dibble, the affidavits submitted by New Yorkers who

met "John Switt" or the photographs submitted by Anna Hocke Switt. These details come from the *Pontiac Press Gazette*, July 30, 1918.

185. The passenger manifest of the SS *Bremen* lists Schmidt's height at five-foot-six and describes him as having black hair and blue eyes. Evidently, the clerk aboard the SS *Bremen* noticed the scars, as the passenger manifest also has the notation "Face marked" under "Marks of Identification."

186. Stipulation, August 15, 1918, "In the Matter of the Estate of Helmuth Schmidt, Deceased."

187. Ibid.

EPILOGUE

188. Discharge of court-appointed guardian, January 27, 1918, Probate Court for the County of Oakland, Michigan, "In the Matter of the Estate of Gertrude Schmidt, a Minor," case file 14375.

189. Michigan Department of Health, certificate of death, Gertrude Anna Maria Kurth, November 19, 1952.

190. Obituary for Mrs. Erich O. Kurth, *Royal Oak Daily Tribune*, November 20, 1952.

191. Michigan Department of Health, certificate of death, Helen Schmidt, July 2, 1964.

192. Detroit city guides published after 1918 do not contain entries for either "Adele Braun" or "Adele Brown."

193. Affidavit of Walter J. Godfrey, January 15, 1943, in *The People v. Allan Livingston*.

194. Willemse, Lemmer and Kofoed, *Behind the Green Lights*, 202.

195. Ibid., 214.

UNANSWERED QUESTIONS

196. *Detroit News*, April 24, 1918.

197. Schmidt's naturalization papers, according to the *Pontiac Press Gazette*, indicate that he was the son of Julius Schmidt and arrived on the SS *Bremen* on November 6. The *Bremen*'s passenger list contains an entry for

"Max Schmidt" from Rostock, Germany, who gave his father's name as "Julius." The physical description of "Max Schmidt" matches Helmuth Schmidt. See endnotes 101, 121 and 185.

198. *Pontiac Press Gazette*, April 24, 1918.

199. Willemse, Lemmer and Kofoed, *Behind the Green Lights*, 214.

200. A *Pontiac Press Gazette* reporter wrote, "The daughter told in answer to questions that her own mother, Anida [*sic*] Schmidt or Braun as they were known in New Jersey…accompanied her to this county in November 1913." *Pontiac Press Gazette*, April 27, 1918.

201. *Detroit Free Press*, May 5, 1918.

202. Willemse, Lemmer and Kofoed, *Behind the Green Lights*, 202.

203. Ibid., 212.

204. Landau, *Enemy Within*, 276.

205. Ibid., 10.

206. *Detroit Times*, April 26, 1918.

207. Ibid.

BIBLIOGRAPHY

BOOKS

Fuller, George N., and George B. Catlin. *Historic Michigan, Land of the Great Lakes; Its Life, Resources, Industries, People, Politics, Government, Wars, Institutions, Achievements, the Press, Schools and Churches, Legendary and Prehistoric Lore.* Vol. 3. [Dayton, OH:] National Historical Association, 1928.

Kilar, Jeremy W. *Germans in Michigan.* East Lansing: Michigan State University Press, 2002.

Landau, Henry. *The Enemy Within: The Inside Story of German Sabotage in America.* New York: G.P. Putnam's Sons, 1937.

Willemse, Captain Cornelius, George James Lemmer and Jack Kofoed. *Behind the Green Lights.* New York: Garden City Publishing Company, 1931.

Woodford, Arthur M. *This Is Detroit: 1701–2001.* Detroit, MI: Wayne State University Press, 2001.

NEWSPAPERS

Chicago Daily Tribune.
Clyde (NY) Herald.
Detroiter Abend-Post.
Detroit Free Press.

Detroit News.
Detroit Times.
New York Herald.
New York Sun.
New York Times.
Pontiac Press Gazette.
Royal Oak Tribune.

DOCUMENTS

The City of New York Municipal Archives, New York, New York. Certificate and Record of Marriage, Emil Braun to Adele M. Ullrich in the Borough of Bronx, December 30, 1914, certificate number 14.

———. Certificate and Record of Marriage, John Swift to Anna Hocke in the Borough of Manhattan, December 16, 1914, certificate number 30961.

Michigan Department of Health, Vital Records Section, County of Oakland. Certificate of Death, Gertrude Anna Maria Kurth, November 19, 1952.

———. Certificate of Death, Helen Schmidt, July 2, 1964.

Michigan Department of Health, Vital Records Section, County of Wayne. Certificate of Death, Helmute [*sic*] Schmidt, April 23, 1918.

Office of the Wayne County Medical Examiner. Report of Autopsy for Irma Pallatinus, May 2, 1918.

"Passenger and Crew Lists of Vessels Arriving at New York, New York," compiled June 16, 1897–July 3, 1957. Record Group 85: Records of the Immigration and Naturalization Service, 1787–2004. Microform T715, Textual Archives Services Division, National Archives and Records Administration, Washington, D.C.

"Passport Applications," compiled January 6, 1906–March 31, 1925. Record Group 59: General Records of the Department of State, 1763–2002. M1490, Textual Archives Services Division, National Archives and Records Administration, Washington, D.C.

The People of the State of Michigan v. Allan Livingston. Oakland County Circuit Court, File No. 3275.

The People of the State of Michigan v. Frank Paroski. Oakland County Circuit Court, File No. 3322.

State of Michigan Probate Court for County of Oakland, Michigan. "In the Matter of the Estate of Gertrude Schmidt, a Minor," case file 14375.

———. "In the Matter of the Estate of Helmuth Schmidt, Deceased," case file 14376.

Wayne County Clerk, Wayne County, Michigan. Marriage License, Helmuth E. Schmidt to Helen A. Tietz, Wayne County, Michigan, December 22, 1915, license no. 125343.

INDEX

About the Author

Tobin T. Buhk began his life as a true crime writer when he did a stint as a volunteer in the Kent County Morgue, where he stood behind Medical Examiner Dr. Stephen D. Cohle, quietly observing as Dr. Cohle unraveled baffling forensic mysteries. This experience led to their first collaboration, *Cause of Death* (Prometheus Books, 2007), which was followed by a second collaboration, *Skeletons in the Closet* (Prometheus, 2008). A love of history and a morbid fascination with the dearly departed led to Buhk's *True Crime Michigan* (Stackpole Books, 2011), a criminal history of the Great Lake State, and to *True Crime in the Civil War* (Stackpole, 2012), which introduces readers to the villains who took the "civil" out of the Civil War.

Visit us at
www.historypress.net

This title is also available as an e-book